The
POET'S
Dictionary

The
POET'S
Dictionary

A Handbook of Prosody and Poetic Devices

WILLIAM PACKARD

HarperPerennial
A Division of HarperCollinsPublishers

Designed by Alma Orenstein

The Library of Congress has catalogued the hardcover edition as follows:

Packard, William.
 The poet's dictionary : a handbook of prosody and poetic devices / William Packard. —1st ed.
 p. cm.
 ISBN 0-06-016130-2
 1. Literature—Terminology. 2. Poetics. 3. Versification. 4. English language—Versification. I. Title.
 PN44.5.P3 1989
 808.1´014—dc19 88-45899

ISBN 0-06-272045-7 (pbk.)

06 RRD H 20 19 18 17 16 15 14 13

*This book is dedicated to the memory of
my father, Arthur Worthington Packard,
who was a brave and decent man.*

Contents

Foreword

Every trade, every art and craft has a language of its own which the practitioner proudly learns and often pretends he does not know. For the poet this language is prosody. If a steelworker balanced on a girder seventy stories above the city calls to his mate for a *rivet* and instead is tossed a *trendle*, the mistake may be fatal. The vocabulary of a craft may seem secret, almost hieratic, but it binds the artist to his art. The poet's dictionary, when available, because they are always going out of date, supplies the neophyte with all the poetic options he can use. Any poet, history tells us, who defects from the prosody, unless he supplies a new one, does so at his peril.

But the poet's dictionary is more than a glossary. It is also an anthology, a garland of expertly chosen illustrations, without which the dictionary would be dry bread. These illustrations are some ancient and famous, some from other languages, some modern, some contemporary, most of them touchstones of one variety or other, the jewels in the crown, real or paste, as the case may be. It has been the experience of this writer that it was a forgotten poet's dictionary which started him writing poetry. In later years, when he was himself a teacher of poetry, he tried to get this long-out-of-print book back into publication, and failing this compiled one of his own, a prosody handbook which served several generations of students. A new poet's dictionary is indispensable.

The twilight of the twentieth century is given to prodigies, a little-noticed one of which is the phenomenon of simultaneous prosodies. It has never happened before that all prosodies, ancient, modern, and experimental, are exercised at the same time in the same place. Such a situation can be viewed as simple chaos or as a historical first. These multifarious prosodies are mostly mutually exclusive but nevertheless coexist and are united if at all only in the poet's dictionary. In this bewildering museum of forms, or zoo, the poet makes his way. Only those of consummate skill and virtuosity can possibly encompass these diverse prosodies (Auden, for example) from the most lofty

and sacred to the popular to the craft of advertising to even the porno-graphic. But it is a rare poet who aspires to this conquest of completeness. Most poets in maturity are happy to limit their craftsmanship to the single voice they have developed over the years (Robert Frost, for example). It is this voice that is the identification card of the poet. No greater compliment can be paid to the poet than this kind of recognition, as when one says of a newly found anonymous poem, "This is a Roethke poem" or "This is a Hopkins." It is no exaggeration to say that the creation of one's particular "voice" in poetry is the final goal of the poet or artist of any category. Any person of moderate education can tell a Frank Lloyd Wright building, a Bernini fountain, a Degas painting, a Haydn quartet, a Chekhov short story, a Faulkner novel from other works of architecture, sculpture, painting, music, or fiction. The distinctive voice however does not necessarily confer a qualitative superiority on the work. The poems of Joyce Kilmer or Eugene Field or for that matter much of Edna St. Vincent Millay or Archibald MacLeish use the distinctive voice to no advantage. It is interesting that the recent "discovery" of a couple of supposititious songs of Shakespeare was laughed out of court by the majority of Shakespeare scholars and general readers of the Bard. The benchmark of Shakespeare was simply not there.

Everyone knows that the ancient name *poet* means maker or author. "To make" means to fabricate or put together. What are the materials, the materia poetica, which the poet uses? Consult the poet's dictionary. But note that these materials are largely immaterial, spiritual, psychological, that they do not require stone, earth, wood, pigment, or iron, but only words fabricated together. The poet is aware of a deep gulf between the actual dictionary, such as the masterpiece of the Oxford English Dictionary, and the poet's dictionary, which begins where the actual dictionary leaves off. Words in the actual dictionary are sometimes referred to as frozen metaphor. It is true that the actual puts a stop to language where the poet's dictionary gives the go sign. In poetry the word thaws and begins to move. It begins to move in all directions like a miniature hurricane or a whirling atom. It picks up temper-atures and atmospheres. Some poets call poetry language in a state of crisis. It certainly is that, but it is the kind of crisis that involves all the emotions and ends in elevation, purification, and catharsis. Poetry is one of the trans-cendent forms of magic.

Talk of the mystical properties of poetry dates from the beginnings of human memory. Though inexplicable, this can be explained on a rational level of understanding: poetry is not rational. On the prosodic level the poet's dictionary reveals language as dance and flight, flight as soaring aloft and flight as escape. The common graphic symbol of poetry is the winged horse. The epic poet's invocation to the Muse is always a prayer of release and

escape from the gravitational anchor of the mundane. The line between poetry and prayer is so fine as to be invisible.

The Muse-goddess is the governor of poets. William Carlos Williams said, it is the woman in me that writes poetry. Macho society always denigrates poetry—a metonymy for all the arts—as effeminate, when in fact poetry is asexual. Attention to the Muse, consciousness of the Muse, address to the Muse, are the seed of poetry.

And the composition of poetry is a hod-carrying sweat. To master such a trade one would do well to have at one's elbow the manual and guidebook of the poet's dictionary.

Karl Shapiro

Preface

Why would anyone want to try to write a dictionary of poetry?

I confess in all honesty, I don't really know. I do know that over the past twenty years, while teaching poetry writing classes at New York University, I have felt a deep need for a single volume on the craft of poetry and prosody that would be of real value to my students who were trying to write poetry. What a wonderful thing it would be if I could find one book on the art of poetics I could hand to them and say: here, you'll find all you really need to know about poetry writing in this one book.

And in fact I did find certain books that were, in one way or another, useful to assign in workshops and writing classes and writers conferences. Among these books were the following: Babette Deutsch, *Poetry Handbook;* Karl Shapiro and Robert Beum, *A Prosody Handbook; Princeton Encyclopedia of Poetry and Poetics;* Paul Fussell, Jr., *Poetic Meter and Poetic Form;* and Lewis Turco, *The Book of Forms.* I felt these books were the best of the bunch, and I still think so. Of course there were many other technical books on the craft of poetry, which are listed in the bibliography at the back of this book, and some of them contain much that is useful.

Even so, the thought stayed with me over the years that most prosody books and books on poetics tended to be too partisan or pedantic or parochial. I felt they were either too technically specialized to be of much use to the practicing writer or, what was far worse, they seemed to be aiming at the lowest common denominator, as if one could ever learn craft or solid poetics from studying examples of middling works or doing a lot of virtuoso exercises on a metrical harpsichord. I began to feel that what was really needed was a single-volume poetry dictionary where a reader/writer could find brief and accurate definitions of the various poetic devices, together with a larger overview of the uses of these devices from the entire range of master poems of world poetry.

Not that such a book would be easy to write, and I dreaded my own

determination to go in this direction. How would I complete all the stagger-
ing research necessary to put such a book together? If this book were to be
done correctly, as I envisaged it, it would have to draw from the earliest epic
poetry of Homer and Virgil and Ovid, through the lyric poetry of Sappho
and Catullus, and all the Anglo-Saxon ballads and Middle English songs, and
the Medieval Troubadour tradition that culminates in Dante's massive *Com-
media*. It would have to include the English Renaissance and Shakespeare
and the poetry of Spenser and Sidney and Wyatt and Drayton and Mark
Alexander Boyd as well as the romantic poets, Keats and Shelley and Words-
worth and Byron and Coleridge. I'd have to add the modern and postmodern
movements of Imagism and Symbolism and Surrealism and Dada and auto-
matic writing as practiced by André Breton and Gertrude Stein, and the
twentieth-century renaissance of contemporary English and American poetry
as heralded by Ezra Pound and T. S. Eliot. It should also represent some of
the outstanding performance lyrics of poets such as Bob Dylan, Paul Simon,
and Judy Collins. And this book should also take note of the prevalent
historical theories of poetry, drawn from such great Western minds as Plato,
Aristotle, Longinus, Gascoigne, Sidney, Coleridge, Saintsbury, Shelley, Poe,
Pound, Eliot, Yvor Winters, Empson, I. A. Richards, Charles Olson, Robert
Creeley, and Allen Ginsberg. And to be truly catholic and representative of
world poetry, the book should also represent a hefty amount of verse from
outside our mainstream Western tradition—from the civilizations of ancient
Egypt, Persia, China, Japan, India, Africa, and all the emerging Third World
nations.

No thank you! It was too much of a job and I had too many other things
to do with my life. But after a couple of years of stalling on the project and
pretending the problem didn't exist, I began to come back to it in the mid-
1980s and decided to write a proposal for a single-volume poetry dictionary
which would be the complete handbook on prosody and poetics for the
practicing writer. I gradually began the enormous task of research and ar-
rangement of the book itself. And I began to hammer out a style of writing
definitions and citing examples that would be clear, simple, and immediately
useful to readers and writers and students of poetry on any level of compe-
tence.

In addition, this book tries to explore the full implication of the words
"contemporary" and "poetry" in light of our experience in the world today.
It also discusses why and how formal structure is related to meaning in a
poem, as well as the possibilities of placement on the page and how line
arrangement can affect a reader's perception of a poem. The book also con-
siders how rhythm and image and voice can ultimately coalesce in the very
greatest poetry.

* * *

Now that the work has been done, I can lean back and feel a tremendous gladness that so much of my life has been centered around poetry. During my senior year at Stanford University in the mid-1950s, where I was majoring in philosophy, I felt I was the only one who didn't have the remotest idea of what I wanted to do with the rest of my life. And that was when I began to write poetry. Those first poems were all miraculously automatic, they came effortlessly and usually all in one piece. Maybe this was simply the lyricism of late adolescence, when one experiences the pulse of possibility in every body part. Whatever it was, I began to write endlessly: poems about love, poems about spring, poems about death, and poems about poems.

At the same time, I wanted to learn as much as I could about the craft of poetry. I began taking various poetry writing classes on both the west and east coasts—with Allen Ginsberg at San Francisco State College, with Stanley Kunitz at the New School, with Yvor Winters at Stanford, and with Léonie Adams at Columbia University.

I also enjoyed a warm friendship in Palo Alto with Kenneth Patchen, whose easy Surrealism came from a simple trust in his own gut hunches. I still believe "The New Being" and "What Is the Beautiful?" and *The Journal of Albion Moonlight* are among the most beautifully intuitive writings that I know. And I value conversations I had with Robert Frost at Bread Loaf, who told me to get the hell out of there because I "didn't belong" among the straight-faced scholars at Middlebury. When I asked him where I should go, he answered, "Anywhere these people aren't," and he also warned me that I would have to learn how to fight for my poetry because it would be my entire lifework.

From 1956 to 1965, I worked for Elizabeth Kray at the Poetry Center of the YMHA in New York, where I introduced guest poets during the scheduled season. This was a rare opportunity for me to meet and talk with some of the greatest poets of our time—W. H. Auden, Marianne Moore, E. E. Cummings, Robert Lowell, Archibald MacLeish, Richard Eberhart, Carl Sandburg, Richard Wilbur, Kenneth Rexroth, W. S. Merwin, William Meredith, John Ciardi, Adrienne Rich, Denise Levertov, Isabella Gardner, Stephen Spender, Louis Untermeyer, Muriel Rukeyser, Peter Viereck, and many, many others.

In 1965, my alexandrine translation of Racine's *Phèdre* was produced off-Broadway starring Beatrice Straight and Mildred Dunnock, directed by Paul-Émile Deiber of the Comédie-Française, and produced by the Institute for Advanced Studies in the Theatre Arts. At about that time Louise Bogan became seriously ill, so I took over her poetry writing classes, which I have

been teaching ever since. I've also taught poetry writing at other colleges and at various writers conferences.

In 1969 I founded *The New York Quarterly,* a magazine devoted to the craft of poetry. Over the last twenty years, the NYQ Craft Interviews have become a regular feature of the magazine, and many of these interviews provided the basis for this book.

As for acknowledgments: all I can do here is list a few of the people who were important in helping me shape my ideas about poetics and prosody. I've already mentioned early key figures such as Kenneth Patchen and Yvor Winters and Allen Ginsberg and Robert Frost; I should also add to this list the many important friendships I've had over the years, especially Bob Lax with his zen circus approach to poetry writing. Helen Adam was a constant source of friendship and encouragement, as were Muriel Rukeyser and Dick Eberhart. Eli Siegel, Carroll Terrell, Michael Moriarty, Charles Bukowski, Martha Schlamme, Andrew Glaze, Stephen Stepanchev, Ruth Herschberger, Robert Peters, Dennis Bernstein, Lola Haskins, Pat Farewell, Susan O'Connor, Virginia Admiral—as they say, the list is endless.

I'd also like to add how much I owe to Brian Bailey and Roger Richards for their help in acquiring a first-rate library of source books, which is rare in this day and age. To Max Siegel at Snap Camera for his generosity and friendship. To Walter James Miller at NYU and at various writers conferences where we worked together with forbearance and insouciance. To Warren Bower and Russell Smith at NYU, and to Zipporah Liben at Hofstra. Special thanks and lifelong gratitude to Herbert Berghof for his teaching and perception of the importance of poetry at the H.B. Studio in Manhattan where I've taught since 1965, and to many fellow artists there: George Axiltree, Dick Longchamps, Michael Beckett, Ed Moorehouse, and Letty Ferrer. To Elise Rindlaub for her listening to the wind in the leaves, and to Shannon John for her choosing the road less traveled by. To Joann Crispi for her friendship and invaluable legal advice, and as always to Shelly Estrin for her steadfast insight and compassion for our poor frail lot.

To Jeanne Flagg at Harper & Row for her early faith in this book, and to Carol Cohen, Susan Randol, and Mary Kay Linge for the actual editing of it.

A word about the text of the book: I have tried to keep the original spellings and punctuation of poems from the Middle English and Renaissance and the

nineteenth century, in poets such as Chaucer, Wyatt, Marlowe, Webster, Jonson, Milton, Donne, Gray, Herrick, Burns, and Emily Dickinson. Wherever possible, I have used the best original text available to me.

William Packard

A

ACCENT

The basic unit of stress in metrical verse, sometimes equated with pitch (force of breath tone) or duration (long or short vowel sound). The following line has five separate accents, as indicated:

> To bé or nót to bé: thát is the quéstion.

See also METER.

ALEXANDRINE

A hexameter line composed of six feet. In French neoclassic poetry, an alexandrine includes an absolute CAESURA division creating two equal hemistiches (half lines) of three feet each on either side. Thus the opening lines of *Phèdre:*

> Le dessein en est pris: je pars, cher Théramène,
> Et quitte le séjour de l'aimable Trézène.
> Dans le doute mortel dont je suis agité,
> Je commence à rougir de mon oisiveté . . .

> (Jean Racine, *Phèdre,* I.i)

The absolute caesura in the above lines falls after the words pris/séjour/mortel/rougir. An English translation of the above passage, retaining the conventions of the neoclassic alexandrine line, follows:

> I have made up my mind: I go, dear Théramène,
> and leave the loveliness of staying in Trézène.

Each day I have new doubts, they drive me to distress,
and I must blush with shame to see my idleness . . .

<div align="right">(tr. William Packard)</div>

The absolute caesura in the above lines falls after the words mind/loveliness/
doubts/shame.

C. S. Lewis in *English Literature in the Sixteenth Century (Excluding
Drama)* explains the departure in English from neoclassic conventions of the
alexandrine:

> The medial break in the alexandrine, though it may do well enough
> in French, quickly becomes intolerable in a language with such a
> tyrannous stress-accent as ours: the line struts. The fourteener has a
> much pleasanter movement, but a totally different one; the line
> dances a jig. Hence in a couplet made of two such yoke-fellows we
> seem to be labouring up a steep hill in bottom gear for the first line,
> and then running down the other side of the hill, out of control, for
> the second.

Thus the so-called Spenserian stanza of *The Faerie Queene* has nine lines
to a stanza, the first eight being pentameter and the ninth a loose alexandrine,
or what Lewis calls a "fourteener":

> The waves come rolling, and the billowes rore
> Outragiously, as they enraged were,
> Or wrathfull *Neptune* did them drive before
> His whirling charet, for exceeding feare:
> For not one puffe of wind there did appeare,
> That all the three thereat woxe much afrayd,
> Unweeting, what such horrour straunge did reare.
> Eftsoones they saw an hideous hoast arrayd,
> Of huge Sea monsters, such as living sence dismayd.

<div align="right">(Edmund Spenser, *The Faerie Queene*)</div>

In the following sonnet, Sir Philip Sidney used loose alexandrines:

> Loving in truth, and fain in verse my love to show,
> That she, dear she, might take some pleasure of my pain,
> Pleasure might cause her read, reading might make her know,
> Knowledge might pity win, and pity grace obtain,

I sought fit words to paint the blackest face of woe;
 Studying inventions fine, her wits to entertain,
Oft turning others' leaves to see if thence would flow
 Some fresh and fruitful showers upon my sun-burned brain.
But words came halting forth, wanting Invention's stay;
 Invention, Nature's child, fled step-dame Study's blows,
And others' feet still seemed but strangers in my way.
 Thus, great with child to speak, and helpless in my throes,
 Biting my truant pen, beating myself for spite,
 'Fool,' said my Muse to me, 'look in thy heart and write.'

 (Sir Philip Sydney, *Astrophel and Stella*)

Shakespeare used alexandrines freely throughout his plays, interweaving them in the blank verse pentameter of his dramatic work. There are seventy-three loose alexandrines in *Othello,* including the following line from the strangulation scene:

That can thy light relume. When I have pluck'd the rose

 (William Shakespeare, *Othello,* V.ii)

John Keats used the so-called Spenserian stanza with its closing loose alexandrine line in the following lines:

 St. Agnes' Eve—Ah, bitter chill it was!
 The owl, for all his feathers, was a-cold;
 The hare limp'd trembling through the frozen grass,
 And silent was the flock in wooly fold:
 Numb were the Beadsman's fingers, while he told
 His rosary, and while his frosted breath,
 Like pious incense from a censer old,
 Seem'd taking flight for heaven, without a death,
Past the sweet Virgin's picture, while his prayer he saith.

 (John Keats, "The Eve of St. Agnes")

Dryden makes use of loose alexandrine lines to extend a regular pentameter couplet:

Thy gen'rous Fruite, though gather'd ere their prime,
Still shew'd a Quickness; and maturing Time
But mellows what we write to the dull Sweets of Rhyme.

But it was just this sort of elongated ending of a couplet that Alexander Pope sought to ridicule:

A needless alexandrine ends the song
That, like a wounded snake, drags its slow length along.

Some modern poets have used alexandrines to interesting effect:

Awake ye muses nine, sing me a strain divine,
Unwind the solemn twine, and tie my valentine!

(Emily Dickinson, "Awake ye muses nine")

And Robert Bridges refers to his "loose alexandrines," including the following line:

in the life of Reason to the wisdom of God.

ALLITERATION

The repetition of consonant sounds. One of the principal devices of melopoeia, the aural musical qualities of language, alliteration is divided into the following groups of letters:

plosives—P/B

dentals—T/D/TH

sibilants—S/SH/Z

nasals—M/N/NG

fricatives—F/V

gutturals—G/K

Alliteration is used to achieve a strong texture of sound, either of cacophony (dissonance) or euphony (harmony), depending on the patterning of consonants.

Alliteration is probably the earliest mnemonic principle, sometimes even having onomatopoetic effect; there are powerful alliterative patterns in *Beowulf*, for example, where there is usually a single alliteration in each line. In the following early English song, the hard "K" sound creates an interesting pattern:

Sumer is icumen in
 Llude sing cuccu!
Groweth sed and bloweth med
 And springth the wude nu:
 Sing cuccu!

 Cuckoo, cuckoo, well singest thou cuckoo;
 Cease thou not, never now;
 Sing cuckoo now, sing cuckoo,
 Sing cuckoo, sing cuckoo, now!

In some of Shakespeare's early comedies, which suffered from the influence of euphuism, there is an overuse of alliteration, sometimes to the point of ridiculousness, as in the following lines:

Regent of love-rimes, lord of folded arms,
The anointed sovereign of sighs and groans,
Liege of all loiterers and malcontents,
Dread prince of plackets, king of codpieces . . .

 (William Shakespeare, *Love's Labour's Lost*, III. i)

But in *Hamlet,* alliteration is used masterfully to strong onomatopoetic effect, embodying the passion of the speaker—as when Hamlet refers to his adulterous mother in his opening soliloquy:

She married. O most wicked speed, to post
With such dexterity to incestuous sheets . . .

 (William Shakespeare, *Hamlet*, I.ii)

In the following act, Hamlet uses alliteration to berate his uncle:

 Bloody, bawdy villain!
Remorseless, treacherous, lecherous, kindless villain!
O! vengeance!

 (II.ii)

Macbeth uses alliteration in speaking of the false thanes:

Were they not forc'd with those that should be ours,
We might have met them dareful, beard to beard,
And beat them backward home.

 (William Shakespeare, *Macbeth*, V.iii)

And in the heath scene of *King Lear,* Shakespeare makes strong use of alliterative "K" and "S" sounds to show the violence of the weather:

Blow, winds, and crack your cheeks! rage! blow!
You cataracts and hurricanoes, spout
Till you have drench'd our steeples, drown'd the cocks!
You sulphurous and thought-executing fires,
Vaunt-couriers to oak-cleaving thunderbolts,
Singe my white head! And thou, all-shaking thunder,
Strike flat the thick rotundity o' the world!
Crack nature's moulds, all germens spill at once
That make ingrateful man!

(William Shakespeare, *King Lear,* III.ii)

There is a pattern of hard "K" sounds in the first four lines of this song by Robert Burns:

Contented wi' little, and cantie wi' mair,
Whene'er I forgather wi' Sorrow and Care,
I gie them a skelp, as they're creeping alang,
Wi' a cog o' gude swats and an auld Scotish sang . . .

(Robert Burns, "Contented wi' Little")

The repetition of the key word "one" enforces the alliterative "W" sounds in the following stanza by Shelley:

One hope within two wills, one will beneath
Two overshadowing minds, one life, one death,
One Heaven, one Hell, one immortality,
And one annihilation. Woe is me!
The winged words on which my soul would pierce . . .

(Percy Bysshe Shelley, "Epipsychidion")

The first and fourth lines of the following stanza are dominated by the alliterative "W" sound:

Whose woods these are I think I know,
His house is in the village, though;
He will not see me stopping here
To watch his woods fill up with snow.

(Robert Frost, "Stopping by Woods
on a Snowy Evening")

John Ashbery uses the alliterative sounds of "Z" and "NT" and "ST" to achieve an interesting effect:

> An exquisite sense—like pretzels,
> He was sent to the state senate
>
> (John Ashbery, "Europe")

See also ONOMATOPOEIA.

ANAPEST *See* METER.

ANAPHORA

Repetition of a key word or phrase at the beginning of successive lines. For example, on August 28, 1963, during the March on Washington, Martin Luther King, Jr., delivered a speech that used anaphora as the key rhetorical device:

I have a dream today.

I have a dream that one day the state of Alabama, whose governor's lips are presently dripping with the words of interposition and nullification, will be transformed into a situation where little black boys and black girls will be able to join hands with little white boys and white girls and walk together as sisters and brothers.

I have a dream today.

Similarly, Allen Ginsberg uses anaphora as a key device for the first section of "Howl":

who bared their brains to Heaven under the El and saw Mohammedan
 angels staggering on tenement roofs illuminated,
who passed through universities with radiant cool eyes hallucinating
 Arkansas and Blake-like tragedy among the scholars of war,
who were expelled from the academies for crazy & publishing obscene
 odes on the windows of the skull,
who cowered in unshaven rooms in underwear burning their money in
 wastebaskets and listening to the Terror through the wall,
who got busted in their pubic beards returning through Laredo with a
 belt of marijuana for New York . . .

(Allen Ginsberg, "Howl," 1956)

Muriel Rukeyser uses anaphora in the following poem:

Yes, we were looking at each other
Yes, we knew each other very well
Yes, we had made love with each other many times
Yes, we had heard music together
Yes, we had gone to the sea together
Yes, we had cooked and eaten together
Yes, we had laughed often day and night
Yes, we fought violence and knew violence
Yes, we hated the inner and outer oppression
Yes, that day we were looking at each other
Yes, we saw the sunlight pouring down
Yes, the corner of the table was between us
Yes, bread and flowers were on the table
Yes, our eyes saw each other's eyes
Yes, our mouths saw each other's mouth
Yes, our breasts saw each other's breasts
Yes, our bodies entire saw each other
Yes, it was beginning in each
Yes, it threw waves across our lives
Yes, the pulses were becoming very strong
Yes, the beating became very delicate
Yes, the calling the arousal
Yes, the arriving the coming
Yes, there it was for both entire
Yes, we were looking at each other

(Muriel Rukeyser, "Looking at Each Other")

APOSTROPHE

Literally, a "turning away," to address some imaginary person or idea, for rhetorical emphasis. In *Julius Caesar*, Cassius uses apostrophe as he is talking to Brutus:

Now, in the names of all the gods at once,
Upon what meat doth this our Caesar feed,
That he is grown so great? Age, thou art sham'd!
Rome, thou hast lost the breed of noble bloods!
When went there by an age, since the great flood,
But it was fam'd with more than with one man?

(William Shakespeare, *Julius Caesar*, I.ii)

And in the Jacobean drama *The Duchess of Malfi,* Duke Ferdinand uses apostrophe as he sees the meaninglessness of his life:

Vertue, where art thou hid? what hideous thing
Is it, that doth ecclipze thee? . . .

 Or is it true, thou art but a bare name,
And no essential thing? . . .

Oh most imperfect light of humaine reason,
That mak'st [us] so unhappy, to forsee
What we can least prevent . . .

 (John Webster, *The Duchess of Malfi,* III.ii)

William Wordsworth uses apostrophe in his direct address to John Milton:

Milton! thou shouldst be living at this hour;
England hath need of thee: she is a fen
Of stagnant waters: altar, sword, and pen,
Fireside, the heroic wealth of hall and bower,
Have forfeited their ancient English dower
Of inward happiness . . .

 (William Wordsworth, "Milton, thou shouldst be living")

See also RHETORIC.

ASSONANCE

Internal rhyming of vowel sounds, the purest form of LYRIC sound in poetry. Assonance uses the repetition of vowel sounds in either long or short TONES, to create patterns of internal RHYME. Christopher Marlowe, one of the great assonantal poets, uses it in the following lines:

 Oh, thou art fairer than the evening air
 Clad in the beauty of a thousand stars.
 (Christopher Marlowe, *Doctor Faustus*)

In the above lines, "fairer" and "air" represent assonantal rhyme. In the following lines from the same play, the long "E" creates assonantal rhyme in no fewer than six words: leape/me/see/see/streames/the:

O Ile leape up to my God: who pulls me downe?
See, see where Christ's blood streames in the firmament . . .

Shakespeare creates an overwhelming sense of assonance in the opening lines of *Richard III*, with variations on "OR" and "OUR" and "UR" and "OW" and "OU":

Now is the winter of our discontent
Made glorious summer by this son of York;
And all the clouds that lour'd upon our house
In the deep bosom of the ocean buried.
Now are our brows bound with victorious wreaths . . .

(William Shakespeare, *Richard III*, I.i)

It should be pointed out that most assonance has to be read aloud to hear its special effect. Thus in the fifth line above, it is almost impossible to articulate the vowel sounds distinctly for the assonance working in Now/are/our/brows. It is not only a tongue twister, its vowel play forces one to change the shape of one's mouth while one is pronouncing the line.

A subtler use of assonance can be found in the opening soliloquy of *Hamlet*, where the "OO" sound is repeated four times in the first two lines:

O that this too too solid flesh would melt,
Thaw and resolve itself into a dew . . .

(William Shakespeare, *Hamlet*, I.ii)

Shelley had one of the finest ears of any poet in English, and he often used assonantal rhyme. Note the use of short "E" in these lines:

Yellow, and black, and pale, and hectic red,
Pestilence-stricken multitudes: O thou,
Who chariotest to their dark wintry bed . . .

(Percy Bysshe Shelley, "Ode to the West Wind")

Tennyson uses strong assonance of long "I" in the following lines:

Tears, idle tears, I know not what they mean,
Tears from the depth of some divine despair
Rise in the heart, and gather to the eyes,
In looking on the happy autumn-fields,
And thinking of the days that are no more . . .

(Alfred, Lord Tennyson, song from *The Princess*)

Robert Frost uses triple assonantal rhymes in a row—long "A," long "U," and short "U"—in the key rhyme words same-pains, you-use, cup-up, in the following lines:

> With the same pains you use to fill a cup
> Up to the brim, and even above the brim.
>
> (Robert Frost, "Birches")

Robert Lowell uses assonance of "AM" sounds in the following line:

Strolling, I yammered metaphysics with Abramowitz
> (Robert Lowell, "Memories of West Street and Lepke")

And finally, Sylvia Plath balances long "U" and long "I":

> And I
> Am the arrow,
>
> The dew that flies
> Suicidal, at one with the drive
> Into the red
>
> Eye, the cauldron of morning.
>
> (Sylvia Plath, "Ariel")

B

BALLAD

A narrative, rhythmic saga of a past affair, sometimes romantic and inevitably catastrophic, which is impersonally related. Babette Deutsch defines a ballad as a LYRIC poem which "presents a romantic theme, impersonally treated." It is the impersonality of the ballad—"seraphically free / from taint of personality"—that creates the sense of distance which makes it so haunting in the unfolding of the inevitable catastrophe.

A ballad can be in any METER but usually has very strong stress in extremely short lines.

One of the earliest anonymous English ballads seems to come screaming at us out of prehistory. "Edward, Edward" is a dialogue between a mother and a son:

> Quhy dois your brand sae drop wi bluid,
> > Edward, Edward?
> Quhy dois your brand sae drop wi bluid?
> > And why sae sad gang yee, O?
> O I hae killed my hauke saw guid,
> > Mither, mither:
> O I hae killed my hauke sae guid:
> > And I had nae mair bot hee, O.

.

> And quhat wul ye leive to your ain mither deir,
> > Edward, Edward?
> And quhat wul ye leive to your ain mither deir?
> > My deir son, now tell me, O.
> The curse of hell frae me sall ye beir,
> > Mither, mither:

The curse of hell frae me sall ye beir,
 Sic counseils ye gave to me, O.

In "Sir Patrick Spens," Patrick is tricked into a fatal sea voyage:

> The king sits in Dunfermline town
> Drinking the blude-red wine;
> 'O whare will I get a skeely skipper
> To sail this new ship o' mine?'
>
> O up and spak an eldern knight,
> Sat at the king's right knee:
> 'Sir Patrick Spens is the best sailor
> That ever sail'd the sea.' . . .

Patrick sails to Norway to bring back the king's daughter, but a storm overwhelms the ship:

> Half-owre, half-owre to Aberdour,
> 'Tis fifty fathoms deep;
> And there lies gude Sir Patrick Spens,
> Wi' the Scots lords at his feet!

"Barbara Allen's Cruelty" opens with a description of Barbara Allen's beauty:

> In Scarlet town, where I was born,
> There was a fair maid dwellin',
> Made every youth cry *Well-a-way!*
> Her name was Barbara Allen . . .

The ballad goes on to describe her heartlessness when a young man falls hopelessly in love with her:

> So slowly, slowly rase she up,
> And slowly she came nigh him,
> And when she drew the curtain by—
> 'Young man, I think you're dyin'.' . . .

The ballad "Johnny, I Hardly Knew Ye" describes how Johnny goes off to war, leaving wife and child behind, and finally returns in unrecognizable shape:

"You haven't an arm and you haven't a leg,
 Hurroo! hurroo!
You haven't an arm and you haven't a leg,
 Hurroo! hurroo!
You haven't an arm and you haven't a leg,
You're an eyeless, noseless, chickenless egg;
You'll have to be put in a bowl to beg;
 Och, Johnny, I hardly knew ye!
With drums and guns and guns and drums,
 The enemy nearly slew ye,
 My darling dear, you look so queer,
 Och, Johnny, I hardly knew ye!"

Other anonymous early ballads include "Frankie and Johnny," "Lord Randall," and all the Robin Hood and King Arthur ballads. The first ballads that can be assigned to known authorship begin in the Renaissance, including the following by Sir Walter Ralegh:

'As you came from the holy land
 Of Walsingham,
Met you not with my true love
 By the way as you came?'
 (Sir Walter Ralegh, "The Walsingham Ballad")

The poem goes on to describe love as fickle, a "careless child" who is blind and deaf, and blames women for its going awry. But the poem ends with an assertion of a deeper vision of love:

'But love is a durable fire
 In the mind ever burning;
Never sick, never old, never dead,
 From itself never turning.'

Modern ballads include Coleridge's "The Rime of the Ancient Mariner," Rudyard Kipling's "Danny Deever" and "Gunga Din," Robert W. Service's "The Cremation of Sam McGee" and "The Shooting of Dan McGrew," W. H. Auden's "The Ballad of Miss Gee," and W. S. Merwin's "The Ballad of John Cable." Dylan Thomas composed the following:

The bows glided down, and the coast
Blackened with birds took a last look

At his thrashing hair and whale-blue eye;
The trodden town rang its cobbles for luck.

Then good-bye to the fishermanned
Boat with its anchor free and fast
As a bird hooking over the sea,
High and dry by the top of the mast,

Whispered the affectionate sand
And the bulwarks of the dazzled quay.
For my sake sail, and never look back,
Said the looking land . . .

> (Dylan Thomas, "The Ballad of the Long-Legged Bait")

BALLADE

Early French form with twenty-eight lines divided into three octave STAN-
ZAS, each stanza having a RHYME scheme of a/b/a/b/b/c/b/c with the final line
as a repeated REFRAIN line; the ballade ends with a four-line ENVOI rhymed
b/c/b/c with the final line being the refrain line.

A variation of the ballade is the chant royale, with sixty lines in five
eleven-line stanzas and one five-line envoi.

An example of an octave of a ballade is the following eight-line stanza:

Tell me now in what hidden way is
 Lady Flora, the lovely Roman,
Where is Hipparchia and where is Thaïs,
 Neither of them the fairer woman,
Where is Echo, beheld of no man,
 Only heard on river and mere,
She whose beauty was more than human?
 But where are the snows of yester-year? . . .

> (François Villon, "Ballade of Dead Ladies,"
> tr. Ezra Pound)

BLANK VERSE

Unrhymed iambic pentameter. Henry Howard (1517–1547), the Earl of
Surrey, is usually credited with the creation of the English blank verse line in
his translation of Books II and IV of Virgil's *Aeneid*. Christopher Marlowe
adapted blank verse to dramatic poetry in his *Tamburlaine* (1587) and *Doctor
Faustus* (1593).

When Shakespeare began using blank verse he found it natural to coincide lines and sentences, and as a result there are mostly end-stopped lines in his early plays:

> No matter where. Of comfort no man speak:
> Let's talk of graves, of worms, and epitaphs:
> Make dust our paper, and with rainy eyes
> Write sorrow on the bosom of the earth;
> Let's choose executors and talk of wills:
> And yet not so—for what can we bequeath
> Save our deposed bodies to the ground?
> Our lands, our lives, and all are Bolingbroke's.
> And nothing can we call our own but death,
> And that small model of the barren earth
> Which serves as paste and cover to our bones . . .
>
> (William Shakespeare, *Richard II*, III.iii)

As Shakespeare developed his blank verse line in his middle period, there were more medial pauses, more midline breaks, and more ENJAMBEMENTS —as in the following lines of Enobarbus:

> Age cannot wither her, nor custom stale
> Her infinite variety; other women cloy
> The appetites they feed, but she makes hungry
> Where most she satisfies; for vilest things
> Become themselves in her, that the holy priests
> Bless her when she is riggish . . .
>
> (William Shakespeare, *Antony and Cleopatra*, II.v)

In his later period, Shakespeare used more and more enjambements and medial pauses, although he also began to return to the end-stopped line—as in these blank verse lines of Prospero:

> Ye elves of hills, brooks, standing lakes and groves;
> And ye, that on the sands with printless foot
> Do chase the ebbing Neptune and do fly him
> When he comes back; you demi-puppets, that
> By moonshine do the green sour ringlets make
> Whereof the ewe not bites; and you, whose pastime
> Is to make midnight mushrooms; that rejoice

To hear the solemn curfew; by whose aid,—
Weak masters though ye be—I have bedimm'd
The noontide sun, call'd forth the mutinous winds,
And 'twixt the green sea and the azur'd vault
Set roaring war; to the dread-rattling thunder
Have I given fire and rifted Jove's stout oak
With his own bolt: the strong-bas'd promontory
Have I made shake; and by the spurs pluck'd up
The pine and cedar: graves at my command
Have wak'd their sleepers, op'd, and let them forth
By my so potent art . . .

<div align="right">(William Shakespeare, The Tempest, V.i)</div>

John Milton used unrhymed blank verse lines for his *Paradise Lost* and
Paradise Regained. Within these lines he deliberately used enjambements,
medial pauses, and Latinate diction to create heavily textured rhetoric:

Me miserable! which way shall I flie
Infinite wrath, and infinite despaire?
Which way I flie is Hell; my self am Hell;
And in the lowest deep a lower deep
Still threatening to devour me opens wide,
To which the Hell I suffer seems a Heav'n.
O then at last relent: is there no place
Left for Repentance, none for Pardon left?
None left but by submission; and that word
Disdain forbids me, and my dread of shame
Among the spirits beneath, whom I seduc'd
With other promises and other vaunts
Then to submit, boasting I could subdue
Th' Omnipotent. Ay me, they little know
How dearly I abide that boast so vaine,
Under what torments inwardly I groane . . .

<div align="right">(John Milton, Paradise Lost, Book Four)</div>

William Wordsworth used the blank verse line in his "Lines Written a
Few Miles above Tintern Abbey," and in his LONG POEM *The Prelude,* which
exhibited all the characteristics of Miltonic blank verse:

Dust as we are, the immortal spirit grows
Like harmony in music; there is a dark

Inscrutable workmanship that reconciles
Discordant elements, makes them cling together
In one society. How strange that all
The terrors, pains, and early miseries,
Regrets, vexations, lassitudes interfused
Within my mind, should e'er have borned a part,
And that a needful part, in making up
The calm existence that is mine when I
Am worthy of myself! Praise to the end! . . .

(William Wordsworth, *The Prelude; or,*
Growth of a Poet's Mind)

C

CACOPHONY

Extreme use of dissonance to create a sense of conflict, tension, and dishar-
mony. The most obvious way to achieve cacophony is to place consonants
so close together that the alliteration becomes plosive and annoying. For
example, the speed and extreme dissonance in this sonnet create a sense of
cacophony:

Th'expense of spirit in a waste of shame
Is lust in action; and till action, lust
Is perjur'd, murderous, bloody, full of blame,
Savage, extreme, rude, cruel, not to trust;
Enjoy'd no sooner but despised straight;
Past reason hunted; and no sooner had,
Past reason hated, as a swallow'd bait,
On purpose laid to make the taker mad:
Mad in pursuit, and in possession so:
Had, having, and in quest to have extreme;
A bliss in proof, and prov'd, a very woe;
Before, a joy propos'd; behind, a dream.
　　All this the world well knows; yet none knows well
　　To shun the heaven that leads men to this hell.

(William Shakespeare, Sonnet 129)

There is so much cacophony in the above lines that it seems as if the poet
has to create a rhyme scheme on the left-hand side of the poem (Is/Is, Past/
Past, Mad/Had) as well as on the right-hand side, to keep the words from
careening off the page. This sonnet is a brilliant example of cacophony being
used as ONOMATOPOEIA, as the subject of the poem is loss of harmony and

ease—hence the poem embodies disharmony and dis-ease through cacophony.

CAESURA

A breath pause, usually enforced. In neoclassic ALEXANDRINES there is an absolute caesura exactly halfway in each line, to form two equal hemistiches of six syllables each:

> Je le vis, je rougis, je pâlis à sa vue
>> (Jean Racine, *Phèdre*, I.iii)

In ordinary poetry, caesuras are most commonly created by ending a word with the consonant or consonants that begin the following word:

> Out of the mouth of babes and sucklings hast thou ordained
> strength because of thine enemies, that thou mightest still the enemy
> and the avenger.
>> (Psalm 8:2)

In these lines, the caesura occurs between "mightest" and "still."

A rare example of a double caesura occurs in the following lines:

> If it were done when 'tis done, then 'twere well
> It were done quickly; if th' assassination
> Could trammel up the consequence, and catch
> With his surcease success . . .
>> (William Shakespeare, *Macbeth*, I.vii)

In these lines, there are caesuras between the words "his" and "surcease," and between the words "surcease" and "success." Anyone pronouncing these lines has to come to a complete breath pause between these words, to avoid slurring them together. Caesura is a poet's way of enforcing a complete pause between words in a line.

CANZONE

An intricate verse form from Troubadour and Italian poetry. Ezra Pound writes in *The Spirit of Romance,* "The canzone was to poets of this period (circa 12th century) what the fugue was to musicians of Bach's time."

The rhyme scheme of a canzone is as follows:

stanza one: a/b/a/a/c/a/a/d/d/a/e/e

stanza two: e/a/e/e/b/e/e/c/c/e/d/d

stanza three: d/e/d/d/a/d/d/b/b/d/e/e

stanza four: c/d/c/c/e/c/c/a/a/c/b/b

stanza five: b/c/b/b/d/b/b/e/e/b/a/a

coda: a/e/d/c/b

Guido Cavalcanti (c. 1250–1300) wrote one of the best-known canzones, which begins in Italian "Donna me priegha" and in Pound's English translation

> Because a lady asks me, I would tell
> Of an affect that comes often and is fell
> And is so overweening: Love by name . . .
>
> (tr. Ezra Pound)

Dante Alighieri (1265–1321) gives detailed commentary on several of his own canzones in *La Vita Nuova*, composed 1292–1295. The first great canzone begins

> Ladies that have intelligence in love,
> Of mine own lady I would speak with you;
> Not that I hope to count her praises through,
> But telling what I may, to ease my mind . . .
>
> (Dante Alighieri, *La Vita Nuova*,
> tr. Dante Gabriel Rossetti)

Francesco Petrarch (1304–1374) wrote canzones in Italian, and William Drummond of Hawthornden (1585–1649) created the first English canzones.

The modern SONNET form of fourteen lines probably derived from the twelve-line stanzas that make up the canzone, and it may have been Guido Guinicelli, who appears in Canto 26 of Dante's *Purgatorio*, who first detached a single canzone stanza and let it stand alone as an independent poem in its own right—i.e., a sonnet.

CAPITALIZATION

The systematic use of uppercase letters; in poetry, principally relating to left-hand margins. Through the nineteenth century, most verse was capitalized uniformly along the left-hand margin; in the twentieth century, however, poets began to protest against what they perceived to be a pointless convention. William Carlos Williams asked who was he trying to please, by capitalizing the left-hand margins of his verse? Charles Olson spoke out against the kind of "verse print bred"—poetry that followed forms which the printing press and typewriter established rather than those which came from the poet's original impulse.

Most contemporary American poetry uses capitalization when it is required by usage, without any automatic capitalization along the left-hand margin. The following is a fair example of the use of capitals in contemporary American poetry:

> All this—
> was for you, old woman.
>
> I wanted to write a poem
> that you would understand.
> For what good is it to me
> if you can't understand it?
> But you got to try hard—
>
> But—
> Well, you know how
> the young girls run giggling
> on Park Avenue after dark
> when they ought to be home in bed?
> Well,
> that's the way it is with me somehow.
>
> (William Carlos Williams, "January Morning")

The poet Don Marquis rebelled humorously against conventional capitalization by reporting that a gigantic cockroach named Archy left poems in his typewriter each night, but the poems did not contain capital letters because the cockroach could not hit the shift key with his head. Don Marquis gave an example of the kind of poem Archy left in the typewriter each night:

> expression is the need of my soul
> i was once a vers libre bard

but i died and my soul went into the body of a cockroach
it has given me a new outlook upon life . . .

(Don Marquis, from *archy and mehitabel*)

CAROL

A light song. R. L. Greene in *Early English Carols* lists some 474 known carols, only 92 of which are classed as "Carols of the Nativity" or what we would call Christmas carols—the rest are on a host of other subjects: religious didactic carols, doomsday warning carols, "Gud day" carols, angelic song carols, shepherd carols, Twelfth Night carols, devotional carols, saint carols, satirical carols, carols on death, and carols of lament from the cross.

The word "carol" itself first appears in English in the late thirteenth century; thus in a Medieval description of Fair events we read

Karolles, wrastlynges or somour games . . .

In French, caroles are often linked stanza to stanza with common chain rhymes. The following Medieval carol has a breathtaking clarity and lyricism:

I sing of a maiden
 That is makèles;
King of alle kingès
 To her son she ches.
He cam also stillè
 Ther His moder was,
As dew in Aprille
 That falleth on the gras.
He cam also stillè
 To His moderes bowr,
As dew in Aprille
 That falleth on the flowr.
He cam also stillè
 Ther his moder lay,
As dew in Aprille
 That falleth on the spray.
Moder and maiden
 Was never none but she;
Wel may swich a lady
 Godès moder be.

("I Sing of a Maiden")

Most carols are written in traditional STANZA form with a four-stressed triplet using a single RHYME, followed by a tail-rhyme which rhymes with the REFRAIN. Stress is often irregular, and ASSONANCE sometimes takes the place of rhyme. Thus the following stanza, which is typical of the carol form:

> Now is joye and now is blys;
> Now is balle and bitterness;
> Now it is, and now it nys;
> Thus pasyt this worlde away.
>
> ("Now Is Joye")

Later secular poetry developed out of this Medieval carol form. "The Nut-Brown Maid" is an obvious derivative, with its story told in stanzas alternating the dialogue between an outlawed knight and a maid:

> O Lorde, what is
> This worldès blisse,
> That chaungeth as the mone?
> My somer's day
> In lusty May
> Is derked before the none.
>
> ("The Nut-Brown Maid")

Here is a Christmas carol that has come down to us in more modern form:

> On the Twelfth Day of Christmas
> My True Love sent to me:
>
> Twelve Drummers drumming:
> Eleven Pipers piping:
> Ten Lords aleaping:
> Nine Ladies dancing:
> Eight Maids amilking:
> Seven Swans aswimming:
> Six Geese alaying:
> Five gold Rings:
> Four calling Birds:
> Three French Hens:
> Two Turtle Doves:
> and a Partridge in a Pear Tree.
>
> ("The Twelve Days of Christmas")

CATALOGUE

The listing of persons or places or things. Catalogues are sometimes endless genealogies or listings of proper names and places that can create an hypnotic effect in the rhythmic repetition of strange and curious and exotic names, like a recitation or an incantation. Eventually the phonetics of the items being listed will become soporific, thus lulling a listener or reader into a mild trance state.

An example of a genealogical catalogue listing occurs in the Gospel According to Saint Matthew:

> The book of the generation of Jesus Christ, the son of David, the son of Abraham.
>
> Abraham begat Isaac; and Isaac begat Jacob; and Jacob begat Judas and his brethren;
>
> And Judas begat Phares and Zara of Thamar; and Phares begat Esrom; and Esrom begat Aram;
>
> And Aram begat Aminadab; and Aminadab begat Naasson; and Naasson begat Salmon;
>
> And Salmon begat Booz of Rachab; and Booz begat Obed of Ruth; and Obed begat Jesse;
>
> (Matthew 1:1–5)

. . . and so on.

Another example of epic catalogue listing occurs in Book Two of Homer's *Iliad*, where the story of the Trojan War is interrupted with a long list of all the Danaan lords and officers who took part in the war. Following is a brief sample of the recitation:

> Of the Boiotians,
> Pêneleôs, Lêïtos, Arkesílaös,
> Prothoênor, and Klónios were captains,
> Boiotians—men of Hyria and Aulis,
> the stony town; and those who lived at Skhoinos
> and Skôlos and the glens of Eteônos;
> Thespeia; Graia; round the dancing grounds
> of Mykalessos; round the walls of Harma;
> Eilésion; Erythrai; Eleôn;

Hylê and Peteôn; and Okaléa;
and Medeôn, that compact citadel;
Kôpai; Eutrêsis; Thisbê of the doves;
those too of Korôneia; and the grassland
of Haliartos; and the men who held
Plataia town and Glisas; and the people
of Lower Thebes, the city ringed with walls;
and great Ongkhêstos, where Poseidon's grove
glitters; and people too of Arnê, rich
in purple wine grapes; and the men of Mideia;
Nisa the blest; and coastal Anthêdôn.
All these had fifty ships. One hundred twenty
Boiotian fighters came in every ship . . .

(Homer, *Iliad*, tr. Robert Fitzgerald)

Sometimes within a poem there can be catalogue lines which list a collection of things, as in the following quatrain:

Thou art slave to Fate, Chance, kings and desperate men,
And dost with poyson, warre, and sicknesse dwell,
And poppie, or charmes can make us sleepe as well,
And better than they stroake . . .

(John Donne, "Holy Sonnet X")

Few modern poets have used catalogue listings in their poetry to greater effect than Walt Whitman in *Leaves of Grass*. Here, Whitman begins a listing of all the things he can think of that are occurring as he writes, and the effect is staggering:

The pure contralto sings in the organ loft,
The carpenter dresses his plank, the tongue of his foreplane whistles its
 wild ascending lisp,
The married and unmarried children ride home to their Thanksgiving
 dinner,
The pilot seizes the king-pin, he heaves down with a strong arm,
The mate stands braced in the whale-boat, lance and harpoon are ready,
The duck-shooter walks by silent and cautious stretches,
The deacons are ordain'd with cross'd hands at the altar,
The spinning-girl retreats and advances to the hum of the big wheel,

The farmer stops by the bars as he walks on a First-day loafe and looks
 at the oats and rye,
The lunatic is carried at last to the asylum a confirm'd case,
(He will never sleep any more as he did in the cot in his mother's bed-
 room;)
The jour printer with gray head and gaunt jaws works at his case,
He turns his quid of tobacco while his eyes blurr with the manuscript;
The malform'd limbs are tied to the surgeon's table,
What is removed drops horribly in a pail;
The quadroon girl is sold at the auction-stand, the drunkard nods by the
 bar-room stove,
The machinist rolls up his sleeves, the policeman travels his beat, the
 gate-keeper marks who pass,
The young fellow drives the express-wagon, (I love him, though I do
 not know him;) . . .

 (Walt Whitman, "Song of Myself")

Similarly, Allen Ginsberg uses catalogue listing throughout "Howl," and
ends with an APOSTROPHE which lists just about everything in the universe
Ginsberg thinks is holy:

Holy! Holy! Holy! Holy! Holy! Holy! Holy! Holy! Holy! Holy! Holy!
 Holy! Holy! Holy! Holy!
The world is holy! The soul is holy! The skin is holy! The nose is holy!
 The tongue and cock and hand and asshole holy!
Everything is holy! everybody's holy! everywhere is holy! everyday is in
 eternity! Everyman's an angel!
The bum's as holy as the seraphim! the madman is holy as you my soul
 are holy!
The typewriter is holy the poem is holy the voice is holy the hearers are
 holy the ecstasy is holy!
Holy Peter holy Allen holy Solomon holy Lucien holy Kerouac holy
 Huncke holy Burroughs holy Cassady holy the unknown
 buggered and suffering beggars holy the hideous human
 angels!
Holy my mother in the insane asylum! Holy the cocks of the
 grandfathers of Kansas!
Holy the groaning saxophone! Holy the bop apocalypse! Holy the
 cafeterias filled with the millions! Holy the mysterious rivers of
 tears under the streets!

Holy the lone juggernaut! Holy the vast lamb of the middle-class! Holy
the crazy shepherds of rebellion! Who digs Los Angeles IS Los
Angeles!
Holy New York Holy San Francisco Holy Peoria & Seattle Holy Paris
Holy Tangiers Holy Moscow Holy Istanbul!
Holy time in eternity holy eternity in time holy the clocks in space holy
the fourth dimension holy the fifth International holy the Angel
in Moloch!
Holy the sea holy the desert holy the railroad holy the locomotive holy
the visions holy the hallucinations holy the miracles holy the
eyeball holy the abyss!
Holy forgiveness! mercy! charity! faith! Holy! Ours! bodies! suffering!
magnanimity!
Holy the supernatural extra brilliant intelligent kindness of the soul!

(Allen Ginsberg, "Footnote to Howl," 1956)

CLOSURE

The ending of a poem; how a poem concludes. Barbara H. Smith in her
book *Poetic Closure: A Study of How Poems End* discusses the various possibil-
ities of closure for a poem. For example, she mentions the "Closure of
Unqualified Assertion," such as "All lovers despair," which is a sweeping
general statement that summarizes everything discussed in the poem.

Too often a closure tries to sum up a poem, reiterate an obvious point in
the poem, or hammer home an idea the poem is trying to develop. We might
call this the "Do-You-Get-It Closure," which assumes the reader is too stupid
to take in the underlying meaning of the poem. Following is such a summary
closure:

And that's how I fell in love last summer
on my Junior Year Abroad
in Avignon, France,
before I came back home.

(William Packard, "How I Fell in Love Last Year")

There is another perilous kind of closure, which poet Marianne Moore
termed "the false flight upwards"—a desire at the end of a poem to send
everything off into the wide blue yonder so the reader can brush shoulders
with a choir of angels as the poem ends. Following is such an ascending
closure:

Therefore life is love, and love is eternal delight,
And eternal delight is heaven, and heaven
Is where my heart is always and forever.

(William Packard, "Life Is Love")

The practical alternative to falling prey to such sappy closure types is simply to leave the poem suspended at the end—no false climax, no fortune cookies to take home, no phoney bouquets. Just an honest job well done.

One can learn a great deal about the positive kinds of closure by examining the sonnets of Shakespeare. Often a sonnet will end with the introduction of some new thought, or else it will turn a previous thought to some slightly different angle and seem to see it afresh. Thus the following couplet closures from five of the greatest sonnets:

So long as men can breathe, or eyes can see,
So long lives this, and this gives life to thee.

(William Shakespeare, Sonnet 18)

Lo, thus, by day my limbs, by night my mind,
For thee and for myself no quiet find.

(Sonnet 27)

For thy sweet love remember'd such wealth brings
That then I scorn to change my state with kings.

(Sonnet 29)

This thou perceiv'st, which makes thy love more strong,
To love that well which thou must leave ere long.

(Sonnet 73)

If this be error, and upon me prov'd,
I never writ, nor no man ever lov'd.

(Sonnet 116)

COALESCENCE

The interweaving of sight and sound and sense in a poem so the elements of IMAGE and RHYTHM and VOICE seem to be indistinguishable. This is really the artistic goal of all poetry.

The following lines of Prospero from *The Tempest* are an example of coalescence of sight and sound and sense:

> Our revels now are ended, these our actors,
> As I foretold you, were all spirits and
> Are melted into air, into thin air:
> And, like the baseless fabric of this vision,
> The cloud-capp'd towers, the gorgeous palaces,
> The solemn temples, the great globe itself,
> Yea, all which it inherit, shall dissolve
> And, like this insubstantial pageant faded,
> Leave not a rack behind. We are such stuff
> As dreams are made on, and our little life
> Is rounded with a sleep . . .
>
> (William Shakespeare, *The Tempest,* IV.i)

In the above lines, image and voice and rhythm are so inextricably linked that they cannot be separated, and all contribute to achieve the final effect.

CONCEIT

A complex IMAGE, usually an extended figure of speech, developed over several lines of poetry. Like a fugue, the conceit consists of interwoven themes.

The following lines from *Romeo and Juliet* present the simplest example of a conceit:

> Sweet, good-night!
> This bud of love, by summer's ripening breath,
> May prove a beauteous flower when next we meet.
>
> (William Shakespeare, *Romeo and Juliet,* II.ii)

Here the figure "bud of love" is developed over the lines; it experiences "summer's ripening breath," and finally becomes a beauteous flower. It is a perfectly realized conceit in only three lines of poetry.

A more complex conceit can be seen when Romeo gazes at Juliet's eyes and imagines that he can exchange them with two stars in the night sky. He completes the conceit by imagining what would happen if those stars were in Juliet's head and her eyes were out there in the night sky. Here is the conceit:

Two of the fairest stars in all the heaven,
Having some business, do entreat her eyes
To twinkle in their spheres till they return.
What if her eyes were there, they in her head?
The brightness of her cheek would shame those stars
As daylight doth a lamp; her eyes in heaven
Would through the airy region stream so bright
That birds would sing and think it were not night . . .

When the metaphysical poets began using conceits as HYPERBOLES, the poetry became more intricate and sometimes difficult to follow. As Kingsley Hart writes in the introduction to *Poems of Love* by John Donne,

In Donne's poetry, conceit becomes more than an adornment to the poem; it becomes the structure upon which an argument, serious or flippant, deeply felt or merely cynically playful, is based. The "conceit" becomes a sustained exercize of "wit" and part of the architecture of the poem, as for example, in *The Extasie* or *The Sunne Rising*. Again and again we feel that paradox and false syllogism are not used merely as a means to impress the reader with the poet's skill and accomplishment but as the natural expression of a complex mind.

An example of a simple conceit in Donne's poetry is the following:

Marke but this flea, and marke in this,
How little that which thou deny'st me is;
It suck'd me first, and now sucks thee,
And in this flea, our two bloods mingled bee; . . .

(John Donne, "The Flea")

But in a more elaborate conceit, Donne describes a compass with one foot fixed while the other foot makes an arc around the first. Note the play on the word "erect," which comes quite naturally out of the compass conceit:

Our two soules therefore, which are one,
 Though I must goe, endure not yet
A breach, but an expansion,
 Like gold to ayery thinnesse beate.

If they be two, they are two so
 As stiffe twin compasses are two,

Thy soule the fixt foot, makes no show
 To move, but doth, if the'other doe.

And though it in the center sit,
 Yet when the other far doth rome,
It leanes, and hearkens after it,
 And growes erect, as that comes home . . .

(John Donne, "A Valediction: Forbidding Mourning")

CONFESSIONAL POETRY

Poetry that reveals crucial material about the personal life of the poet. The term was coined by critic M. L. Rosenthal to describe a loose movement in contemporary American poetry that began to focus on intimate details of the poet's own psychic biography.

To be sure, an intensely personal tenor has been present in literature of all ages. The Greek poet Sappho thought nothing of writing about men and women with whom she had contact daily, and the Latin poet Gaius Valerius Catullus wrote about his mistress "Lesbia" in a way that allowed the reader to figure out she was Clodia, a married woman who had plotted against Caesar. Ovid published *Confessions of Women,* which purported to champion the legal claims of women against their lovers. St. Augustine's *Confessions* recorded his early childhood experiences of stealing from a pear tree, taking part in an unholy cauldron of lust in Carthage, and converting to Christianity.

In the modern world, the Swedish playwright August Strindberg wrote about his ex-wives, who appeared as themselves on stage. T. S. Eliot admitted that his *Waste Land* was not the archetypal cultural poem some American academics took it to be, but rather "a personal grouse" Eliot had written during an unendurable first marriage.

Confessional poetry probably began in America with the publication in 1959 of W. D. Snodgrass' "Heart's Needle," about the poet's quest for his daughter during a broken marriage and its aftermath. Snodgrass explained the impetus for writing this poem in an NYQ Craft Interview:

At the time I came through school it was forbidden to write about any of your personal affairs—even though this is something poets always *had* done . . . I was moved in that direction by some of the German poets who wrote about lost children, dead children. Our children don't die as often, they get divorced. . . .

The poignance of Snodgrass' pain is expressed in formal stanzas with strict rhyme schemes:

Love's wishbone, child, although I've gone
As men must and let you be drawn .
 Off to appease another,
It may help that a Chinese play
Or Solomon himself might say
 I am your real mother.

 (W. D. Snodgrass, "Heart's Needle")

About the time Snodgrass was writing "Heart's Needle," Robert Lowell was making a radical shift in his poetry from mythical themes and formal speech to confessional writing and vernacular language. In the collection *Life Studies,* Lowell ranged over his marital problems, hospital experiences, and memories of his youth, as in these lines:

Only teaching on Tuesdays, book-worming
in pajamas fresh from the washer each morning,
I hog a whole house on Boston's
"hardly passionate Marlborough Street,"
where even the man
scavenging filth in the back alley trash cans,
has two children, a beach wagon, a helpmate,
and is a "young Republican."
I have a nine months' daughter,
young enough to be my granddaughter.
Like the sun she rises in her flame-flamingo infants' wear.

These are the tranquillized *Fifties,*
and I am forty. Ought I to regret my seedtime?
I was a fire-breathing Catholic C. O.,
and made my manic statement,
telling off the state and president, and then
sat waiting sentence in the bull pen
beside a Negro boy with curlicues
of marijuana in his hair . . .

 (Robert Lowell, "Memories of West Street and Lepke")

Anne Sexton was a student of Lowell at Boston University, but she claims he did not discuss *Life Studies* with his class, and that his students were not

overtly encouraged or influenced to write "confessionally." Sexton had already completed the manuscript of her first book of poetry, *To Bedlam and Part Way Back,* and was at work on her second collection, *All My Pretty Ones,* which contains this stanza from the title poem:

> I hold a five-year diary that my mother kept
> for three years, telling all she does not say
> of your alcoholic tendency. You overslept,
> she writes. My God, father, each Christmas Day
> with your blood, will I drink down your glass
> of wine? The diary of your hurly-burly years
> goes to my shelf to wait for my age to pass.
> Only in this hoarded span will love persevere.
> Whether you are pretty or not, I outlive you,
> Bend down my strange face to yours and forgive you.
>
> (Anne Sexton, "All My Pretty Ones")

Sylvia Plath, who committed suicide at the age of thirty, was also a student in that same class of Lowell, and she is one of the central figures of the Confessional movement. Lowell intimated the dangers of Confessional poetry in his introduction to Plath's book *Ariel:*

> These poems are playing Russian roulette with six cartridges in the cylinder, a game of "chicken," the wheels of both cars locked and unable to swerve.

Plath often wrote about her suicidal tendency:

> The first time it happened I was ten.
> It was an accident.
>
> The second time I meant
> To last it out and not come back at all.
> I rocked shut
>
> As a seashell.
> They had to call and call
> And pick the worms off me like sticky pearls.
>
> Dying
> is an art, like everything else.
> I do it exceptionally well.

I do it so it feels like hell.
I do it so it feels real.
I guess you could say I've a call.

(Sylvia Plath, "Lady Lazarus")

In the final analysis, writers may have no choice but to write about themselves and their own worlds, no matter how well disguised and remote the events may be. William Butler Yeats may have been right in "The Circus Animals' Desertion" when he claimed that all poems must have their origin in "the foul rag and bone shop of the heart."

CONNOTATION

The indirect, suggestive meaning of a word or phrase which colors the association of the word. Ambiguities, sarcasm, and irony all turn on connotative meaning.

The following passage from *Henry V* is an example of strong connotation. Here the French Ambassador tells the new King Henry V to stay away from France:

> The Prince our master
> Says that you savour too much of your youth,
> And bids you be advis'd there's nought in France
> That can be with a nimble galliard won;
> You cannot revel into dukedoms there.

(William Shakespeare, *Henry V*, I.ii)

In this passage, the words "savour," "galliard," and "revel" are all used for their strong connotative associations, with the implication that Henry is a wastrel and an irresponsible drunk. Of course the Ambassador could not say as much in plain denotative words, so he relies on connotation to make his point.

See also DENOTATION.

COUPLET

Two lines of RHYMED verse, sometimes open, sometimes closed.
The following is an example of a closed couplet, where the meaning is made complete by the second end-rhyme:

> So full of artless jealousy is guilt
> It spills itself, in fearing to be spilt.
>
> (William Shakespeare, *Hamlet,* IV.v)

This kind of closed couplet, so familiar to us as the ending of the traditional SONNET, came to be known as the "heroic couplet"—a couplet that must be complete in sense by the second end-rhyme, without any spillover or ENJAMBEMENT into a new line, as in the following heroic couplets:

> Hope springs eternal in the human breast:
> Man never is, but always to be bless'd:
> The soul, uneasy and confined from home,
> Rests and expatiates in a life to come.
>
> (Alexander Pope, "Essay on Man")

Not only the sense, but also the ideas and images are contained within each couplet unit and do not spill over. An open couplet, on the other hand, will extend its meaning and imagery beyond the two-line couplet into more lines.

Following is an example of an open couplet. Notice there is an enclosed rhyme couplet in these lines, with the rhyme scheme a/b/b/a and with "sky" and "cry" creating the enclosed rhyme couplet:

> "The stars," she whispers, "blindly run;
> A web is woven across the sky;
> From out waste places comes a cry,
> And murmurs from the dying sun . . ."
>
> (Alfred, Lord Tennyson, "In Memoriam")

CRITICISM

The art of evaluation, judgment, or analysis of a literary work.

The following is a checklist of technical points that pertain to any poem, giving specific points one can question, step by step, in the attempt to criticize by description. The checklist is more practical than theoretical. All of the techniques cited are found elsewhere in this dictionary.

OPENING OF POEM:

Is poem titled or untitled? Does title seem apt?
Does poem have strong enough opening?

Do first few lines establish appropriate tone?
Would any later part of poem make a better opening?

SIGHT DEVICES:

Are there enough specific image details in poem?
Are the metaphors and similes apt?
Do any figures or conceits need further development?
Are any sections of poem weak in visual images?

SOUND DEVICES:

Is there any strong assonance—vowel sounds?
Is there any strong alliteration—consonant sounds?
Any problem with scansion of rhythm in poem?
Anything special about texture of sound in poem?

SENSE DEVICES:

What is voice or persona or point of view in poem?
Is diction consistent? Any odd word choices?
Is syntax appropriate? Sentence structuring?
What is totality of tone in poem?

CLOSURE OF POEM:

Do last few lines seem right for ending of poem?
Does the closure seem artificial or overwritten?
Could poet get out of poem in any better way?
Should poem be left suspended, with no closure?

PLACEMENT ON PAGE:

Do the line breaks seem right? Enjambements?
Does poem have left-hand capitals? Why? Or why not?
Can any punctuation in poem be stripped away?
Could line placements be arranged in any better way?

GENERAL OBSERVATIONS:

Can this poem be tightened in any way?
Is there any rhetoric, generality, abstract words?
Could any parts of poem be developed more?
More proper names, place names, concrete particulars?

 The chief virtue of this checklist is that it tries to cover the entire range of technical considerations that go into the making of a poem.

But as we said at the outset, this checklist is simply meant as a practical guide to arrive at an objective description of what is already there on the page. To be sure, the answers to the various questions on the checklist will require considerable critical judgment and deliberate choices on the part of the poet or reader or whoever is trying to apply the checklist to any particular poem. But that's all a part of the training one has to go through to be able to see what kind of a poem one is trying to describe.

And as we said, the best criticism is always description.

D

DACTYL *See* METER.

DADA

A movement begun in 1916 in Zurich by Hans Arp and Hugo Ball, out of a need for total freedom of form. Deriving from the Cubists, Dada focused on collage and juxtaposition of words and IMAGES, more out of randomness and chance than out of any reason or manifest order. Dada was opposed to morality and religion and any other manifestation of traditional form.

O. B. Hardison, Director of the Folger Shakespeare Library, wrote of Dada in the *New York Times* of November 29, 1981, as follows:

That a radical cultural change of some sort took place in the early 20th century is commonplace. Freud's "Interpretation of Dreams," published in 1900, was part of the change. However, the decisive change in science occurred in physics rather than psychology. It was the work of such figures as Maxwell, Rutherford, Planck, Bohr and Einstein. It can be dated symbolically by the publication date (1905) of Einstein's papers on special relativity, mass-energy equivalence, Brownian motion, and the photon theory of light. The moment was decisive because after it, the time-honored mechanistic view of Nature was no longer tenable. The external world was still there, but it had lost its comforting solidity and uniformity.

In fact, relativity had far more radical implications than the introduction of heliocentric astronomy in the Renaissance. If the heliocentric system undermined time-honored religious beliefs, it also vindicated the power of human reason and the rationality of Nature. Relativity, conversely, appeared to set limits to rational knowledge and to unsettle Nature itself. It was as though mankind had been

lifted out of a secure two-bedroom house and dropped without warning into the hall of mirrors of an amusement park. Einstein's theory was ridiculed, misrepresented and ignored, but for those who understood Einstein, it was the beginning of a new era, and demanded new modes of thought and a new language to express them.

Dada is the most widely known of these movements. The key to dada is randomness. Achieving randomness, however, is more difficult than it sounds. . . . A typical method of constructing a dada poem, for example, is cutting up phrases or words from newspaper, stirring them in a hat, and pasting them on a piece of paper in the order in which they are withdrawn. Obviously, the words come from a natural language, and, being printed, they are in a visual medium (the Roman alphabet) that is opaque rather than transparent. Even if we ignore these objections, we still confront the fact that the words are an inadequate statistical sample of the words in the natural language of the journal from which they were clipped. They are not arbitrary.

The random quality of the front page of a newspaper is not accidental but essential. When we buy a newspaper, part of our interest may be in a particular story, but part of the charm of the newspaper is that it will introduce us to the unexpected. We know the newspaper will have a story on the latest plan for balancing the budget; but who can predict stories on a child falling into a well in Oklahoma, the production of human interferon from bacteria, a hurricane in Florida, the resignation of the superintendent of highways in North Dakota, a rebellion in Chad and the like?

The dada quality found in newspapers is also evident in art forms created by high technology. Movies are produced in "takes" that ignore the cause-effect patterns of their plots, and they are often seen by viewers from middle to end to beginning, with short subjects, cartoons and previews coming between end and beginning, rather than in the familiar Aristotelian sequence of stage drama, from beginning to middle to end. This sort of discontinuity is minor, however, compared to the standard practice of American television which routinely cuts from the heroine watching her lover dying in the cancer ward to a commercial for toilet paper to a plug for underarm deodorants to a station break to a preview of the evening news and *back* to the heroine.

In the light of this, dada begins to look less like an eccentric aberration than an anticipation in the early years of the century of what was to become commonplace by its end. The dada poets were

prophets and seers in the old sense of those terms. They were not magicians who could predict the future, but sensitive individuals who, by contemplating the obvious, were able to describe what most citizens could not see until many years later.

DENOTATION

The literal, dictionary meaning of a word or phrase. All puns turn on denotation; for example, Hamlet's first line is a pun:

> A little more than kin, and less than kind.
>
> (William Shakespeare, *Hamlet*, I.ii)

Because "kind" can mean both "considerate" and also "kinned," related to one by blood association, the denotation of the word helps create a pun.

See also CONNOTATION.

DICTION

Word choice; the consistent feature of the type and style of words that are used. Diction can be a mix of slang, conversational language, plain style, and literary rhetoric, usually implying a mix of Anglo-Saxon, Latinate words, and assorted regionalisms or ethnic dialect words.

Aristotle in the *Poetics* has this to say about diction:

The perfection of diction is that it be at once clear and not pedestrian. The clearest diction is made up of plain-style words for things. . . . On the other hand, diction becomes distinguished and not prosy by the use of unfamiliar terms, i.e., strange words, metaphors, elongated forms, and whatever deviates from ordinary speech. . . .

A certain admixture, therefore, of unfamiliar terms is necessary. These strange words, metaphors, figurative phrases, &c., will keep the language from seeming pedestrian and prosy, while the plain-style words will keep the needed clearness. What helps most, however, to render the diction at once clear and not prosy is the use of the elongated, foreshortened, and altered forms of words.

In English there is a tremendous reservoir of words from several different sources, most notably from Anglo-Saxon, from Latin, and from colloquial

speech. We can sense the difference in diction between the following words: thrill (Anglo-Saxon), excitement (Latin), turn-on (colloquial)—lie (Anglo-Saxon), prevaricate (Latin), fib (colloquial)—trick (Anglo-Saxon), prestidigitation (Latin), con (colloquial)—swoon (Anglo-Saxon), ecstasy (Latin), high (colloquial).

In writing, the poet should try to recreate his or her own plain style of simple word choices, avoiding as much as possible the overuse of Latinate words that have more to do with concepts than they do with images. Imagery can best be conveyed through simple plain-style monosyllabic words.

The following passage from *Macbeth* is an example of diction shift. In the first part of the speech, Lady Macbeth uses plain style—simple monosyllabic words like love/babe/milks/face/gums/brains; the imagery of this part of the speech is direct and simple as she describes nursing a newborn baby. In the second part of the speech, however, she suddenly shifts diction and uses dense Latinate words—polysyllabic words like whereto/convince/memory/warder/receipt/limbeck; there is hardly any imagery in this part of the speech, as she inflates her language and obscures her syntax in order to be impressive rather than descriptive. Here are the two parts of the speech:

> I have given suck, and know
> How tender 'tis to love the babe that milks me:
> I would, while it was smiling in my face,
> Have pluck'd my nipple from his boneless gums,
> And dash'd the brains out, had I so sworn as you
> Have done to this.
> . . .We fail:
> But screw your courage to the sticking-place
> And we'll not fail. When Duncan is asleep,
> Whereto the rather shall his day's hard journey
> Soundly invite him, his two chamberlains
> Will I with wine and wassail so convince
> That memory, the warder of the brain,
> Shall be a fume, and the receipt of reason
> A limbeck only . . .

> (William Shakespeare, *Macbeth*, I.vii)

The diction shift above is fairly obvious, and functions as a kind of secret stage direction to the actress, who must somehow change her entire tone and temperament as she moves from the first to the second part of the speech. It shows graphically how powerful diction and word choice can be in determining the total emotional effect of a passage.

DIDACTIC POETRY

Any poetry that teaches, or tries to teach, some moral or informational or religious lesson. The earliest examples of didactic poetry include innocuous mnemonic jingles such as:

> Thirty days hath December,
> April, June, and November;
> All the rest have thirty-one
> Excepting February . . .

The eighth century B.C. poet Hesiod in "Works and Days" included a lot of ethical maxims about farming and pastoral life, and in "Theogony" he wrote a didactic poem that included a CATALOGUE of all the various gods. A more concentrated form of didactic poetry can be found in the work of Lucretius, whose poem *De Rerum Natura* developed the atomic theory of Epicurus. It is often difficult with certain philosophical poets, like Dante and Wallace Stevens, to determine whether their underlying point of view is didactic or merely structural.

Yet most didactic poetry tends to be simplistic or silly. For example, the following poem by Arthur Hugh Clough, which consists of ten rhymed couplets, summarizes the Ten Commandments of Moses:

> Thou shalt have one God only; who
> Would be at the expense of two?
>
> No graven images may be
> Worshipp'd, except the currency:
>
> Swear not at all; for, for thy curse
> Thine enemy is none the worse:
>
> At church on Sunday to attend
> Will serve to keep the world thy friend:
>
> Honour thy parents; that is, all
> From whom advancement may befall:
>
> Thou shalt not kill; but need'st not strive
> Officiously to keep alive:
>
> Do not adultery commit;
> Advantage rarely comes of it:

Thou shalt not steal; an empty feat,
When 'tis so lucrative to cheat:

Bear not false witness; let the lie
Have time on its own wings to fly:

Thou shalt not covet, but tradition
Approves all forms of competition.
 (Arthur Hugh Clough, "The Latest Decalogue")

The following wry poem is a modern example of didactic poetry:

I will teach you my townspeople
how to perform a funeral—
for you have it over a troop
of artists—
unless one should scour the world—
you have the ground sense necessary.

See! the hearse leads.
I begin with a design for a hearse.
For Christ's sake not black—
nor white either—and not polished!
Let it be weathered—like a farm wagon—
with gilt wheels (this could be
applied fresh at small expense)
or no wheels at all:
a rough dray to drag across the ground . . .
 (William Carlos Williams, "Tract")

DRAB POETRY

Poetry that is unadorned. Beginning around the Tudor period under Henry
VIII, Drab Age verse tended toward plain style, straightforward statement,
and a simple speaking voice. Drab poetry is usually without ornament or
elaboration; an anonymous sixteenth-century song tells us, "It is a precious
jewel to be plain." C. S. Lewis, in *English Literature in the Sixteenth Century
(Excluding Drama)*, explains the origins of this plain style:

There is little aureation, few metaphors, no stylized syntax, and none
of the sensuous imagery loved by the Elizabethans. One reason for

this plainness is that we are reading songs; richness and deliciousness would be supplied by the air and the lute and are therefore not wanted in the words. When they are read merely as poems it produces results which were probably unforeseen by the authors. It makes some pieces seem flat and dull; others, admirably fresh and ingenuous.

An example of drab style is Wyatt's line

> With naked fote stalking in my chambre
>
> (Sir Thomas Wyatt, "They Flee fro Me")

DRAMATIC-NARRATIVE POETRY

Poetry that is dramatic, insofar as it involves two or more notes or TONES or VOICES, and narrative, insofar as it tells a story.

Examples of dramatic-narrative poetry abound. In Middle English, some of the *Canterbury Tales* are dramatic-narrative poems—especially the Knight's Tale, the Miller's Tale, and the Nun's Priest's Tale. In each of these tales the poet assumes several different voices and yet tells a single story with beginning, middle, and end.

In the Renaissance, both of Shakespeare's LONG POEMS—"Venus and Adonis" and "The Rape of Lucrece"—may be considered dramatic-narrative poems.

An example of dramatic narrative from the Victorian period is Alfred, Lord Tennyson's "Ulysses," where the poet tells his story in the voice of a PERSONA:

> It little profits that an idle king,
> By this still hearth, among these barren crags,
> Match'd with an aged wife, I mete and dole
> Unequal laws unto a savage race,
> That hoard, and sleep, and feed, and know not me.
> I cannot rest from travel; I will drink
> Life to the lees . . .
>
> (Alfred, Lord Tennyson, "Ulysses")

And in modern poetry, the great master of dramatic-narrative poetry is Robert Browning. Browning's powerful dramatic impulse is evident in the opening of the following poem:

Who will, may hear Sordello's story told:
His story? Who believes me shall behold
The man, pursue his fortunes to the end,
Like me: for as the friendless-people's friend
Spied from his hill-top once, despite the din
And dust of multitudes, Pentapolin
Named o' the Naked Arm, I single out
Sordello, compassed murkily about
With ravage of six long sad hundred years.
Only believe me. Ye believe? . . .

(Robert Browning, "Sordello")

Edwin Arlington Robinson also wrote dramatic-narrative poems:

She fears him, and will always ask
 What fated her to choose him;
She meets in his engaging mask
 All reasons to refuse him;
But what she meets and what she fears
Are less than are the downward years,
Drawn slowly to the foamless weirs
 Of age, were she to lose him . . .

(Edwin Arlington Robinson, "Eros Turannos")

Robert Frost wrote many dramatic-narrative poems, including the following:

Mary sat musing on the lamp-flame at the table,
Waiting for Warren. When she heard his step,
She ran on tiptoe down the darkened passage
To meet him in the doorway with the news
And put him on his guard. "Silas is back."
She pushed him outward with her through the door
And shut it after her. "Be kind," she said.
She took the market things from Warren's arms
And set them on the porch, then drew him down
To sit beside her on the wooden steps . . .

(Robert Frost, "The Death of the Hired Man")

DRAMATIC POETRY

Poetry that involves two or more notes or TONES or VOICES, as opposed to lyric poetry, which involves a single note or tone or voice. Dramatic poetry is not often represented in standard anthologies of English and American poetry because most dramatic verse is written for the theater. William Shakespeare, Christopher Marlowe, John Webster, T. S. Eliot, Christopher Fry, and Maxwell Anderson are notable poets who wrote dramatic poetry.

E

ECLOGUE

An IDYL or pastoral poem, usually in dialogue form. The root word *eklegein* from the Greek means "to choose" and may refer to selecting different flowers to make a particular bouquet, as in an anthology; Dante favored the root *aeglogue* from the Latin, deriving from the word *aix* (goat), which would combine not only pastoral/rural themes but also hints at an element of Dionysian fertility and eroticism.

Virgil wrote ten *Eclogues;* the following lines are from the introduction:

MELIBOEUS: You, Tityrus, under that shading beech
 lie there in peace and so repeat your speech
 on rural things; for my part, I must go
 so far away from here, as you well know.
 I have been exiled, Tityrus, while you
 loafe and fool in those shadows as you do,
 singing "Fair Amaryllis" to the trees.

TITYRUS: Remember, Meliboeus, all our ease
 was given to us by a god, and I
 intend to honor that god by
 offering a lamb to his sacred name.
 Through the gift of this god's eternal fame
 my cattle roam the fields from noon to night
 and I myself can sing what songs I like . . .

(Virgil, "First Eclogue," tr. William Packard)

Other eclogues have been written by Spenser, Pope, Swift, and Frost.

ELEGY

A poem of grief or mourning; a lyric lament. Milton wrote an elegy "On the
Death of a Friend drowned in his passage from Chester on the Irish Seas,
1637":

> Yet once more, O ye laurels, and once more,
> Ye myrtles brown, with ivy never sere,
> I come to pluck your berries harsh and crude,
> And with forced fingers rude
> Shatter your leaves before the mellowing year,
> Bitter constraint, and sad occasion dear,
> Compels me to disturb your seasons due;
> For Lycidas is dead, dead ere his prime,
> Young Lycidas, and hath not left his poor.
> Who would not sing for Lycidas? . . .
>
> (John Milton, "Lycidas")

Shelley wrote an elegy on the death of John Keats, "Author of Endy-
mion, Hyperion, Etc.":

> I weep for Adonais—he is dead!
> O, weep for Adonais! though our tears
> Thaw not, sad Hour, selected from all years
> To mourn our loss, rouse thy obscure compeers,
> And teach them thine own sorrow, say: "With me
> Die Adonais; till the Future dares
> Forget the Past, his fate and fame shall be
> An echo and a light unto eternity!" . . .
>
> (Percy Bysshe Shelley, "Adonais")

Not all elegies are written out of personal grief. Thus, the German poet
Rainer Maria Rilke and his *Duino Elegies* raised the form to philosophical
heights. Written between 1912 and 1922 in France, Spain, Germany, and
Switzerland, these ten massive meditations on man's fate were written out of
a universal metaphysical sadness and terror. Following are the opening lines
of the "First Elegy":

> Who if I cried aloud among the angelic orders
> would hear me? And even if one did

take me suddenly into his heart, I should perish
before his more exalted being. For beauty is nothing
but the beginnings of terror we can hardly bear,
and we are in awe of it because it politely scorns
to wipe us out. Every angel is terrifying.
So I remain calm and choke back the strong wish
to sob out loud. But then who is there to use?
Not angels, and not men, and the cunning animals
know that we are rather ill at ease
in this world we've conceived. Perhaps on a distant
hillside some special tree stays in place so
we can see it every day; and the street we saw
yesterday remains for us; and some comfortable habit
we had gotten used to and did not want to do without.
And the night, the night, with its wind
of curious whispers . . .

(Rainer Maria Rilke, "First Elegy," tr. William Packard)

In 1939, two great figures died: William Butler Yeats and Sigmund Freud. W. H. Auden wrote extraordinary elegies for both these men, although they were historical rather than personal poems of grief. Auden explains in his NYQ Craft Interview:

NYQ: The two elegies that you wrote, on Freud and Yeats, seem to be more general as elegies than, say, elegies like "Lycidas" or "Adonais."

AUDEN: Those elegies of mine are not poems of grief. Freud I never met, and Yeats I only met casually and didn't particularly like him. Sometimes a man stands for certain things, which is quite different from what one feels in personal grief.

The elegy for Yeats begins,

He disappeared in the dead of winter:
The brooks were frozen, the airports almost deserted,
And snow disfigured the public statues;
The mercury sank in the mouth of the dying day.
O all the instruments agree
The day of his death was a dark cold day.

Far from his illness
The wolves ran on through the evergreen forests,
The peasant river was untempted by the fashionable quays;
By mourning tongues
The death of the poet was kept from his poems . . .

> (W. H. Auden, "In Memory of W. B. Yeats,
> died January 1939")

The elegy for Freud begins,

When there are so many we shall have to mourn,
when grief has been made so public, and exposed
 to the critique of a whole epoch
 the frailty of our conscience and anguish,

of whom shall we speak? For every day they die
among us, those who were doing us some good,
 who knew it was never enough but
 hoped to improve a little by living.

Such was this doctor: still at eighty he wished
to think of our life from whose unruliness
 so many plausible young futures
 with threats or flattery ask obedience,

but his wish was denied him: he closed his eyes
upon that last picture, common to us all,
 of problems like relatives gathered
 puzzled and jealous about our dying . . .

> (W. H. Auden, "In Memory of Sigmund Freud,
> died September 1939")

Not all elegies are about individuals; thus this poem personifies an old
farm building that burned down:

As though an aged person were to wear
Too gay a dress
And walk about the neighborhood
Announcing the hour of her death,

So now, one summer day's end,
At suppertime, when wheels are still,
The long barn suddenly puts on the traitor, beauty,

And hails us with a dangerous cry,
For: "Look!" she calls to the country,
"Look how fast I dress myself in fire!" . . .

(Thomas Merton, "Elegy for the Monastery Barn")

Surely one of the most overwhelming poems of our time is Allen Ginsberg's "Kaddish," which is a headlong Oedipal elegy for his mother, Naomi Ginsberg. The poem unfolds in long STROPHE breath lines, like these opening lines:

Strange now to think of you gone without corsets & eyes, while I walk
 on the sunny pavement of Greenwich Village,
downtown Manhattan, clear winter noon, and I've been up all night,
 talking, talking, reading the Kaddish aloud, listening to Ray
 Charles blues shout blind on the phonograph,
the rhythm the rhythm—and your memory in my head three years after
 —And read Adonais' last triumphant stanzas aloud—wept,
 realizing how we suffer—
And how Death is that remedy all singers dream of, sing, remember,
 prophesy as in the Hebrew Anthem, or the Buddhist Book of
 Answers—and my own imagination of a withered leaf—at
 dawn—
Dreaming back thru life, Your time—and mine accelerating toward
 Apocalypse . . .

(Allen Ginsberg, "Kaddish")

ELISION *See* ELLIPSE.

ELLIPSE

An omission or elision of a necessary word or part of speech, sometimes to give the effect of speed or impetuosity.

William Blake originally wrote this stanza of "The Tyger":

And what shoulder, & what art,
Could twist the sinews of thy heart?
And when thy heart began to beat,
What dread hand Form'd thy dread feet?

In a later version, however, he changed the fourth line above to read

What dread hand? & what dread feet?

thus creating an ellipse, or omission of the necessary predicate verb, to create the illusion of overwhelming speed on the part of the deity.

END-RHYME *See* RHYME.

END STOP *See* COUPLET; ENJAMBEMENT; RHYME.

ENJAMBEMENT

Spillover of poetry from the end of one line to the beginning of the next line. Enjambement plays on the subtle momentary pause that is customary at the ending of any line, to create the illusion of energy being carried over to the following line.

When a poetic line is end-stopped, the line break occurs at the end of the sentence; for example:

O, she doth teach the torches to burn bright!

(William Shakespeare, *Romeo and Juliet*, I.v)

However, when the sense of a sentence is not completed at the end of the poetic line, it carries over to the following line in an enjambement:

Let me not to the marriage of true minds
Admit impediments . . .

(William Shakespeare, Sonnet 116)

In Shakespeare's early comedies and tragedies, poetic lines are mostly end-stopped. However, during his middle and later periods, Shakespeare introduced more and more enjambements, as if to create a tension between the BLANK VERSE ending of a poetic line and the sense of the sentence, which had to spill over. Thus in Macbeth's soliloquy:

And pity, like a naked new-born babe,
Striding the blast, or heaven's cherubim, hors'd
Upon the sightless couriers of the air,
Shall blow the horrid deed in every eye,
That tears shall drown the wind.

(William Shakespeare, *Macbeth*, I.vii)

And there is strong enjambement in the opening lines of Cleopatra's death speech:

> Give me my robe, put on my crown, I have
> Immortal longings in me; now no more
> The juice of Egypt's grape shall moist this lip . . .
>
> (William Shakespeare, *Antony and Cleopatra*, V.ii)

In the Jacobean period, John Webster used enjambements as a natural counterpoint to the regularity of blank verse:

> I doe love these auncient ruynes:
> We never tread upon them, but we set
> Our foote upon some reverend History.
> And questionles, here in this open Court
> (Which now lies naked to the injuries
> Of stormy weather) some men lye Enterr'd
> Lov'd the Church so well, and gave so largely to't,
> They thought it should have canopide their Bones
> Till Doombes-day: But all things have their end:
> Churches, and Citties (which have diseases like to men)
> Must have like death that we have.
>
> (John Webster, *The Duchess of Malfi*, V.iii)

At times enjambement can have a strong whiplash effect that may be quite disconcerting, as in the *Macbeth* and *Antony and Cleopatra* examples; in other cases, enjambement may seem to recreate the actual breathing of the poet behind his poetry, as in Webster's lines.

Modern poets use enjambement in FREE VERSE as a matter of course: Walt Whitman practices it in *Leaves of Grass*, and Gerard Manley Hopkins uses it to stunning effect in his sonnets. Part of the power of the following lines by E. E. Cummings comes from his use of enjambement:

> pity this busy monster, manunkind,
> not.
>
> (E. E. Cummings, "pity this busy monster,
> manunkind,")

ENVOI

A salutation and a sending forth of one's poetry, either to a patron or to posterity. Sometimes referred to as "Ité," meaning "go forth."

Catullus writes an envoi in his very first poem:

> Qui dono lepidum nouum libellum
> arido modo pumice expolitum?
> Corneli, tibi: namque tu solebas
> meas esse aliquid putare nugas; . . .

> Who shall receive my new-born book,
> my poems, elegant and shy,
> neatly dressed and polished?

> You, Cornelius,
> shall be my single patron,
> for, long ago, you praised
> my slender lines and stanzas; . . .
>
> (tr. Horace Gregory)

Chaucer tells his poetry to follow in the steps of Virgil, Ovid, Homer, Lucan, and Statius:

> Go, litel book, go, litel myn tragèdy,
> Ther God thy makere yet, er that he die,
> So sendé might to make in some comèdy!
> But litel book, no making thou n'envie,
> But subgit be to allé poësie;
> And kiss the steppès where as though seest pace
> Virgìle, Ovìde, Omèr, Lucàn, and Stace.
>
> (Geoffrey Chaucer, *Troilus and Criseyde*)

Robert Louis Stevenson writes a generous envoi for his poetry:

> Go, little book, and wish to all
> Flowers in the garden, meat in the hall,
> A bin of wine, a spice of wit,
> A house with lawns enclosing it,
> A living river by the door,
> A nightingale in the sycamore.
>
> (Robert Louis Stevenson, "Go, little book,
> and wish to all")

Ezra Pound sounds a defiant envoi for his poetry:

> Go, my songs, seek your praise from the young and from
> the intolerant,
> Move among the lovers of perfection alone.
> Seek ever to stand in the hard Sophoclean light
> And take your wounds from it gladly.

<div align="right">(Ezra Pound, "Ité")</div>

And in contemporary poetry, W. S. Merwin sounds an ironic and heroic envoi:

Go book

go
now I will let you
I open the grave
live
I will die for us both

go but come again if you can
and feed me in prison

if they ask you why
you do not boast of me
tell them as they
have forgotten
truth habitually
gives birth in private

Go without ornament
without showy garment
if there is in you any
joy
may the good find it

for the others be
a glass broken in their mouths

Child
how will you
survive with nothing but your virtue
to draw around you
when they shout Die die

who have been frightened before
the many

I think of all I wrote in my time
dew
and I am standing in dry air

Here are what flowers there are
and what hope
from my years
and the fire I carried with me

Book
burn what will not abide your light

When I consider the old ambitions
to be on many lips
meaning little there
it would be enough for me to know
who is writing this
and sleep knowing it

far from glory and its gibbets

and dream of those who drank at the icy fountain
and told the truth.

(W. S. Merwin, "Envoy from D'Aubigné")

EPIC

A heroic lyric-narrative poem, the extension of an ODE. Originally an oral form, the epic usually contains a good deal of history.

Most epic poems adhere strictly to certain thematic conventions. The opening usually invokes a Muse or Goddess for inspiration in the execution of the poem, then states the epic theme or topic the entire poem will develop. The following are classic examples:

Anger be now your song, immortal one,
Akhilleus' anger doomed and ruinous,
that caused the Akhaians loss on bitter loss
and crowded brave souls into the undergloom,
leaving so many dead men—carrion
for dogs and birds; and the will of Zeus has done . . .

(Homer, *Iliad*, tr. Robert Fitzgerald)

Sing in me, Muse, and through me tell the story
of that man skilled in all ways of contending,
the wanderer, harried for years on end,
after he plundered the stronghold
on the proud height of Troy . . .

(Homer, *Odyssey,* tr. Robert Fitzgerald)

I sing of warfare and a man at war.
From the sea-coast of Troy in early days
He came to Italy by destiny,
To our Lavinian western shore,
A fugitive, this captain, buffeted
Cruelly on land as on the sea
By blows from powers of the air—behind them
Baleful Juno in her sleepless rage.
And cruel losses were his lot in war,
Till he could found a city and bring home
His gods to Latium, land of the Latin race,
The Alban lords, and the high walls of Rome . . .

(Virgil, *Aeneid,* tr. Robert Fitzgerald)

Halfway through the path of my life I knew
 that I had gone astray in a dark wood
 and the true way was nowhere in my view.
It is hard to say now how far from good
 I was in that wild forest—once again
 I feel such fear to think of where I stood.
In death itself there is no sharper pain.
 But since there were such blessings there I found,
 I will speak here of those things that I saw.
I do not know how I came on that ground,
 I was so full of sleep and felt so raw
 when I began my wandering around . . .

(Dante Alighieri, *Commedia,* tr. William Packard)

Of mans First Disobedience, and the Fruit
Of that Forbidden Tree, whose mortal taste
Brought Death into the World, and all our woe,
With loss of *Eden,* till one greater Man
Restore us, and regain the blissful Seat,
Sing Heav'nly Muse, that on the secret top

of *Oreb,* or of *Sinai,* didst inspire
That Shepherd, who first taught the chosen Seed,
In the Beginning how the Heav'ns and Earth
Rose out of *Chaos* . . .

 (John Milton, *Paradise Lost*)

Most epic poems also include an experience of *nekuia,* or descent into the
underworld. Thus in the opening lines of the *Iliad,* we are told that the souls
of many Achaians are cast down into Hades; and in Book XI of the *Odyssey,*
Odysseus finally visits this underworld to hear the prophecy of Tiresias,
where he also views the souls of the dead. In Book VI of the *Aeneid,* Aeneas
crosses the river Styx and approaches Tartarus to view the souls of the dead
of Elysium. Dante begins his *Commedia* by going with Virgil down to the
various circles of the *Inferno* where he sees the damned souls suffering for
their respective sins. Milton recreates the damnation and fall of Lucifer in
Books III and IV of *Paradise Lost.* And in the twentieth century, Ezra Pound
begins his epic *Cantos* with a translation of Book XI of the *Odyssey,* thus
substituting *nekuia* for both invocation and statement of epic theme.

Little is known about the composition of an epic poem. We know noth-
ing of how Homer wrote the *Iliad* and the *Odyssey,* sometime around the
ninth century B.C., if indeed one poet actually wrote both poems. Tradition
tells us Homer was blind, and that both the *Iliad* and the *Odyssey* survived
from generation to generation through oral recitation, usually by profes-
sional rhapsodes; there is a sharp description of such a rhapsode in Plato's
dialogue *Ion.*

We know that Virgil was encouraged by the Emperor Augustus to write
the *Aeneid* as the great national epic poem, that Virgil spent the last eleven
years of his life on it, and that he probably read aloud Books III, IV, and VI
to Augustus before Virgil's death in A.D. 19.

We know that Dante wrote the first few cantos of his *Commedia* in Latin,
then changed his mind and wrote the entire poem in vernacular Italian. And
we know that the blind Milton dictated much of *Paradise Lost* to his daugh-
ter, which may account for the declamatory feeling of some passages.

Coleridge never wrote an epic poem, but he once commented on how he
should go about it:

I should not think of devoting less than twenty years to an epic poem.
Ten years to collect materials and warm my mind with universal
science. I would be a tolerable mathematician. I would thoroughly
understand Mechanics; Hydrostatics; Optics and Astronomy; Bot-

any; Metallurgy; Fossilism; Chemistry; Geology; Anatomy; Medicine; then the minds of men, in all Travels, Voyages, and Histories. So I would spend ten years; the next five in the composition of the poem, and the next five in the correction of it. So would I write, haply not unhearing of that divine and nightly whispering voice, which speaks to mighty minds, of predestined garlands, starry and unwithering.

EPIGRAM

A short gnomic verse, cleverly turned, sometimes aphoristic in nature. The EPITAPH is a species of epigram; but so are the following caustic lines of satire:

> Friend Rundall fell with grievous bump,
> Upon his reverential rump.
> Poor rump, thou hadst been better sped,
> Had thou been join'd to Boulter's head.
> An head so weighty and profound,
> Would needs have kept thee from the ground.
>
> (Jonathan Swift, "An Epigram," 1735)

William Blake wrote a series of what can be considered loose poetic epigrams, consisting usually of one-line turns:

The Road of excess leads to the palace of wisdom.

If the fool would persist in his folly he would become wise.

The fox condemns the trap, not himself.

The cistern contains: the fountain overflows.

Always be ready to speak your mind and a base man will avoid you.

The eagle never lost so much time as when he submitted to learn of the crow.

The tygers of wrath are wiser than the horses of instruction.

Listen to the fool's reproach! it is a kingly title!

Damn braces; Bless relaxes.

Sooner murder an infant in its cradle than nurse unacted desires.
 (William Blake, "Proverbs of Hell")

Epigrams can be used as specific forms of social protest. Byron, for example, used an epigram to lampoon a journalist on the *Quarterly Review* who had written of the "Endymion" of John Keats, "we almost doubt that any man in his senses would put his real name to such a rhapsody. . . ."
 After Keats abandoned "Endymion" and died, Byron wrote the following epigram:

> "Who kill'd John Keats?"
> "I," says the Quarterly,
> So savage and Tartarly;
> "'Twas one of my feats."

In modern poetry, the epigram has been used more generally to express the epitome of an event or situation:

Friend, on this scaffold Thomas More lies dead
Who would not cut the Body from the Head.
 (J. V. Cunningham, from *The Exclusions of a Rhyme*)

Cunningham is also capable of turning an epigram to satirical ends:

> Here lies New Critic who would fox us
> With his poetic paradoxes.
> Though he lies here rigid and quiet,
> If he could speak he would deny it.
> (J. V. Cunningham, from *The Exclusions of a Rhyme*)

EPISTLE

A letter in verse; a poem in the form of a direct address to a particular person or persons. Every letter presupposes someone who is being addressed, and also a strong message to be sent. Therefore the epistle always has a single

strong focus, and usually inclines toward the didactic, since there is something very important to be said.

A case in point is the New Testament, over one-half of which consists of letters or epistles—by Paul, Peter, James, John, and Jude. In the opening lines of the first Epistle to Timothy, Paul begins with a customary salutation which identifies him as the sender and Timothy as the receiver of the letter; then Paul goes immediately to his message, which is the chief reason for writing the letter:

> Paul, an apostle of Jesus Christ by the commandment of God our Saviour, and Lord Jesus Christ, which is our hope;
>
> Unto Timothy, my own son in the faith: Grace, mercy, and peace, from God our Father and Jesus Christ our Lord.
>
> As I besought thee to abide still at Ephesus, when I went into Macedonia, that thou mightest charge some that they teach no other doctrine,
>
> Neither give heed to fables and endless genealogies, which minister questions, rather than godly edifying which is in faith; so do.
>
> (I Timothy 1:1–4)

As a purely literary form, the epistle reached its heights in the hands of Alexander Pope. In the following lines, Pope reveals his reason for writing:

> Why did I write? what sin to me unknown
> Dipt me in Ink, my parents, or my own?
> As yet a child, nor yet a fool to fame,
> I lisp'd in numbers, for the numbers came.
> I left no calling for this idle trade,
> No duty broke, no father disobey'd.
> The Muse but serv'd to ease some friend, not Wife,
> To help me thro' this long disease, my Life . . .
>
> (Alexander Pope, "Epistle to Dr. Arbuthnot")

And Robert Burns used the epistle form to express what was most important to him in life:

> It's no in titles nor in rank;
> It's no in wealth like Lon'on Bank,
> To purchase peace and rest;

It's no in makin muckle *mair:*
It's no in books; it's no in lear,
 To make us truly blest:
If Happiness hae not her seat
 And centre in the breast,
We may be wise, or rich, or great,
 But never can be blest:
 Nae treasures, no pleasures,
 Could make us happy lang;
 The *heart* ay's the part ay,
 That makes us right or wrang.
 (Robert Burns, "Epistle to Davie")

In the modern period, W. H. Auden used the epistle form to express his feelings about what it means to be a poet; writing an imaginary letter to Lord Byron helped Auden to focus his views:

Excuse, my lord, the liberty I take
 In thus addressing you. I know that you
Will pay the price of authorship and make
 The allowances an author has to do.
 A poet's fan-mail will be nothing new.
And then a lord—Good Lord, you must be peppered,
Like Gary Cooper, Coughlin, or Dick Sheppard,

With notes from perfect strangers starting, "Sir,
 I liked your lyrics, but *Childe Harold*'s trash,"
"My daughter writes, should I encourage her?"
 Sometimes containing frank demands for cash,
 Sometimes sly hints at a platonic pash,
And sometimes, though I think this rather crude,
The correspondent's photo in the rude . . .
 (W. H. Auden, "Letters to Lord Byron")

Auden also wrote a more general epistle as if it were an annual letter about the state of the world to be circulated privately among his friends:

Under the familiar weight
Of winter, conscience and the State,
In loose formations of good cheer,

Love, language, loneliness and fear,
Towards the habits of next year,
Along the streets the people flow,
Singing or sighing as they go:
Exalté, piano, or in doubt,
All our reflections turn about
A common meditative norm,
Retrenchment, Sacrifice, Reform . . .

 (W. H. Auden, "New Year's Letter")

Archibald MacLeish wrote an epistle as if it were meant to be part of a time capsule:

. . . It is colder now,
 there are many stars, we are drifting
North by the Great Bear,
 the leaves are falling,
The water is stone in the scooped rocks,
 to southward
Red sun grey air:
 the crows are
Slow on their crooked wings,
 the jays have left us:
Long since we passed the flares of Orion.
Each man believes in his heart he will die.
Many have written last thoughts and last letters.
None know if our deaths are now or forever:
None know if this wandering earth will be found.

We lie down and the snow covers our garments.
I pray you,
 you (if any open this writing)
Make in your mouths the words that were our names.
I will tell you all we have learned,
 I will tell you everything:
The earth is round,
 there are springs under the orchards,
The loam cuts with a blunt knife,
 beware of
Elms in thunder,
 the lights in the sky are stars—

We think they do not see,
 we think also
The trees do not know nor the leaves of the grasses hear us:
The birds too are ignorant.
 Do not listen.
Do not stand at dark in the open windows.
We before you have heard this:
 they are voices:
They are not words at all but the wind rising.
Also none among us has seen God.
(. . . We have thought often
The flaws of sun in the late and driving weather
Pointed to one tree but it was not so.)
As for the nights I warn you the nights are dangerous:
The wind changes at night and the dreams come.

It is very cold,
 there are strange stars near Arcturus,

Voices are crying an unknown name in the sky
 (Archibald MacLeish, "Epistle to Be Left in the Earth")

The American poet Charles Olson called almost all of his poems "Letters," as if they were epistles addressed to the reader. Using the PERSONA of "Maximus," Olson wrote epistles trying to explain his experiences—in the following letter, he tries to explain what it is to be an American:

 An American
 is a complex of occasions,
 themselves a geometry
 of spatial nature

 I have this sense,
 that I am one
 with my skin,

 Plus this—plus this:
 that forever the geography
 leans in
 on me, and I compell
 backwards I compell Gloucester

> to yield to Maximus, to
> change
>
> Polis
> is this
>
> (Charles Olson, "Letter 27,"
> from *The Maximus Letters*)

Paul Blackburn wrote a lyric poem in the form of an epistle, in which the poet writes to his mother from a ship somewhere at sea:

Lat.	41°	34′	N
Long.	16°	58′	E
Declination of sun	24°	09′	

> Say I know where you are
> Now you know where I am
> Time on Board (not Greenwich)
> 9 hrs. 24 min. 52 sec.
> the 3rd of August, 1955.
> Your son and daughter-in-law send you herewith
> greetings
> and that we thought of you,
> this, your day .
>
> (Paul Blackburn, "The Letter")

The contemporary American poet Andrew Glaze expressed his deepest feeelings about poetry in this epistle:

> I tell you, David,
> poetry ought to be shocking,
> and poets ought to be dangerous people.
> In whatever country, honest feeling is always
> shocking and dangerous.
> Anyone true to the heart can simply enough and at
> any time be both.
>
> But for their contempt, we've ourselves to blame.
> We've been cowardly,
> We've made the stuff so cheap

begging their love
that poets are poor people
from wearing out the money of never was
passing it back and forth among themselves.

Rub the truth in their faces!
What is the point of being a poet anyway,
if you can't be a kind of prophet? . . .

<div align="right">(Andrew Glaze, "A Letter to David Matske")</div>

EPISTROPHE

Repetition of a key word or phrase at the end of successive lines. Epistrophe creates the same effect of repetition at line endings that ANAPHORA does at line openings. For example, Walt Whitman writes,

Underneath all, individuals,
I swear nothing is good to me now that ignores individuals,
The American compact is altogether with individuals,
The only government is that which makes minute of individuals,
The whole theory of the universe is directed unerringly to one single
 individual—namely to You.

<div align="right">(Walt Whitman, "By Blue Ontario's Shore")</div>

EPITAPH

A short verse on the life and death of a particular person or persons, real or imaginary, for placement on a tombstone.

The *Greek Anthology* contains several epitaphs, including a famous verse inscribed for the Spartans who were slain under Leonidas at the Pass of Thermopylae:

> Go, tell the Lacedaimonians, passer-by,
> that here, obedient to their laws, we lie.

Similarly, the epitaph for Aeschylus, one of Greece's great playwrights, records only that he fought at the Battle of Marathon against the Persians in 490 B.C.:

Here lies Aeschylos. I fought at the Battle of Marathon.
If you wish to know how brave I was,
Go ask the long-haired Persian, he will tell you.

Ovid records the epitaph for Phaethon who made the wild ride in his father's Chariot of the Sun:

> HERE LIES PHAETHON WHO DROVE HIS FATHER'S
> CHARIOT:
> HE FAILED GREATLY, YET HE ALSO RISKED GREATLY.

<div align="right">(Ovid, Metamorphoses)</div>

Shakespeare wrote his own epitaph, perhaps in an effort to keep grave-snatchers away from his tomb in Stratford Church. The epitaph reads simply and amiably enough, and we have no serious reason to doubt it was Shakespeare's own composition. It also succeeded in its intention, as no one has so far dared to disturb this final resting-place:

> GOOD FREND FOR IESVS SAKE FORBEARE,
> TO DIGG THE DVST ENCLOASED HEARE:
> BLESE BE YE MAN Y SPARES THES STONES,
> AND CVRST BE HE TY MOVES MY BONES.

If he had written nothing else, Ben Jonson would be remembered for his epitaph for his son, with its heart-breaking tenth line, which is a masterpiece of understatement and plain-style writing:

> Farewell, thou child of my right hand, and joy;
> My sinne was too much hope of thee, lov'd boy,
> Seven yeeres thou'wert lent to me, and I thee pay,
> Exacted by thy fate, on the just day.
> O, could I lose all father, now. For why
> Will man lament the state he should envie?
> To have so soone scap'd worlds, and fleshes rage,
> And, if no other miserie, yet age?
> Rest in soft peace, and, ask'd, say here doth lye
> BEN. JONSON his best piece of *poetrie*.
> For whose sake, hence-forth, all his vowes be such,
> As what he loves may never like too much.

<div align="right">(Ben Jonson, "On His First Sonne")</div>

In modern poetry, Walter Savage Landor wrote a fierce epitaph that showed his scorn of any rivals:

I strove with none, for none was worth my strife.
 Nature I loved, and, next to Nature, Art:
I warm'd both hands before the fire of life;
 It sinks, and I am ready to depart.

 (Walter Savage Landor, "Epitaph")

Robert Louis Stevenson expressed a haunting sense of peace and equanimity in his epitaph:

 Under the wide and starry sky
 Dig the grave and let me lie:
 Glad did I live and gladly die,
 And I laid me down with a will.

 This be the verse you grave for me:
 Here he lies where he long'd to be;
 Home is the sailor, home from sea,
 And the hunter home from the hill.

 (Robert Louis Stevenson, "Requiem")

A. E. Housman wrote an overwhelming epitaph for the dead young men who were slain in the First World War:

Life, to be sure, is nothing much to lose,
But young men think it is, and we were young.

 (A. E. Housman, from *More Poems*)

Edgar Lee Masters composed a host of fictional epitaphs in his *Spoon River Anthology,* where various persona speak from the grave and give living epitaphs for themselves:

I am Anne Rutledge who sleeps beneath these weeds,
Beloved in life of Abraham Lincoln,
Wedded to him, not through union,
But through separation.
Bloom forever, O Republic,
From the dust of my bosom!

 (Edgar Lee Masters, "Anne Rutledge")

William Butler Yeats composed a terse epitaph, which is on the headstone of his grave in Ireland:

> Cast a cold eye
> On life, on death.
> Horseman, pass by.

Ezra Pound, in "Hugh Selwyn Mauberly," an early poem-cycle in his book *Personae*, subtitled the main poem, "E. P. Ode pour l'Election de son Sepulchre"; and later, in his *Cantos*, Pound takes as his own epitaph the words of Tiresias as they appear in Book XI of the *Odyssey:*

> A man of no fortune, with a name to come.

Robert Frost has a single-line epitaph on his headstone in Vermont:

> I had a lover's quarrel with the world.

Not all epitaphs are serious; one thinks of the waggish epitaph that W. C. Fields proposed for himself:

> On the whole I'd rather be in Philadelphia.

and of the anonymous epitaph

> Here mother lies
> As usual

EPITHALAMION

A poem for marriage, or for a wedding celebration.

Several poems of Catullus are hymns devoted to marriage:

> O Hymenaee, Hymen,
> O Hymen, Hymenaee.
>
> And the man who marries you
> knows that he will never
> make your bed adulterous but will sleep forever

with his head between your breasts
your limbs his limbs entwining
as the flexible nervous vine winds about a tree and
mingles with its branches . . .

Come virgins, for the day is done
we've no more song to give them.
The doors are closed. Husband and wife are joined.
Their youthful love will breed
a vigorous generation.

<div align="right">(Catullus, Poem 61, tr. Horace Gregory)</div>

Edmund Spenser wrote a collection of poems which includes these lines:

Her goodly eyes like sapphires shining bright,
Her cheeks like apples which the sun hath rudded,
Her lips like cherries charming men to bite,
Her breast like to a bowl of cream uncrudded,
Her paps like lilies budded,
Her snowy neck like to a marble tower,
And all her body like a palace fair,
Ascending up with many a stately stair,
To honour's seat and chastity's sweet bower . . .

<div align="right">(Edmund Spenser, *Amoretti and Epithalamion*)</div>

In the modern period, Erica Jong wrote the following epithalamion in response to a *New York Times* account of an archeologist who reported "A Turk won't marry a woman unless she can cook eggplant at least a hundred ways." Erica Jong develops a surrealistic epithalamion playing on this report:

1

There are more than a hundred Turkish poems
about eggplant.
I would like to give you all of them.
If you scoop out every seed,
you can read me backward
like an Arabic book.
Look.

2

(Lament in Aubergine)

Oh aubergine,
egg-shaped
& as shiny as if freshly laid—
you are a melancholy fruit.
Solanum Melongena.
Every animal is sad
after eggplant. . . .

(Erica Jong, "The Eggplant Epithalamion")

F

FIGURE

Any word or group of words that evokes an overtone of sensory impression beyond the literal or stated meaning of the words themselves, thus transforming them to a metaphorical level. Robert Frost once defined figure and figurative language as "saying one thing and meaning another."

Figures are sometimes referred to as "tropes" and include such poetic devices as METAPHOR, SIMILE, SYNECHDOCHE, METONYMY, and IRONY.

Many prosody books refer to figures and tropes as "ornaments" or "illustrative devices," although in fact when these techniques are properly used, they are not so much ornamental as organic, not so much illustrative as central to the theme or idea being developed in a poem. Indeed, figures and tropes can usually embody a thought or feeling more effectively than any literal prose rendering.

A simple example of a figure of speech, which is the combination of one image and one idea, would be Hamlet's reference to "a sea of troubles." Another example would be Longfellow's reference to a "ship of state."

When any simple figure of speech becomes extended over several lines of poetry, it becomes a CONCEIT.

The following examples show how figurative language can dominate the literal meaning of the words. In the opening of Shakespeare's *Richard III,* Gloucester explains that the past was unhappy but now everything is erotic and pleasing:

> Now is the winter of our discontent
> Made glorious summer by this sun of York;
> And all the clouds that lour'd upon our house
> In the deep bosom of the ocean buried.
> Now are our brows bound with victorious wreaths;
> Our bruised arms hung up for monuments;

FIGURE 74

> Our stern alarums changed to merry meetings;
> Our dreadful marches to delightful measures.
> Grim-visag'd war hath smooth'd his wrinkled front;
> And now,—instead of mounting barbed steeds,
> To fright the souls of fearful adversaries,—
> He capers nimbly in a lady's chamber
> To the lascivious pleasing of a lute . . .
>
> (William Shakespeare, *Richard III*, I.i, 1–13)

Gloucester then goes on to give a figurative description of his own physical reality, which is so misshapen and deformed that it frightens dogs on the street, and causes him to have a grotesque fascination with his own shadow:

> But I, that am not shap'd for sportive tricks,
> Nor made to court an amorous looking-glass;
> I, that am rudely stamp'd, and want love's majesty
> To strut before a wanton ambling nymph;
> I, that am curtail'd of this fair proportion,
> Cheated of feature by dissembling nature,
> Deform'd, unfinished, sent before my time
> Into this breathing world, scarce half made up,
> And that so lamely and unfashionable
> That dogs bark at me, as I halt by them;
> Why, I, in this weak piping time of peace,
> Have no delight to pass away the time,
> Unless to see my shadow in the sun
> And descant on mine own deformity . . .
>
> (I.i, 14–27)

In modern poetry, Hart Crane uses highly compressed figurative language to express intensity. In order to convey the feeling of fierce heat at midday on Wall Street, Crane telescopes several images into a single line: a rip-tooth saw; an acetylene torch; the blazing sun in the sky overhead:

> Down Wall, from girder into street noon leaks,
> A rip-tooth of the sky's acetylene . . .
>
> (Hart Crane, "The Bridge")

And Christopher Fry creates a cascading figurative poetry that comes out of the "verbal intoxication" of his characters:

 Just see me
As I am, me like a perambulating
Vegetable, patched with inconsequential
Hair, looking out of two small jellies for the means
Of life, balanced on folding bones, my sex
No beauty but a blemish to be hidden
Behind judicious rags, driven and scorched
By boomerang rages and lunacies which never
Touch the accommodating artichoke
Or the seraphic strawberry beaming in its bed . . .
 (Christopher Fry, *The Lady's Not for Burning*)

A figure need not be elaborate or extended to be effective. W. S. Merwin
creates a brilliant quick figure of three words,

 Pilate the fly
 (W. S. Merwin,
 "For Now")

—in which one imagines a fly washing its hands endlessly, much as Pilate
washed his hands as Christ stood before him.

FOOT *See* METER.

FREE VERSE

Poetry of any line length and any PLACEMENT on the page, with no fixed
measure or METER.

 Of course there are those for whom the very idea of free verse is anathema
—from T. S. Eliot in his essay "Reflections on Vers Libre," where he says,
"No *vers* is *libre* for the man who wants to do a good job," to Robert Frost,
who once commented caustically, "I'd as soon write free verse as play tennis
with the net down."

 The lack of any imposed or *a priori* form in free verse does not neces-
sarily mean the poet has license to do anything he or she wants; on the
contrary, the poet must concern him- or herself even more attentively with
the organic requirements that grow out of the materials at hand. The Italian
poet Guido Cavalcanti described this difficult discipline of freedom in these
lines:

> Who well proceedeth, form not seeth,
> following his own emanation.
>
> (Guido Cavalcanti, from *Canzone*,
> tr. Ezra Pound)

This is to say that the poet, in a purely intuitive state, may not necessarily be aware of external requirements of form but can trust to creating his or her own order simply by following the impulse of his or her own genius in action. The American poet Robert Duncan commented that psychoanalysis enables the poet to do the same thing by trusting to the inner process of poetry: "After Freud, we discover that unwittingly we find our own form."

This being the case, a poet may be said to have an even greater responsibility to him- or herself when departing from metered lines and strict end-rhyme to embark on the uncharted terrain of free verse. The poet must now at all points stay attuned to the peculiar form and shape of his or her own impulse or breath line or process poetry, and will independently create line placements, STANZA breaks, and all the other external manifestations of form that previously had been given to poets.

Surely some of the greatest examples of free verse writing in our literature occur in the Psalms of the Old Testament—in a language that is unaccented and unmetered, having only breath units and clusters of images and ideas to tie them together. We can see how close to modern free verse these Psalms are if we take one of them and strip it of verse breaks and allow it to find its own placement on the page:

> O Lord our Lord,
> how excellent is thy name
> in all the earth!
>
> who hast set thy glory
> above the heavens.
>
> Out of the mouth
> of babes and sucklings
> hast thou ordained strength
> because of thine enemies,
> that thou mightest still
> the enemy and the avenger.
>
> When I consider thy heavens,
> the work of thy fingers,
> the moon and the stars,
> which thou hast ordained;

what is man,
that thou art mindful of him?
and the son of man,
that thou visitest him? . . .

(Psalm 8:1–9)

One could do the same with some of the prose sections of Shakespeare's plays. In the following speech, a young man wonders what will happen in the next day's battle, if his army's cause is not good.

WILLIAM: But if the cause be not good, the king himself hath a heavy reckoning to make; when all those legs and arms and heads, chopped off in a battle, shall join together at the latter day and cry all, 'We died at such a place;' some swearing, some crying for a surgeon, some upon their wives left poor behind them, some upon the debts they owe, some upon their children rawly left. I am afeard there are few die well that die in a battle; for how can they charitably dispose of any thing when blood is their argument? Now, if these men do not die well, it will be a black matter for the king that led them to it, whom to disobey were against all proportion of subjection.

(William Shakespeare, *Henry V*, IV.i)

We can experiment with rearranging these lines, and allowing them to find their own form on a page, creating new line breaks and space separations:

But if the cause be not good,
the king himself
hath a heavy reckoning to make;

when all those legs and arms and heads,
chopped off in a battle,
shall join together at the latter day
and cry all,

'We died at such a place;'

some swearing,
some crying for a surgeon,
some upon their wives left poor behind them,
some upon the debts they owe,
some upon their children rawly left.

I am afeard there are few die well
that die in a battle;
for how can they charitably
dispose of any thing
when blood is their argument?

Now, if these men do not die well,
it will be a black matter
for the king that led them to it,

whom to disobey
were against all proportion
of subjection.

As with most free verse, probably no two persons would agree as to either the scansion or the placement of the above lines. And yet by opening up the form and playing with line breaks and space separations, we have explored possibilities of form and arrangement that are not available to us in more traditional poetry.

Modern American poetry began with the free verse of Walt Whitman's *Leaves of Grass*, and these lines show the delight Whitman took in line breaks and clusters of phrasing that somehow found their own form:

I celebrate myself, and sing myself,
And what I assume you shall assume,
For every atom belonging to me as good belongs to you.

I loafe and invite my soul,
I lean and loafe at my ease observing a spear of summer grass.

My tongue, every atom of my blood, form'd from this soil, this air,
Born here of parents born here from parents the same, and their parents
 the same,
I, now thirty-seven years old in perfect health begin,
Hoping to cease not till death.

Creeds and schools in abeyance,
Retiring back a while sufficed at what they are, but never forgotten,
I harbor for good or bad, I permit to speak at every hazard,
Nature without check with original energy.

 (Walt Whitman, "Song of Myself")

Three pioneers in the early part of the twentieth century set out to free poetry of its traditional conventions of strict meter and end-rhyme and stan-

zaic units: Ezra Pound, T. S. Eliot, and William Carlos Williams. The follow-
ing lines illustrate Williams' use of free verse:

Say it! No ideas but in things. Mr.
Paterson has gone away
to rest and write. Inside the bus one sees
his thoughts sitting and standing. His
thoughts alight and scatter—

Who are these people (how complex
the mathematic) among whom I see myself
in the regularly ordered plateglass of
his thoughts, glimmering before shoes and bicycles?
They walk incommunicado, the
equation is beyond solution, yet
its sense is clear—that they may live
his thought is listed in the Telephone
Directory—

(William Carlos Williams, *Paterson*)

G

GENERIC TERMS

Collective names for species or types. Following are the most interesting and exotic examples of generic terms that refer to specific types of life:

a pace of asses
a sloth of bears
a swarm of bees
a dissimulation of birds
a peep of chickens
a murder of crows
a cowardice of curs
a dule of doves
a paddling of ducks
a herd of elephants
a gang of elk
a business of ferrets
a skulk of foxes
a husk of hares
a brood of hens
a siege of herons
a kundle of kittens

a leap of leopards
a pride of lions
a band of men
a labor of moles
a litter of pups
a nest of rabbits
a crash of rhinoceroses
a bevy of roebucks
a pod of seals
a flock of sheep
a hover of trout
a rafter of turkeys
a pitying of turtledoves
a bale of turtles
a gam of whales
a fall of woodcocks

GENRES

There are three principal genres or types of poetry: lyric, dramatic, and narrative.

Lyric poetry tends to involve one voice, one theme, one subject; dramatic poetry tends to involve two or more voices, themes, and actions; narrative poetry tends to be a linear description of persons, places, or events.

It is possible to mix the above genres: hence, a poem may be lyric-narrative or dramatic-narrative. Shakespeare mixes lyric songs with his dramatic poetry—for example, the following lyric poem does not advance the action of the play, but is a touching interlude:

> Blow, blow, thou winter wind,
> Thou art not so unkind
> As man's ingratitude;
> Thy tooth is not so keen
> Because thou art not seen,
> Although thy breath be rude.
> Heigh-ho! sing, heigh-ho! unto the green holly:
> Most friendship is feigning, most loving mere folly:
> Then heigh-ho, the holly!
> This life is most jolly . . .
>
> (William Shakespeare, *As You Like It,* II.vii)

The following lines are an example of dramatic poetry:

> To be, or not to be: that is the question:
> Whether 'tis nobler in the mind to suffer
> The slings and arrows of outrageous fortune,
> Or to take arms against a sea of troubles,
> And by opposing, end them? To die: to sleep;
> No more; and, by a sleep to say we end
> The heart-ache and the thousand natural shocks
> That flesh is heir to, 'tis a consummation
> Devoutly to be wish'd . . .
>
> (William Shakespeare, *Hamlet,* III.i)

The following lines are an example of narrative poetry:

> Often I think of the beautiful town
> That is seated by the sea;
> Often in thought go up and down
> The pleasant streets of that dear old town,
> And my youth comes back to me.
> And a verse of a Lapland song
> Is haunting my memory still:
> "A boy's will is the wind's will,
> And the thoughts of youth are long, long thoughts."
>
> (Henry Wadsworth Longfellow, "My Lost Youth")

The following lines are an example of dramatic-narrative poetry:

> It is an ancient Mariner
> And he stoppeth one of three.
> 'By thy long grey beard and glittering eye,
> Now wherefore stopp'st thou me?
>
> The Bridegroom's doors are opened wide,
> And I am next of kin;
> The guests are met, the feast is set:
> Mayst hear the merry din.'
>
> He holds him with his skinny hand,
> 'There was a ship,' quoth he.
> 'Hold off! unhand me, grey-beard loon!'
> Eftsoons his hand dropt he . . .

> (Samuel Taylor Coleridge,
> "The Rime of the Ancient Mariner")

See also DRAMATIC-NARRATIVE POETRY; DRAMATIC POETRY; LYRIC.

GEORGIC

Any didactic poem that instructs or teaches a skill in some art or science. Hesiod's "Works and Days" (750 B.C.) was an early example of a georgic, and the following lines from Virgil's first and third Georgics show the Latin poet's concern with imparting information on farming, cattle-raising, and bee-keeping:

> What pleases the corn, and under which star,
> Maecenas, you should plough the field
> Or set out the vine; how to raise the steer
> And how to care for cattle; and what rules
> You should use to oversee the bees;—
> These are my themes . . .
>
> As for the honey, that blessed sweetness, I will
> Now tell the tale . . .
>
> First place your bees in a secure lodge
> Where there are neither winds (for winds blow

The bees returning home with nectar)
Nor sheep, no feisty kids that kick the flowers,
Nor calves that sprint across the plain,
Spilling the fresh dew and flattening the grass.
Let the licking lizard with his scaly sides
Stay far away also from the honey place,
And whatever eats bees, and the birds as well . . .

> (Virgil, *Georgics*, from the first and third Georgic,
> tr. William Packard)

GNOMIC POETRY *See* EPIGRAM.

GRAMMAR

There are enough irregularities in English grammar to provide any poet with
ample opportunity to experiment and improvise with variants of expression.
However, before venturing on such alternate modes of saying something,
the poet would do well to master the basic elements of traditional grammar.

Toward this end, the following summary of English grammar is offered
as a reference point for most of the important elements that one comes across
in trying to achieve a correct usage of the English language:

*8 PARTS
OF SPEECH:*
noun
pronoun
adjective
verb
adverb
preposition
conjunction
interjection

7 PRONOUNS:
personal (me)
possessive (my)
reflexive (myself)
demonstrative (this)
indefinite (some)
relative (that)
interrogative (what)

VERB FORMS:
infinitive
participle
gerund

transitive / intransitive
active / passive
indicative / subjunctive

*State of being verbs take predicate
nominative and predicate adjective:
be/become/feel/taste/see/seem/etc.*

VERB TENSES:
past—past perfect
present—present perfect
future—future perfect

3 ADJECTIVES: *5 ADVERBS:*
regular (good) time (then)
comparative (better) place (there)
superlative (best) manner (well)
 degree (very well)
 cause (because)

IRREGULAR VERBS:

lie/lay/lying/lain lay/laid/laying/laid
rise/rose/rising/risen raise/raised/raising/raised
sit/sat/sitting/sat set/set/setting/set

A phrase does *not* contain a complete subject and predicate (it's always subordinate).
A clause *does* contain a complete subject and predicate (it may be either independent
 or subordinate).

4 TYPES OF SENTENCE:

declarative From you have I been absent in the spring.
interrogative Shall I compare thee to a summer's day?
imperative Sweet love, renew thy force.
exclamatory O she doth teach the torches to burn bright!

4 KINDS OF SENTENCE:

simple My mind's not right.
compound It is the east and Juliet is the sun.
complex There never was a war that was not inward.
compound-complex Come Lesbia, let us live and love, nor give a damn what
 sour old men say.

A simple sentence has one complete independent clause.
A compound sentence has two complete independent clauses.
A complex sentence has one complete independent and one or more subordinate
 clauses.
A compound-complex sentence has two complete independent clauses and one or
 more subordinate clauses.

See also SENTENCES.

HAIKU

Japanese short-form poem, sometimes called *hokku,* with origins as far back as the thirteenth century. Haiku are written syllabically with seventeen separate syllables arranged in three STANZAS according to a 5/7/5 count. The longer tanka poem, from which the haiku derives, has thirty-one separate syllables arranged in five stanzas with a 5/7/5/7/7 count.

Every traditional haiku uses a *kigo,* or season word, to specify whether the poem is of winter, spring, summer, or autumn mood. Traditional haiku will also be characterized by *rensō,* or loose association of disparate images, and contain an elliptical leap from the second to the third line which simulates sudden zen *satori* or enlightenment, illumination of the true nature of reality.

Haiku are noteworthy for their use of plain-style, everyday language, according to the teaching of the classical master Bashō (1644–1694), who advocated the principle of *hosomi,* or slenderness, the use of terse expression and understatement. Bashō taught the most rigorous objectivity and strict observation:

> One can learn about pine only from the pine, about bamboo only from the bamboo. When one sees an object, one must leave one's subjective concerns with oneself, or one will impose oneself onto the object and not learn anything. Oneself and object must become a single thing, and from that singleness the poetry issues. No matter how eloquent, if the feeling is not absolutely natural—if the object and oneself are still kept separate—then the poetry is not true poetry but just one's own perception.

Bashō is credited with writing the archetypal masterpiece haiku, which roughly translated reads as follows:

> old pond
> frog jumps in
> splosh

The poem embodies a simple event so starkly that the reader enters into the nature of the universe. Another poem by Bashō embodies the paradox of time and space:

> in Kyō I am
> but I still long for Kyō
> oh bird of time!

Onitsura describes the rapture of realization that comes from the sudden apprehension of things as they are:

> cherry blossoms, more
> and more now! birds have two legs!
> oh horses have four!

Buson shows the enlightenment that can come from the perception of the simplest things:

> temple bell
> on it sits and sleeps
> a butterfly

The haiku poet Issa wrote a book of *haibun*, which combines prose and haiku, entitled *Oraga Haru* or *The Year of My Life*. The book is an exquisitely beautiful journal of all the important things that happened to Issa during the year 1819, including his observations on the irony of things:

> oh snail
> climb Mount Fuji
> but slowly, slowly

The book includes Issa's greatest haiku, on the death of his young daughter:

> this dewdrop world
> is a dewdrop world
> and yet, and yet

HEROIC COUPLET *See* COUPLET.

HYPERBOLE

Extravagant or excessive exaggeration, which inflates or reinforces a point of view in poetry. Hyperbolic writing can be effective in flashes to show extreme states of mind or feeling, but if hyperbole is sustained for too long, it tends to fall into rhetorical bombast.

Othello uses hyperbole to describe his anguish at the thought of his wife's infidelity:

> I had been happy, if the general camp,
> Pioners and all, had tasted her sweet body,
> So I had nothing known.
>
> (William Shakespeare, *Othello*, III.iii)

Lady Macbeth uses hyperbole to describe the impossibility of ever ridding herself of the blood on her hand:

> Here's the smell of the blood still: all the
> perfumes of Arabia will not sweeten this little hand.
>
> (William Shakespeare, *Macbeth*, V.iii)

Hamlet uses hyperbole to describe how radically different his uncle is from his father:

> My father's brother, but no more like my father
> Than I to Hercules . . .
>
> (William Shakespeare, *Hamlet*, I.ii)

In the modern period, Walt Whitman made consistent and effective use of hyperbole as an organic part of his "barbaric yawp." Occasionally, as in the following passages, the hyperbole seems to create a special bond between poet and reader, as if Whitman's exaggerated promises were a part of some primal trust:

> 2.
> Have you reckon'd a thousand acres much? have you reckon'd the earth
> much?
> Have you practis'd so long to learn to read?
> Have you felt so proud to get at the meaning of poems?

Stop this day and night with me and you shall possess the origin of all
 poems,
You shall possess the good of the earth and sun, (there are millions of
 suns left,)
You shall no longer take things at second or third hand, nor look
 through the eyes of the dead, nor feed on the spectres in books,
You shall not look through my eyes either, nor take things from me,
You shall listen to all sides and filter them from your self.

25.

Dazzling and tremendous how quick the sun-rise would kill me,
If I could not now and always send sun-rise out of me.

44.

It is time to explain myself—let us stand up.

What is known I strip away,
I launch all men and women forward with me into the Unknown.

The clock indicates the moment—but what does eternity indicate?

We have thus far exhausted trillions of winters and summers,
There are trillions ahead, and trillions ahead of them.

 (Walt Whitman, sections from "Song of Myself")

I

IAMBIC PENTAMETER *See* METER.

IDYL

Any pastoral poem, rustic and bucolic, such as an ECLOGUE. From the Greek, meaning "little picture," an idyl is usually a short poem showing the joys of rural nature.

Idyls customarily praise the simplicity of the shepherd's life, the honesty of toil, and staying close to the four elements of air, earth, fire, and water, and the four seasons of the year. The idyl probably began in early Greece as an expression of the growing difference between town and country, city and nature; the idyl shows the ambivalence toward any civilization that takes its citizens away from the roots of the rural countryside. Thus the idyl contains a naive nostalgia for simple country life, and it tends to idealize the virtues of the peasant and the common people who live far away from the hectic pace of city life.

Probably the earliest example of the idyl is the work of Theocritus, who praised the rustic life of Sicily, and whom Virgil imitated in his own idyls. We can also feel the purest idyl impulse in the 23rd Psalm with its simple shepherd imagery:

> The Lord is my shepherd; I shall not want.
>
> He maketh me to lie down in green pastures: he leadeth me beside the still waters.
>
> He restoreth my soul: he leadeth me in the paths of righteousness for his name's sake.
>
> Yea, though I walk through the valley of the shadow of death, I will fear no evil; for thou art with me; thy rod and thy staff they comfort me.

Thou preparest a table before me in the presence of mine enemies:
thou anointest my head with oil; my cup runneth over.

Surely goodness and mercy shall follow me all the days of my life:
and I will dwell in the house of the Lord for ever.

(Psalm 23:1–6)

Spenser describes the shepherd's abandonment of his native pastoral
scene for the vanities of court life, his disillusionment there, and his ultimate
return to the joys of rural living:

'The time was once, in my first prime of years,
 When pride of youth forth pricked my desire,
That I disdained amongst mine equal peers
 To follow sheep, and shepherds' base attire:
 For further fortune then I would inquire.
And leaving home, to royal court I sought;
 Where I did sell myself for yearly hire,
And in the Prince's garden daily wrought:
There I beheld such vainness, as I never thought.

With sight whereof soon cloyed, and long deluded
 With idle hopes, which them do entertain,
After I had ten years myself excluded
 From native home, and spent my youth in vain,
 I 'gan my follies to myself to plain,
And this sweet peace, whose lack did then appear,
 Tho back returning to my sheep again
I from thenceforth have learned to love more dear
This lovely quiet life, which I inherit here.'

(Edmund Spenser, *The Faerie Queene*)

The lyric songs in *As You Like It* that extol the simple virtues of country
life probably come closest to the Renaissance expression of the idyl in litera-
ture:

Under the greenwood tree
Who loves to lie with me,
And turns his merry note
Unto the sweet bird's throat.

Come hither, come hither, come hither:
Here shall he see
No enemy
But winter and rough weather . . .
(William Shakespeare, *As You Like It,* II.v)

One feels the wistful charms of rustic living in Gray's "Elegy":

The curfew tolls the knell of parting day,
The lowing herd wind slowly o'er the lea,
The plowman homeward plods his weary way,
And leaves the world to darkness and to me.

Now fades the glimmering landscape on the sight,
And all the air a solemn stillness holds,
Save where the beetle wheels his droning flight,
And drowsy tinklings lull the distant folds;

Save that from yonder ivy-mantled tow'r
The moping owl does to the moon complain
Of such, as wand'ring near her secret bow'r,
Molest her ancient solitary reign.

Beneath those rugged elms, that yew-tree's shade,
Where heaves the turf in many a mould'ring heap,
Each in his narrow cell for ever laid,
The rude Forefathers of the hamlet sleep . . .

(Thomas Gray,
"Elegy Written in a Country Churchyard")

The spirit of a pastoral idyl can also be felt in these lines by Oliver Goldsmith:

The sheltered cot, the cultivated farm,
The never-failing brook, the busy mill,
The decent church that topt the neighbouring hill,
The hawthorn bush, with seats beneath the shade . . .
(Oliver Goldsmith, "The Deserted Village")

In modern poetry one can feel the estrangement from nature and a separation from elemental laws, with a strong nostalgia and longing for a lost simplicity. But modern poets are too conscious of the ineradicable cleavage

between man and nature to pretend that it can ever be restored by simple wish or will or whim. Following T. S. Eliot's epic indictment of Western civilization in *The Waste Land*, which depicts men and women in a state of irreversible and hopeless forlornness, modern poets have begun to demonstrate through their work that it is no longer possible to return to a simple harmony with nature. Robert Frost may have been the last poet of the idyl in our time, although even his poems, such as "Birches," "Mending Wall," and "The Death of the Hired Man," reveal an irony and melancholy that are not present in earlier pastoral poetry. Contemporary poets such as Philip Larkin in "Church Going," William Stafford in "Traveling through the Dark," Galway Kinnell in "The Bear," and Robert Lowell in "Beyond the Alps" all attest to the major separation that has taken place between technological civilization and rustic living with its naive pieties. One begins to realize that the fantasy of living out the rest of one's life in a modest cottage by the side of an old dirt road is precisely that: nothing but a fantasy, more and more archaic as the twentieth century continues to evolve its cybernetics and computer sciences and space-age hardware.

IDYLL

A narrative poem dealing with EPIC or Romantic themes. Idylls have their beginning in the early fables; for example, the legends of King Arthur and his Knights of the Round Table are idylls. In the twelfth century Geoffrey of Monmouth in his *History of the Kings of Britain* treated Arthur historically, but by the fifteenth century Thomas Malory in his *Le Mort D'Arthur* presented an Arthur who is clearly a fabulous figure, the embodiment of the codes of chivalry.

In 1859 Alfred, Lord Tennyson issued his *Idylls of the King*, a retelling of these early fables—the Holy Grail, Camelot, the Round Table, Lancelot, Guinevere, and the Morte d'Arthur. Tennyson's version was so popular that it sold over ten thousand copies in its first week of publication. Tennyson claimed he had "infused into the legends a spirit of modern thought and an ethical significance," as this passage from Arthur's farewell to Guinevere, in which the King summarizes the importance of his life and work, clearly shows:

> . . . I was first of all the kings who drew
> The knighthood-errant of this realm and all
> The realms together under me, their Head,
> In that fair Order of my Table Round,
> A glorious company, the flower of men,

To serve as model for the mighty world,
And be the fair beginning of a time . . .

(Alfred, Lord Tennyson, *Idylls of the King*)

IMAGE

A simple picture, a mental representation. In addition to being seen, an image can also be felt or heard or smelled or tasted or touched or otherwise sensually represented. Perhaps the most serviceable definition of "image" is Ezra Pound's statement, "An image is that which presents an intellectual and emotional complex in an instant of time."

Imagery is the heart and soul of poetry. Through specific images, a poem unlocks the resources of sound and texture and RHYTHM which lie dormant through the use of abstraction and generality. Images open the door to emotion and the very deepest psychological realities.

We can test the primacy of image in our own lives when we realize that our own unconscious is continuously presenting images to us in our dreams. When we become clear about any idea we say, "I get the picture"—as if this clarification came in the form of an image. And historically, we know the power of the very early attempts at human communication in the form of primitive images: at Altamira in northern Spain, during the Magdalenian culture some 16,000 years B.C., where the cave walls and ceilings are covered with stark images of horses and deer and mammoths.

Images are the most crucial elements in our earliest literature. The Book of Job, which higher Bible criticism tells us is probably the oldest book of the Old Testament, is filled with breathtakingly reckless imagery. The following passage from Job, where God describes the wonderful performance of the horse, is a good example:

> Hast thou given the horse strength? hast thou clothed his neck with thunder?
>
> Canst thou make him afraid as a grasshopper? the glory of his nostrils is terrible.
>
> He paweth in the valley, and rejoiceth in his strength: he goeth on to meet the armed men:
>
> He mocketh at fear, and is not affrighted: neither turneth he back from the sword.

The quiver rattleth against him, the glittering spear and the shield.

He swalloweth the ground with fierceness and rage: neither
believeth he that it is the sound of the trumpet.

He saith among the trumpets, Ha, ha: and he smelleth the battle afar
off, the thunder of the captains, and the shouting.

(Job 39:19–25)

One can get some sense of how powerfully images affect the human
imagination from the following lines. Here the poet is lying in bed, unable
to sleep, when the image of his beloved suddenly comes to him and trans-
forms the entire night:

Save that my soul's imaginary sight
Presents thy shadow to my sightless view,
Which, like a jewel hung in ghastly night,
Makes black night beauteous and her old face new.

(William Shakespeare, Sonnet 27)

In Sonnet 73, Shakespeare presents the image of an autumn tree that is
covered with yellow leaves, then he takes all the leaves away, then he replaces
a few to create a truly wistful figure:

That time of year thou mayst in me behold
When yellow leaves, or none, or few, do hang
Upon those boughs which shake against the cold,
Bare ruin'd choirs, where late the sweet birds sang.

(William Shakespeare, Sonnet 73)

In *Hamlet,* Gertrude describes the death of Ophelia in a series of images
relating to flowers and mermaids:

There is a willow grows aslant a brook,
That shows his hoar leaves in the glassy stream;
There with fantastic garlands did she come,
Of crow-flowers, nettles, daisies, and long purples,
That liberal shepherds give a grosser name
But our cold maids do dead men's fingers call them:
There, on the pendent boughs her coronet weeds
Clambering to hang, an envious sliver broke,
When down her weedy trophies and herself

Fell in the weeping brook. Her clothes spread wide,
And, mermaid-like, awhile they bore her up;
Which time she chanted snatches of old tunes,
As one incapable of her own distress,
Or like a creature native and indu'd
Unto that element; but long it could not be
Till that her garments, heavy with their drink,
Pull'd the poor wretch from her melodious lay
To muddy death.

(William Shakespeare, *Hamlet*, IV.vii)

In *Othello*, the Moor describes the adventures of his earlier life in bizarre
and exotic images:

Wherein of antres vast and desarts idle,
Rough quarries, rocks and hills whose heads touch heaven,
It was my hint to speak, such was the process;
And of the Cannibals that each other eat,
The anthropophagi, and men whose heads
Do grow beneath their shoulders . . .

(William Shakespeare, *Othello*, I.iii)

Othello's adversary, Iago, begins his treacherous work by using a gro-
tesque image for the lethal jealousy he is about to unleash:

O! beware, my lord of jealousy;
It is the green-ey'd monster which doth mock
The meat it feeds on; that cuckold lives in bliss
Who, certain of his fate, loves not his wronger . . .

(William Shakespeare, *Othello*, III.iii)

Macbeth is filled with negative images, images of things that are not really
present but which affect the imagination of the characters even more pow-
erfully than the things themselves. Thus Macbeth thinks he sees the ghost of
Banquo at the feast; Lady Macbeth thinks she sees blood on her hands during
the sleep-walking scene; and earlier in the play, Macbeth believes he sees a
dagger in mid-air:

Is this a dagger which I see before me,
The handle toward my hand? Come, let me clutch thee;

I have thee not, and yet I see thee still.
Art thou not, fatal vision, sensible
To feeling as to sight? or art thou but
A dagger of the mind, a false creation,
Proceeding from the heat-oppressed brain?
I see thee yet, in form as palpable
As this which now I draw.
Thou marshall'st me the way that I was going;
And such an instrument I was to use.
Mine eyes are made the fools o' the other senses,
Or else worth all the rest: I see thee still;
And on thy blade and dudgeon gouts of blood,
Which was not so before . . .

(William Shakespeare, *Macbeth*, II.i)

In *King Lear*, the poet creates an image of all the pitiful creatures caught in a cruel storm:

Poor naked wretches, wheresoe'er you are,
That bide the pelting of this pitiless storm,
How shall your houseless heads and unfed sides,
Your loop'd and window'd raggedness, defend you
From seasons such as these?

(William Shakespeare, *King Lear*, III.iv)

Images can be used to establish mood and atmosphere; thus Tennyson in two lines creates a tone of bleakness:

And ghastly thro' the drizzling rain
On the bald street breaks the blank day.

(Alfred, Lord Tennyson, "In Memoriam")

In Coleridge's "Kubla Khan," the poet suddenly interjects the image of the head of the poet as he is describing the image of the pleasure dome:

I would build that dome in air,
That sunny dome! those caves of ice!
And all who heard should see them there,
And all should cry, Beware! Beware!
His flashing eyes, his floating hair!

> Weave a circle round him thrice,
> And close your eyes with holy dread,
> For he on honey-dew hath fed,
> And drunk the milk of Paradise.
>
> (Samuel Taylor Coleridge, "Kubla Khan")

William Butler Yeats creates a terrifying image by withholding specific details of the image:

> Surely some revelation is at hand;
> Surely the Second Coming is at hand.
> The Second Coming! Hardly are those words out
> When a vast image out of *Spiritus Mundi*
> Troubles my sight: somewhere in sands of the desert
> A shape with lion body and the head of a man,
> A gaze blank and pitiless as the sun,
> Is moving its slow thighs, while all about it
> Reel shadows of the indignant desert birds . . .
>
> (William Butler Yeats, "The Second Coming")

In a single line, Hart Crane creates a powerful figurative image out of a seemingly insignificant detail:

> A burnt match skating in a urinal—
>
> (Hart Crane, "The Bridge")

In the early part of the twentieth century, the Surrealist movement (see SURREALISM) had a field day with random and unexpected imagery. In *What Is Surrealism?*, Franklin Rosemont, quoting Charles Fort, observes,

> "If there is an underlying oneness of all things, it does not matter where we begin, whether with stars, or laws of supply and demand, or frogs, or Napoleon Bonaparte"—or, to be sure, with opossums signalling to us, perhaps desperately, from doorways downtown.

Allen Ginsberg extended this idea to create the concept of "images juxtaposed" in "Howl," where he conjoined widely disparate figure systems to form single, instantaneous images such as "hydrogen jukebox." Other contemporary poets have similarly seen the image as the gateway to a new kind

of perceptual poetry which can communicate subliminal effects. Thus James
Dickey uses a negative image to intensify an emotional state of awareness:

> Beneath me is nothing but brightness
> Like the ghost of a snowfield in summer.
>
> (James Dickey, "The Lifeguard")

IMAGISM

The intensive use of representational or picture words in poetry.

Ezra Pound first used the term Imagism, in *Ripostes,* where he used this
example:

> The apparition of these faces in the crowd;
> Petals on a wet, black bough.
>
> (Ezra Pound, "In a Station of the Metro")

At its most concentrated level, Imagism simply presents an image and
allows the image to carry the entire poem, as in Chinese and Japanese poetry.
The Imagist poet refrains from drawing any implications or making any
general statements about the meaning of the image; he or she permits the
specific image to do the work of any abstract generality.

As early as 1857, Charles Baudelaire in *Les Fleurs du Mal* was practicing
the principles of Imagism, and it is noteworthy that Baudelaire paid tribute
to the American poet Edgar Allan Poe, whose poem "To Helen" is an
excellent example of Imagism. Other French poets such as Arthur Rimbaud,
Paul Verlaine, and Stéphane Mallarmé were developing a poetry which
would later be called Symbolist (see SYMBOLISM), which strongly influenced
poets such as Rainer Maria Rilke, Wallace Stevens, William Butler Yeats,
William Carlos Williams, and Marianne Moore. In 1914, Ezra Pound edited
Des Imagistes: An Anthology, which included the work of poets who were
loosely associated with the movements in England and America, including
Amy Lowell, F. S. Flint, and H.D.

The following couplet by Archibald MacLeish summarizes the whole
teaching and practice of Imagism:

> For all the history of grief
> An empty doorway and a maple leaf.
>
> (Archibald MacLeish, "Ars Poetica")

INVOCATION

The formal petitioning to a Muse or Deity for assistance in the writing of
one's poem, particularly an epic poem, and usually at the very beginning of
a work. Thus Homer begins the *Iliad* with an invocation:

> Sing, goddess, of the anger of Achilles
> and its aftermath which sent Achaians
> by the hundreds hurtling headlong down
> to Hades, but left their bodies in the fields
> to be devoured by dogs and birds, and the will of Zeus
> was accomplished.
>
> (Homer, *The Iliad,* tr. William Packard)

Lucretius begins his long philosophical poem *De Rerum Natura* with an
invocation:

> Venus, out of your great creative nature, you
> who guide good strong ships that sail on the deep sea, who
> overlook the sweet fields of corn, who make each thing
> rise up and see the bright light of day, you who sing
> how clouds accumulate across the high wide sky,
> how flowers display their separate petals, try
> to lend some of your lovely charms to this poor song
> that strives to tell the nature of things, right or wrong.
>
> (Lucretius, *De Rerum Natura,* tr. William Packard)

Ovid begins his *Metamorphoses* with an invocation to all the gods:

> Now shall I tell of things that change, new being
> Out of old; since you, O Gods, created
> Mutable arts and gifts, give me the voice
> To tell the shifting story of the world
> From its beginning to the present hour.
>
> (Ovid, *Metamorphoses,* tr. Horace Gregory)

At the beginning of the *Paradiso,* the third part of Dante's *Commedia,*
which sets forth Scholastic Catholic doctrine, the poet begins, oddly enough,
with an invocation to the pagan god Apollo:

> For the last labour, good Apollo, I pray
> Make me so apt a vessel of thy power
> As is required for gift of thy loved bay.
>
> (Dante Alighieri, *Commedia*)

An example of multiple invocation occurs in the Proem to the Fourth Book of *Troilus and Criseyde,* in which Chaucer calls on the three Furies and the god Mars to aid him in the writing of his poem:

> O ye Herines, Nightes doughtren three,
> That endelees compleynen ever in pyne,
> Megera, Alete, and eek Thesiphone;
> Thou cruel Mars eek, fader to Quiryne,
> This ilke ferthe book me helpeth fyne,
> So that the los of lyf and love y-fere
> Of Troilus be fully shewed here.
>
> (Geoffrey Chaucer, *Troilus and Criseyde*)

In the opening lines of *Henry V,* Shakespeare makes a mock invocation:

> O! for a Muse of fire, that would ascend
> The brightest heaven of invention;
> A kingdom for a stage, princes to act
> And monarchs to behold the swelling scene.
> Then should the war-like Harry, like Himself,
> Assume the port of Mars; and at his heels,
> Leash'd in like hounds, should famine, sword and fire
> Crouch for employment. But pardon, gentles all,
> The flat unraised spirits that have dared
> On this unworthy scaffold to bring forth
> So great an object: can this cockpit hold
> The vasty fields of France? or may we cram
> Within this wooden O the very casques
> That did affright the air at Agincourt? . . .
>
> (William Shakespeare, *Henry V,* Prologue)

IRONY

A statement or a point of view that is usually the opposite of what is expected. Irony is one of the major tropes or FIGURES that can be used in

VOICE, and at its extreme, irony may express itself in outright sarcasm or cynicism.

One of the most powerful examples of irony in all literature is Clytemnestra's welcoming speech to her husband, Agememnon, upon his return from the Trojan War in Aeschylus' *Agamemnon*. Unknown to her husband, Clytemnestra has spent the past ten years plotting his murder. But there is no hint of hatred or homicide in her welcoming speech; instead, she greets Agamemnon with the voice of a loving wife who has longed for her husband to return. The audience that knows what Clytemnestra plans receives these lines as the height of irony:

Old men of Argos, lords of our land,
shame will not make me shrink from showing
the love I bear my lord. Such a shyness
dies last in hearts that feel human feelings.
My own soul will show what I know
and what kind of life I have lived
unwillingly during these past ten years,
while my lord was waging war with Ilium.

(Aeschylus, *Agememnon*, tr. William Packard)

The American poet Kenneth Patchen uses irony in the following poem, where he seems to accept everything he is told to do:

IN ORDER TO

Apply for the position (I've forgotten now for what) I had to marry the Second Mayor's daughter by twelve noon. The order arrived at three minutes of.

I already had a wife; the Second Mayor was childless: but I did it.

Next they told me to shave off my father's beard. All right. No matter that he'd been a eunuch, and had succumbed in early childhood: I did it, I shaved him.

Next they told me to burn a village; next, a fair-sized town; then, a city; a bigger city; a small, down-at-heels country; then one of "the great powers;" then another (another, another)—In fact, they went right on until they'd told me to burn up every man-made thing on the face of the earth! And I did it, I burned away every last trace, I left nothing, nothing of any kind whatever.

Then they told me to blow it all to hell and gone! And I blew it all to hell and gone (oh, didn't I) . . .

Now, they said, put it back together again; put it all back the way it was when you started.

Well . . . it was my turn then to tell *them* something! Shucks, I didn't want any job that bad.

<div align="right">(Kenneth Patchen, "In Order To")</div>

J

JONGLEUR

Roughly from the fifth to the fifteenth centuries, throughout France and Tuscany and northern Italy, Jongleurs were entertainers (acrobats, actors, musicians, singers) who originally wandered from town to town offering their arts for a fee. Later, these Jongleurs became official fixtures of the various European courts as jesters, clowns, and reciters of poetry.

At first the Jongleur did not create his own poems but drew from a repertory of *ballata* and *canti* and *chansons de geste,* but by the twelfth century the minstrels or trouvères or Troubadours of Provençal and Tuscany were writing their own poems to be sung.

Southeastern France used a *langue d'oc* dialect called Provençal, and Troubadour poetry began with William IX, Guillaume de Poitou, Duke of Aquitane, lord of an immense realm, who "believed all things were moved by chance, and not ruled by Providence"; William's adventurous "leis de con" were an erotic substitute for theological order and Providence, and set the tone for later courtly love. William's granddaughter, Eleanor of Aquitane, began to gather poets at Toulouse, among them Berand de Ventadour and, later, Bertrans de Born.

We know the names of about 446 Troubadours—the Benedikbeuern monastery in Upper Bavaria preserved the manuscript of the *Carmina Burana* or Beuern Poems, which is the main source for our catalogue of Troubadour poems. The major corpus of Troubadour work includes poems by Richard the Lion-Hearted; Marcabrun; Sordello; Hugh Primus of Orleans; Guido Guinicelli, an immediate predecessor of Dante; Arnaut Daniel, to whom Dante has Guinicelli pay tribute as "il miglior fabbro"; Guido Cavalcanti; Dante himself in *La Vita Nuova;* and Francesco Petrarch in his *canzoniere,* or songbook, which consists of some 366 sonnets to Laura (one of which, number CII, Chaucer translates as his "Cantus Troili").

The Italian poets came to be known for their practice of *dolce stil nuova*, "the sweet new style," which Dante defines in Canto 26 of the *Purgatorio* as "sweet and delicate rimes of love." And in point of fact the entire Troubadour movement gave rise to many new, complex verse forms such as the sestina (invented by Arnaut Daniel), the canzone (brought to perfection by Cavalcanti and Dante), and the sonnet form (probably invented by Guinicelli and brought to perfection by Dante and Petrarch and later Shakespeare).

Almost all of these Troubadour and Jongleur poems were originally written to be sung—*motz el son;* words as song—which was the chanson tradition. As one Troubadour, Folquet, put it: "A poem without music is a mill without water." We have records of about 2,600 surviving songs, *cantigas* or *cantos* or *canticles,* all of them originally set to music of some sort and played on instruments including bells, drums, guitars, lyres, trumpets, harps, pipes, lutes, horns, and organs. In addition, returning Crusaders began to bring musical songs back from the East to enhance the Troubadour tradition.

The Troubadour poet (from *trobar,* to invent; also from *trouvère,* to find) usually sang of courtly love—the ethereal, extramarital praise of any Lady who inspired the poet to virtue and to moral excellence and achievement. Sometimes the Troubadour's songs followed specific conventions, as the following list indicates:

canzo—song of love

balada—story in verse

plante—elegy, or dirge for a lost lover

serenade—evening song

alba—dawn song, when lovers realize day has come and they must part

Still later, in Shakespeare's *Romeo and Juliet,* the *alba* is beautifully realized in an exchange between the two lovers, who have spent their only night together and must now separate from each other forever—and they try desperately to deceive themselves that it is not really the true dawn:

> JULIET: Wilt thou be gone? it is not yet near day:
> It was the nightingale, and not the lark,
> That pierced the fearful hollow of thine ear;
> Nightly she sings on yon pomegranate-tree:
> Believe me, love, it was the nightingale.
>
> ROMEO: It was the lark, the herald of the morn,
> No nightingale: look, love, what envious streaks

Do lace the severing clouds in yonder east:
Night's candles are burnt out, and jocund day
Stands tiptoe on the misty mountain tops.
I must be gone and live, or stay and die.

(William Shakespeare, *Romeo and Juliet,* III.v)

In France the *chansons de geste* were epic poems to be sung which related the heroism and chivalry of Charlemagne and other feudal lords, thus anticipating the exploits of the later Crusaders. The *Chanson de Roland,* an epic poem of 4,002 verses, was composed between 1050 and 1100 in France and tells how Charlemagne's rear guard was overwhelmed in the Valley of Roncevaux in A.D. 778 by the Saracens, who were aided by the traitor Ganelon. The poem celebrates Roland's proud refusal to blow his horn, the olifan, and his vain attempt to break his sword, Durendal, before he is killed. Another *chanson de geste,* Chrétien de Troye's *Le Chevalier de la Carrette,* the first stories of the Knights of the Round Table, celebrated the courtly love of Lancelot for Guinevere. In 1180, Chrétien wrote *Perceval* or *Le Conte du Graal* which changed the goal of chivalry from courtly love for the Lady to Knight-Errantry in quest of the Holy Grail.

The *fablaux* or *romans* of this period were fables that were woven around tales of courtly love: thus the *Roman de la Rose* of Guillaume de Lorris in 1225–1237 was an allegory and satire of wooing, and *Aucassin et Nicolette* was a *roman* that rose to heights of lyric beauty:

Lily-flower, so white, so sweet,
Fair the faring of thy feet,
Fair thy laughter, fair thy speech,
Fair our playing each with each,
Sweet thy kisses, soft thy touch,
All must love thee overmuch . . .

The *Roman de Renart* consisted of some thirty tales of Reynard the Fox, satires on lords, courts, and church forms, running to a total of some 24,000 lines; Chaucer would later adapt one of these tales for his "Nun's Priest's Tale" in *The Canterbury Tales.*

In Germany the Jongleur tradition began with the first Minnesängers, or "lover-singers," some three hundred of whom have come down to us by name. Some of these early Jongleurs were illiterate and had to dictate their songs to be written down by another; hence the modern German word for poetry, *dichtung,* or dictation. The first Minnelieder, "Ladies Strophes," dates

from 1152, and Kurenberg is the first recorded Minnesänger, in 1157. The Minnesänger Tannhäuser lived from 1205 to 1270, and the epic poem *Lohengrin* was written about 1285. At about this same time, the Nibelungen legends were taking shape; the *Nibelungenlied* was a thirteenth-century poem telling of Siegfried, son of Siegmund and Sieglind. In the poem, Siegfried woos Kriemhild, then helps Gunther woo Brunhild, queen of Issland; Siegfried is eventually killed by the bitter Hagen.

In England, the Jongleur and Troubadour traditions eventually provided Shakespeare with materials for both his sonnets and songs and dramatic characters; for example, aspects of the Jongleur/Troubadour types can be seen in both Mercutio and Romeo in *Romeo and Juliet*.

K

KENNING

From old German, a SIMILE device used as an adjective; hence any repeated word or phrase that accompanies or takes the place of that which is being described.

An epithet is a simple name applied to someone; a kenning is an adjectival phrase that becomes a standard feature of references to a person, place, or thing, and is thus used repeatedly. In Greek epics, someone is "ox-eyed" or "wily-minded" and the epithet sticks and becomes synonymous with the person. So in the *Iliad* and the *Odyssey* there are kenning phrases: Agamemnon is "son of Atreus," "lord of the great plain," "lord of men," and so on.

Throughout world literature kenning phrases are common: thus Oedipus is "club foot," Hamlet is "melancholy Dane," Cassius is "lean and hungry." One can see the use of kenning phrases in the field of sports, where certain simile phrases become identified with particular athletes: Jim Thorpe, "the Fabulous Indian"; Jack Dempsey, "the Manassa Mauler"; Lou Gehrig, "the Iron Horse"; Babe Ruth, "the Bambino" and "the Sultan of Swat"; and so on.

L

LIMERICK

Usually anonymous five-line light verse poem, generally with surprise or eccentric RHYMES, with first and second and fifth lines in anapestic trimeter, and with a rhyme scheme of a/a/b/b/a. Limericks often play on geographical or ethnic proper names, and commonly treat an outrageous subject irreverently.

Critical comment on the limerick tends to stress its anti-literary pedigree; thus Arnold Bennett said, "All I have to say about Limericks is that the best ones are entirely unprintable." George Bernard Shaw commented, "They are most unfit for publication. They must be left for oral tradition." Film director Mike Nichols, commenting on a limerick contest he was once asked to judge, said, "It was easy. We just threw out the dirty limericks and gave the prize to the one that was left."

Commenting on the technical effect of a limerick, Morris Bishop wrote in *The New York Times Book Review:* "The structure should be a rise from the commonplace reality of line one to logical madness in line five." Thus the subject matter of limericks invariably tends toward sexual prodigies, incest, vivisection, bestiality, madness, infanticide, abortion, and masturbation, with a strong sexist bias against women. As such, the limerick may have functioned at one time in a social context to discharge male sexual anxieties and fears of impotence behind a comic veneer of ridicule and absurdity.

The earliest record of the limerick form occurs in nonsense and nursery rhymes, as collected in 1719 in *Mother Goose Melodies for Children:*

> Hickory dickory dock
> The mouse ran up the clock
> The clock struck one
> The mouse ran down
> Hickory dickory dock.

One can hear early echoes of a surprise or trick rhyme scheme and rising anapest rhythm in various songs in Shakespeare's plays, as in Ophelia's mad song:

> His beard was as white as snow
> All flaxen was his poll,
> He is gone, he is gone,
> And we cast away moan:
> God ha' mercy on his soul!
>
> (William Shakespeare, *Hamlet*, IV.v)

Modern interest in the limerick form can be dated from 1863 with the reprinting of Edward Lear's *Book of Nonsense* in London; thereafter, the English humor magazine *Punch* began regularly to publish examples of limericks. Sir Arthur Sullivan provided lively melodies for limerick verse in three Gilbert and Sullivan operettas: *The Yeomen of the Guard, Iolanthe,* and *Patience*.

The bawdy rhythm of the limerick is probably the closest we can ever come to the lusty rhythms of the Greek Satyr plays, which served as comic relief to the great Greek tragedies of Aeschylus, Sophocles, and Euripides. The modern limerick verse has the same indecency and playful obscenity that the classical Satyr plays are reputed to have had. In fact, there is reputedly only one genuine limerick that appears to be clean and tasteful, although even this limerick tends to barbarity and cruel humor:

> There once were two cats of Kilkenny;
> Each thought there was one cat too many:
> So they scratched and they bit
> In a quarrelsome fit
> Til instead of two cats, there weren't any.

The stalemate impasse of the two cats of Kilkenny is more usually translated in limerick form to a sexual impasse, as in the following:

> A pansy who lived in Khartoum
> Took a lesbian up to his room,
> And they argued all night
> Over who had the right
> To do what, and with which, and to whom.

Not all limericks are explicit to the point of obscenity, and some of the best achieve their humorous effect through implication rather than direct statement, as in the following:

> There was a young lady of Norway
> Who hung by her heels in a doorway;
> She said to her beau,
> "Look at me, Joe,
> I think I've discovered one more way."

Some limericks content themselves with relatively tame and modest subject matter:

> No one can tell about Myrtle,
> Whether she's sterile or fertile;
> If anyone tries
> To tickle her thighs,
> She closes them tight like a turtle.

And the very best limericks may achieve their effect through a sophistication of trick rhymes, as in the following:

> There was a young lady of Exeter,
> So pretty that men craned their necks at her;
> One was even so brave
> As to take out and wave
> The distinguishing mark of his sex at her.

Limericks are sometimes composed and strung together in a series to form limerick cycles that unfold a fabulous narrative about a fictional person's incongruous sexual prowess.

LINE LENGTH

The specific duration of any individual unit of words.

The various possibilities of standard line lengths in poetry are as follows (where each "foot" contains one stressed and one or more unstressed syllables).

Monometer One foot, one or two syllables.

The following is an example of single foot/single syllable line length, and has been claimed to be the shortest poem in the English language:

> I—
> Why?
> (Eli Siegel,
> "One Question")

Here is an example of a single foot with two or more syllables:

> Thus I
> Passe by,
> And die:
> As One,
> Unknown,
> And gon;
> I'm made
> A shade,
> And laid
> I' the grave,
> There have
> My Cave.
> Where tell
> I dwell,
> *Farewell.*
>
> (Robert Herrick,
> "Upon His Departure Hence")

Dimeter Two feet, four or five syllables.

> Imagine Lear
> beneath a plain
> prosaic sky.
> Disfigured here,
> he has no rain
> to signify
> his rage or mere
> impotent pain.
>
> Still, an insane
> old man will cry
> and hope to hear
> a hurricane
> spout its reply,

> or a fool's jeer
> tell in refrain
> the reason why.
> (William Packard)

Trimeter Three feet, six or seven syllables.

> God banish from your house
> The fly, the roach, the mouse
>
> That riots in the walls,
> Until the plaster falls;
>
> Admonish from your door
> The hypocrite and liar;
>
> No shy, soft, tigrish fear
> Permit upon your stair,
>
> Nor agents of your doubt.
> God drive them whistling out . . .
> (Stanley Kunitz, "Benediction")

Tetrameter Four feet, generally eight or nine syllables.

> Tyger! Tyger! burning bright
> In the forests of the night,
> What immortal hand or eye
> Could frame thy fearful symmetry?
>
> In what distant deeps or skies
> Burnt the fire of thine eyes?
> On what wings dare he aspire?
> What the hand dare seize the fire?
>
> And what shoulder, & what art,
> Could twist the sinew of thy heart?
> And when thy heart began to beat,
> What dread hand? & what dread feet?
>
> What the hammer? what the chain?
> In what furnace was thy brain?
> What the anvil? what dread grasp
> Dare its deadly terrors clasp?

> When the stars threw down their spears,
> And water'd heaven with their tears,
> Did he smile his work to see?
> Did he who made the Lamb make thee?
>
> Tyger! Tyger! burning bright
> In the forests of the night,
> What immortal hand or eye,
> Dare frame thy fearful symmetry?
>
> (William Blake, "The Tyger")

Pentameter Five feet, ten or eleven syllables.

> The Moving finger writes; and, having writ,
> Moves on: nor all your Piety nor Wit
> Shall lure it back to cancel half a Line,
> Nor all your Tears wash out a Word of it.
>
> (Rubáiyát of Omar Khayyám, tr. Edward FitzGerald)

Hexameter Six feet, twelve or thirteen syllables.

The following lines of Desdemona in *Othello* are hexameter length, occurring in an irregular pattern among the blank verse pentameter lines. Lines 3 and 5 and 6 are hexameter, having six feet to each line; lines 2, 4, 7, 8, and 9 are pentameter, having five feet to each line. Lines 1 and 10 are foreshortened lines:

> My noble father,
> I do perceive here a divided duty:
> To you I am bound for life and education;
> My life and education both do learn me
> How to respect you; you are the lord of duty;
> I am hitherto your daughter. But here's my husband,
> And so much duty as my mother show'd
> To you, preferring you before her father,
> So much I challenge that I may profess
> Due to the Moor my lord.
>
> (William Shakespeare, *Othello,* I.iii)

The neoclassic ALEXANDRINE line is a special type of hexameter line length, having its peculiar conventions of an absolute CAESURA in mid-line

with hemistiches of three feet each on either side. The following example
shows alexandrine lines in heroic rhymed COUPLETS:

Traitor and slave!—how dare you stand before me here?
Sky's brightest lightning bolt should throw you to the void,
almost the last outlaw of those I have destroyed!
After this ugly lust had come into your head
and led you to defame your mother's wedding bed,
you still present yourself, and show your hated face,
and so parade your shame throughout this fatal place,
and do not go away, under some foreign sun,
where my own name may be unknown to everyone.
Fly, traitor!—do not try to brave my hatred now,
so go, while my great rage is kept inside somehow.
It is enough for me to bear my own despair
for having brought you forth into the living air,
without your death as well dishonoring my name
and spoiling endlessly the splendor of my fame . . .
 (Jean Racine, *Phèdre,* IV.ii, tr. William Packard)

Septameter Seven feet, fourteen or fifteen syllables.

Of shapes transformde to bodies straunge, I purpose to entreate;
Ye gods vouchsafe (for you are they ty wrought this wondrous feate)
To further this mine enterprise. And from the world begunne,
Graunt that my verse may to my time, his course directly runne
Before the Sea and Land were made, and Heaven that all doth hide,
In all the worlde one onely face of nature did abide,
Which *Chaos* hight, a huge rude heape, and nothing else but even
A heavie lump and clotted clod of seedes togither driven
Of things at strife among themselves for want of order due . . .
 (Ovid, *Metamorphoses,* tr. Arthur Golding)

Octameter Eight feet, sixteen or seventeen syllables.

Once upon a midnight dreary, while I pondered, weak and weary,
Over many a quaint and curious volume of forgotten lore—
While I nodded, nearly napping, suddenly there came a tapping,
As of someone gently rapping, rapping at my chamber door.

"'Tis some visitor," I muttered, "tapping at my chamber door—
Only this and nothing more."

(Edgar Allan Poe, "The Raven")

When a line exceeds eight feet in length, it is customarily broken up into smaller prosodic units for the purposes of scansion.

LONG POEM

Any verse that exceeds a short lyric of a dozen or so STANZAS or goes well over a hundred lines or greatly exceeds the space of a single page.

Through the ages, poets have sustained their poetry beyond the length of a short lyric poem in order to explore the possibilities of VOICE and TONE and subject matter in a larger context and framework. From Chaucer's *Canterbury Tales* and *Troilus and Criseyde* and Spenser's *Fairie Queene,* poets have developed unique forms for the long poem, forms which are not necessarily related to traditional modes like the epic or canto or ode. Shakespeare's "Venus and Adonis" and "The Rape of Lucrece" are examples of Renaissance models for the long poem.

From the seventeenth to the nineteenth century, the long poem flourished in a variety of structural forms and principles. Milton's "Comus," Blake's *Songs of Innocence and Experience,* Pope's "Dunciad," Longfellow's "Hiawatha," Tennyson's *Idylls of the King,* and Coleridge's "The Rime of the Ancient Mariner" are all attempts to sustain a poem beyond the length of a short lyric.

At the beginning of the twentieth century, several landmark long poems set the standard for modern poetry. Whitman's "Song of Myself," published in 1855, is a loosely organized voice poem made up of fifty-four disparate sections, all of them extolling the poet's role in the modern world. Valéry's "Le Cimetière Marin" and Rilke's *Duino Elegies* are long poems that use SYMBOLISM to explore the metaphysical role of poetry and the poet. And William Butler Yeats created his own form for the long poem in "The Tower," an alternately meditative and exclamatory summation of his life and work as a poet.

Of the long poems that followed in England and America, the most significant are Eliot's *The Waste Land,* Pound's *Cantos,* Hart Crane's "The Bridge," and Wallace Stevens' "Sunday Morning" and "The Idea of Order at Key West." All try to make some sense and order out of the multiplicity of shapes and forms that are available in the modern world.

It might be useful to examine one long poem in modern American poetry to see what principles help tie it together. William Carlos Williams wrote the

poem *Paterson* in five separate "Books" together with notes for an unfinished sixth "Book"; in these six Books he gathered different kinds of materials relating to things that happened in or around the township of Paterson, New Jersey, both past and present. Thus Williams includes such disparate elements as FREE VERSE passages on his life as a family doctor, extracts from historical data on Paterson, speculations on the Federal Reserve System, letters from love-crazed female admirers, excerpts from *Studies of the Greek Poets* by John Addington Symonds, news clippings of an 1850 murder of an aged couple by a farmer, letters from the young Allen Ginsberg discussing his early poetry, and other assorted prose and poetry passages. The total poem is something like an epic collage, in which the various materials are subsumed under the umbrella idea that Paterson is a living reality in the life and imagination of the poet.

Examples of other contemporary long poems are Galway Kinnell's "The Avenue Bearing the Initial of Christ into the New World"; W. D. Snodgrass' "Heart's Needle"; and Robert Lowell's book *Life Studies,* the entire volume of which can be read as a long poem made up of the individual poem sections that comprise the book. Allen Ginsberg's poems "Howl" and "Kaddish" are significant new forms of the long poem in our time.

One approach to creating a long poem is simply to link shorter poem elements together into a numbered cycle or series or sequence under a single title or motif or theme. SONNET sequences can be created this way, as well as *haibun,* or mixed HAIKU and prose passages; even LIMERICKS can be strung together in sequences. One example of a contemporary long poem made up of shorter numbered sections begins,

1 To employ her
 construction ball
 Morning fed on the
 light blue wood
 of the mouth
 cannot understand
 feels deeply)

2 A wave of nausea—

3 A few berries

4 the unseen claw
 Babe asked today
 The background of poles roped over
 into star jolted them

5 filthy or into backward drenched flung heaviness
 lemons asleep patterns crying

 (John Ashbery, "Europe")

LULLABY

A form of CAROL, dating from the thirteenth century, that combines the
strong RHYTHM of song and dance with the rocking of a cradle. The follow-
ing line is typical:

Lollai, lollai, litil child, whi whepistou so sore?

Like a nursery rhyme or a fairy tale, the lullaby may sometimes contain a
disguised warning about the sorrows of life:

rockabye baby
on the tree top

when the wind blows
the cradle will rock

when the bough breaks
the cradle will fall

down will come cradle
baby and all

LYRIC

A song, usually of one theme or note, with a strong regular RHYTHM or
METER and usually RHYME.

The various types of lyric poem include simple songs, lays, and the fol-
lowing variants:

canticle—a litany, ritual song

canto—a song

CAROL—a hymn of joy

chant—a work song, or a religious song

madrigal—a love poem set to music

pastoral—an IDYL of rural life

round—any lyric poem with a recurring refrain

The earliest examples of lyric poetry can be found in poems by the Greek Sappho and the Roman Catullus, and in the Psalms of David, which were sung to the music of a harp. Lyric poems were set to music in Charlemagne's court in A.D. 800, and throughout the Medieval period lyric poems were composed and sung by Troubadours (see JONGLEUR).

James Stephens, the Irish poet, describes the domain of the lyric poet:

It may be said that the lyrical poet is undisputed master of all the *extremes* that can be expressed in terms of time or speed or tempo. No pen but his can hold excessive velocity or excessive slowness. A swift lyrical line is as quick as lightning; a slow one can be slower than a snail; and it is only in these difficult regions, distant regions, that the poet can work with ease and certainty.

Some of the purest examples of lyric are to be found in the plays of Shakespeare:

> When that I was and a little tiny boy,
> With hey, ho, the wind and the rain;
> A foolish thing was but a toy
> For the rain it raineth every day . . .
> (William Shakespeare, *Twelfth Night,* V.i)

> It was a lover and his lass,
> With a hey, and a ho, and a hey nonino,
> That o'er the green corn-field did pass,
> In the spring time, the only pretty ring time,
> When birds do sing, hey ding a ding ding;
> Sweet lovers love the spring . . .
> (William Shakespeare, *As You Like It,* V.iii)

Lyric poetry became popular again in the Romantic period; Keats and Blake and Wordsworth and Shelley wrote songs with strong regular rhythms and rhyme. One of the purest lyric poets was Robert Burns:

> O my luve's like a red, red rose
> That's newly sprung in June:
> O my luve's like the melodie
> That's sweetly played in tune!
> (Robert Burns, "A Red, Red Rose")

In twentieth-century musical theater, "lyric" has come to mean the words accompanying a song; or more specifically, words that are written by a lyricist to accompany music written by a composer. Thus Lorenz Hart, Oscar Hammerstein II, Irving Berlin, Stephen Sondheim and others wrote "lyrics" to music that was either preexisting or to be written based on the words.

M

MACARONICS

The use of foreign words to enrich the texture of DICTION in a poetic line. The most common practice of macaronics is the mixture of vernacular words with Latin words, but macaronics can be any combination of two or more languages in any given passage.

In Shakespeare's *Henry V*, the Archbishop of Canterbury uses macaronics to try to prove to Henry that he has the right to lay claim to lands in France:

> There is no bar
> To make against your highness' claim to France
> But this, which they produce from Pharamond,
> *In terram Salicam mulieres ne succedant,*
> "No woman shall succeed in Salique land" . . .

> <div align="right">(William Shakespeare, Henry V, I.ii)</div>

In the opening lines of "Canto II," Ezra Pound skips over four languages in eleven lines:

> Hang it all, Robert Browning,
> there can be but the one "Sordello."
> But Sordello, and my Sordello?
> Lo Sordels si fo di Mantovana.
> So-Shu churned in the sea.
> Seal sports in the spray-whited circle of cliff-wash,
> Sleek-head, daughter of Lir,
> eyes of Picasso,
> Under black fur-hood, lithe daughter of Ocean;
> And the wave runs in the beach groove:
> "Eleanor, ἐλέναυς and ἐλέπτολις!"

> <div align="right">(Ezra Pound, "Canto II")</div>

120

MEDIAL PAUSES *See* CAESURA.

METAPHOR

Any figure that asserts the equivalence of two or more disparate elements, as in mathematics when one states, for example, that A = B. Thus in Martin Luther's classic metaphor, "A mighty fortress is our God," God is claimed to be the same as a fortress stronghold.

Metaphor provides the unique thrill of insight in poetry when one realizes a sameness that underlies difference in things, as Aristotle says in the *Poetics:*

> It is a great thing, indeed, to make a proper use of these poetical forms, as also of compounds and strange words. But the greatest thing by far is to be a master of metaphor. It is the one thing that cannot be learned from others; and it is also a sign of genius, since a good metaphor implies an intuitive perception of the similarity in dissimilars.

One can get some sense of the exceptional power of metaphor by contrasting it with SIMILE, which is an indirect comparison using "like" or "as." If Martin Luther had said, "Our God is *like* a mighty fortress," his statement would not have carried the full force of the metaphorical "Our God *is* a mighty fortress." Conversely, if Robert Burns had said, "My love *is* a red, red rose," he would have lost some of the delicate subtlety of the simile statement, "My love's *like* a red, red rose."

Modern poets agree about the centrality of metaphor in poetry. Richard Wilbur, in an NYQ Craft Interview, stated, "Metaphor, in the small sense and the large, is the main property of poetry." And May Swenson, in another NYQ Craft Interview, distinguished a particular usage of metaphor in her own work: "Organic metaphor is where the metaphor moves all the way through the work, and it builds with just one metaphor."

The following are the various additional types of metaphor:

Double Metaphor A metaphor can be expressed in two different ways to intensify an equivalence. Romeo uses a double metaphor at the beginning of the balcony scene:

> But soft! what light through yonder window breaks?
> It is the east, and Juliet is the sun!

> (William Shakespeare, *Romeo and Juliet,* II.ii)

Here the light is the east and Juliet is the sun; it's like saying A = B and C = D. The double metaphor enforces our perception and shows the extreme emotion Romeo is experiencing.

Triple Metaphor In rare cases a metaphor can express three equivalences, as when Gertrude Stein says, "A rose is a rose is a rose"—which is like saying A = A = A; the equivalence is repeated to call attention to its tautological force.

Multiple Metaphor A metaphor can equate one term with several different things, as in the opening lines of "Song of Myself":

> A child said *What is the grass,* fetching it to me with full hands;
> How could I answer the child? I do not know what it is any more than
> he.
>
> I guess it must be the flag of my disposition, out of hopeful green stuff
> woven.
>
> Or I guess it is the handkerchief of the Lord,
> A scented gift and remembrancer designedly dropt,
> Bearing the owner's name someway in the corners, that we may see and
> remark, and say *Whose?*
>
> Or I guess the grass is itself a child, the produced babe of the
> vegetation.
>
> Or I guess it is a uniform hieroglyphic . . .
>
> (Walt Whitman, "Song of Myself")

In the above lines, Whitman equates the grass with a flag, then with a handkerchief, then with a child, and finally with a hieroglyphic. It's like saying A = B = C = D = E.

Negative Metaphor A metaphor can assert that one thing is *not* the same as another thing—it's like saying A ≠ B.

> Love's not time's fool . . .
> (William Shakespeare, Sonnet 116)

Past Tense Metaphor A metaphor can assert that one thing *was* the same as another thing at some past time, regardless of whether the same equivalence can be made at the present time.

> Those are pearls that were his eyes . . .
> > (William Shakespeare, *The Tempest*, I.ii)

Tentative Metaphor A metaphor can assert that one thing *may be* the same as another thing, with no definite assurance of certainty.

> This Place Rumord to have been Sodom
> might have been.
> > (Robert Duncan, "This Place Rumord
> > to Have Been Sodom")

Juxtaposed Metaphor A metaphor can imply an equivalence when the various terms are simply set down next to one another, with no explicit equivalence asserted—it's like saying A/B/C/D/E. Ezra Pound achieved maximum metaphorical force in his *Cantos* by using abrupt juxtapositions, setting one element right next to another element with no explicit metaphor stated. Allen Ginsberg did the same thing in "Howl" with a technique he described as "images juxtaposed." Gary Snyder also used juxtaposed metaphor:

> Lay down these words
> Before your mind like rocks
> > placed solid, by hands
> In choice of place, set
> Before the body of the mind
> > in space and time:
> Solidity of bark, leaf, or wall
> > riprap of things:
> Cobble of milky way.
> > straying planets,
> These poems, people,
> > lost ponies with
> Dragging saddles—
> > and rocky sure-foot trails . . .
>
> > > (Gary Snyder, "Riprap")

METER

The formal measure of the natural RHYTHM of language as it falls into regular patterns of stress or elongation. Metrics can be read by the practice of scansion, which determines accentual patterns or long or short syllables within

individual feet. ("Long" and "short" refer to the length of time it takes to pronounce any given syllable, the "long" being roughly twice the length of the "short.")

Meter may have begun as a mnemonic device to make verse easier to remember; or it may have developed its own intuitive music through execution. Yet whatever the early origins of meter, the primal base of all metrics invariably refers back to the predominant pulse of the individual heartbeat for its ultimate power and authentication.

When the Greeks described poetry as "numbers," they were alluding to certain conspicuous elements of verse that could be counted off: "feet" were strong dance steps that could be measured out in separate beats of a choral ode or strophe or refrain. These "feet" could then be scanned for repeating patterns of syllable quantities, either long or short, within STROPHES and anti-strophes of a chorus. Greek metrics, then, did not derive from accent or stress but rather from the elongation required in the pronunciation of certain vowels and syllable lengths.

Latin poetry was similarly quantitative in measuring syllable lengths, although later, Latin began to develop accent and rhythms which resulted in shorter lines and sharper stress: thus an "*iamb*" (see below) became gradually converted from a "short/long" unit to an "unstressed/stressed" unit of measurement, and accentual metrics came into being.

Modern English is a hybrid composite of various rhythmic textures and influences. One component is the relic of quantitative metrics with its distinction of "long" (ā) and "short" (ă) vowel lengths, which echoes the Greek and early Latin practice. Another is the strong stress of early Teutonic speech in the plain-style diction of the Angles and Saxons and Jutes who were in England from the fifth century onward, and these strongly stressed rhythms can be felt in the heavily accentual verse of early Anglo-Saxon poems and ballads and Middle English song. Finally, there is the mellifluous and ameliorating influence of the Romance languages dating from the Norman conquest of England in 1066, when French became the dominant spoken language in the courts of the first three English kings.

And during all of this early English history, classical Latin remained the official language for reading and writing in all matters pertaining to state religion and education. Thus the typical Englishman was forced to stay fairly close to an inflected language (Latin) that had case endings and predicate endings to each sentence, all the while actually speaking and thinking in a non-inflected and heavily accentual language (English) which was a conglomerate of Anglo-Saxon and Romance influences.

By the time Chaucer (1340–1400) began his official court service to King Richard II and traveled to Italy to taste the "sweet new style," as it was

being practiced there by Petrarch, the English language was ready to receive
an entirely new metric and musical principle. The opening lines of the Pro-
logue to *The Canterbury Tales* present us with just such a new metric: Chau-
cer uses an astonishing variety of musical tones in these revolutionary verses.
There is the strong regular *iambic* stress in each line (the opening foot is a
trochee; thereafter the poetry reverts to strong iamb). Chaucer includes the
occasional Latinate word in lines 4, 6, and 11 (engendred/inspired/nature)
to give the lines a sense of inflection and abstract weight. The charm of plain-
style monosyllabic diction is as straightforward and stark as the vernacular
word choices Dante employed in the Italian of his great *Commedia* a century
earlier. And finally, the elegance and sonority of the Provençal French influ-
ence seems to give these lines their subtle and soaring lyricism:

> Whan that Aprille with his shoures sote
> The droghte of Marche hath perced to the rote,
> And bathed every veyne in swich licour,
> Of which vertu engendred is the flour;
> Whan Zephirus eek with his sete breeth
> Inspired hath in every holt and heeth
> The tendre croppes, and the yonge sonne
> Hath in the Ram his halfe cours y-ronne,
> And smale fowles maken melodye,
> That slepen al the night with open yë,
> (So priketh hem nature in hir corages):
> Than longen folk to goon on pilgrimages
> (And palmers for to seken straunge strondes)
> To fern halwes, couthe in sondry londes;
> And specially, from every shires ende
> Of Englond, to Canterbury they wende,
> The holy blisful martir for to seke,
> That hem hath holpen, whan that they were seke . . .

> (Geoffrey Chaucer, Prologue, *The Canterbury Tales*)

Over the next five hundred years, English poetry continued to be written
and scanned according to a variety of metrical principles to accommodate
the complex background and texture of the language. Poets wrote quantita-
tive verse (poetry that is judged according to elongation of vowel sounds or
"pitch" deriving from the Latin); syllabic verse (poetry that is judged accord-
ing to the syllable count within each individual line); and, finally, accentual
verse (poetry that is judged according to the stress and non-stress patterns
that occur in a poem).

We will be concerned here only with accentual verse and the metrical scansion of stress and non-stress within the individual feet of a poem.

The following are the meters most often found in English and American poetry, with examples for each:

Iambic From the Greek, "funny girl with skirts up."

. / . /

> I died for Beauty—but was scarce
> Adjusted in the Tomb
> When One who died for Truth, was lain
> In an adjoining Room—
>
> He questioned softly "Why I failed"?
> "For Beauty", I replied—
> "And I—for Truth—Themself are One—
> We Brethren, are", He said—
>
> And so, as Kinsmen, met a Night—
> We talked between the Rooms—
> Until the Moss had reached our lips—
> And covered up—our names—
>> (Emily Dickinson, "I died for Beauty")

> Whose woods these are I think I know.
> His house is in the village though;
> He will not see me stopping here
> To watch his woods fill up with snow.
>> (Robert Frost, "Stopping by Woods
>> on a Snowy Evening")

Trochaic From the Greek, "running."

/ . / .

> I'll drain him dry as hay:
> Sleep shall neither night nor day
> Hang upon his penthouse lid;
> He shall live a man forbid:

> Weary se'nnights nine times nine
> Shall he dwindle, peak, and pine:
> Though his bark cannot be lost,
> Yet it shall be tempest-toss'd.—
>
> (William Shakespeare, *Macbeth*, I,iii)

> Never, never, never, never, never!
>
> (William Shakespeare, *King Lear*, V.iii)

Anapestic From the Greek, "beaten back"; upbeat, thrust; natural gait of a horse walking.

. . / . . /

> Come and sit by my side if you love me,
> Do not hasten to bid me adieu,
> But remember the Red River Valley
> And the cowboy who loved you so true.
>
> ("Red River Valley")

Dactyllic From the Greek, "finger with one long and two short joints."

/ . . / . .

> Half a league, half a league, half a league onwards . . .
>
> (Alfred, Lord Tennyson,
> "The Charge of the Light Brigade")

Spondaic From the Greek, "spilling out of wine from a jug."

/ / / /

> Out, out brief candle . . .
> (William Shakespeare, *Macbeth*, V.iii)

> Rocks, Caves, Lakes, Fens, Bogs, Dens, and Shades of Death.
> (John Milton, *Paradise Lost*, Book Two)

> I saw the best minds of my generation . . .
> (Allen Ginsberg, "Howl")

Other meters are variations of the five described above; they include

pyrrhic (one or more unaccented syllables) . .
amphibrachic (one short, one long, one short) . / .
bacchic (one short and two long) . / /
choriambic (one long, two short, one long) / . . /

No matter how adept one becomes at metrical scansion, one should remember that poets have always insisted that the intuitive music of poetry must come first. Thus Shelley wrote in "A Defense of Poetry" (1812),

An observation of the regular modes of the recurrence of harmony in the language of poetical minds, together with its relation to music, produced meter, or a certain system of traditional forms of harmony and language.

Emerson in his essay "The Poet" reminds us that more than mere metrics is required to produce a strongly metered poem:

For it is not meters, but a meter-making argument, that makes a poem —a thought so passionate and alive, that, like the spirit of a plant or an animal, it has an architecture of its own, and adorns nature with a new thing.

Coleridge agrees in his *Biographia Literaria:*

Our genuine admiration of a great poet is for a continuous undercurrent of feeling; it is everywhere present, but seldom anywhere a separate excitment.

T. S. Eliot in his "Dialogue on Dramatic Poetry" affirms the inevitability of rhythm and meter in all heightened human utterance:

The human soul, in intense emotion, strives to express itself in verse. It is not for me, but for the neurologists, to discover why this is so, and why and how feeling and rhythms are related. The tendency, at any rate, of prose drama is to emphasize the ephemeral and superficial; if we want to get at the permanent and universal, we tend to express ourselves in verse.

Ezra Pound in his "Treatise on Meter" relates the origins of meter to the practice of song and singing: "Symmetry of strophic forms naturally HAPPENED in lyric poetry when a man was singing a long poem to a short melody which he had to use over and over." In his own *Cantos,* Pound is proudest of having gotten rid of rote metrics:

(To break the pentameter, that was the first heave)

(Ezra Pound, "Canto LXXXI")

METONYMY

A figure of speech that substitutes for a word or phrase; from the Greek, meaning "change of name." Using "the White House" to mean the entire federal government is an example of metonymy.

See also SYNECHDOCHE.

MYTH

A body of allusion and METAPHOR that helps us to understand our own origins, our fertility cycles and territorial sagas, and the sources of our religious practices.

Ancient Greek myths can be divided into three broad areas: explanations of natural phenomena and the origins of man and nature and the universe; stories of quest and adventure and the agons of heroes; and psychosexual allegories of encounters between gods and mortals.

The principal sources of Western myths include Homer's *Iliad* and *Odyssey;* Hesiod's "Theogony" and "Works and Days"; Aeschylus' "Prometheus Bound" and the "Oresteia"; Sophocles' "Oedipus Rex"; Euripides' "The Bacchae"; Aristophanes' "The Birds"; Plato's *Republic,* Book X, the Myth of Er; Virgil's *The Aeneid;* Ovid's *Metamorphoses;* and Dante's *Commedia.*

N

NARRATIVE *See* DRAMATIC-NARRATIVE POETRY; GENRES.

NOH

A tradition in Japanese poetry and theater that is over six hundred years old; called "the immeasurable scripture" because it is a synthesis of song and dance and poetry and drama and religion. "The heart is the form" is one way of describing *yugen,* that indefinable experience of pure spirit which a Noh actor realizes in each performance, the dark and obscure happening that animates the way he moves, the way he feels, the way he is.

The following are three passages from *Ikkaku Sennin,* a Noh play written by Komparu Zembō Moyoyasu. The action concerns a holy hermit unicorn who has captured the dragon gods and kept them from causing rain to fall; the hermit is seduced and loses all his magic powers through an encounter with the beautiful Lady Senda Bunin. The poetry of this Noh play is filled with autumn imagery which is as poignant as it is subtle:

WAKI: Mountains and mountains and mountains,
 mists that cover over all the weary travelers,
 cold winds that blow through the open woods,
 as we keep going,
 no sleep on the mountain side,
 no sweet dreams for us.
 Dew that drops like rain,
 dew that drops like rain, like rain
 on the deep ravine
 so that even the lowest leaves receive water,
 change to strange autumn colors.
 We are kept so cold

as we keep climbing, climbing, climbing on
our way.
The road goes through so much mist,
through clouds on high hills.
How do we know where we are?
Up in the mountains
we do not know where we are,
we wander around
wondering where does this road go, this road
we're on,
does anyone know anything about this road?
Day after day, we've hurried on our way,
traveling on this old road that no one knows
about,
now we are lost, we are all worn out.
Look, there are many rocks, they are lying
on the ground and piled up in a mound, I
wonder why?
—how sweet the breezes as they blow over
the rock pile, I can tell the smell of pine.
Perhaps this is where the wizard lives, the
holy hermit unicorn, perhaps this is the place.
We could keep quiet and get close to it,
slowly, slowly, get up close so we can see if
the wizard is hiding inside.
Gracious lady, if your patience will permit it
we would like to stay right here.

SHITE: I scoop water from deep streams with my
magic gourd, I call forth all my art.
I lift up clouds that have folded over forests
and I make them boil swiftly,
then I play music.
But I play alone.
The mountains rise up high above river
banks.
Green leaves suddenly become the color of
blood.
I play music and I play alone in autumn.

(Komparu Zembō Moyoyasu, *Ikkaku Sennin*,
tr. William Packard)

O

OCCASIONAL POETRY

Poems written for a particular event or happening, usually ceremonial or honorific. For example, John Milton wrote a "Hymn on the Morning of Christ's Nativity, Composed 1629," and Richard Crashaw wrote "A Hymn to the Name and Honour of the Admirable Saint Teresa."

Sometimes, however, an occasional poem will be written to commemorate a contemporary event, such as "In Time of Pestilence" by Thomas Nash, "Upon the Sudden Restraint of the Earl of Somerset, Then Falling from Favour, 1615" by Sir Henry Wotton, and "On the Late Massacre in Piedmont" by John Milton.

Sometimes an occasional poem will be written to celebrate an idiosyncratic event of the poet's own choosing, such as "To His Mistress Desiring to Travel with Him as His Page" by John Donne and "To a Louse, on Seeing One on a Lady's Bonnet at Church" by Robert Burns. William Wordsworth used the occasional poem to record his own meditations, as in "Lines Written a Few Miles above Tintern Abbey, on Revisiting the Banks of the Wye during a Tour, July 13, 1798."

Some modern poets use the occasional poem to record their refusal to respond to a particular occasion; thus William Butler Yeats wrote,

> I think it better that in times like these
> A poet's mouth be silent, for in truth
> We have no gift to set a statesman right;
> He has had enough of meddling who can please
> A young girl in the indolence of her youth,
> Or an old man upon a winter's night.

<div align="right">

(William Butler Yeats,
"On Being Asked for a War Poem")

</div>

Dylan Thomas also used the form of the occasional poem to record his reluctance to respond to a particular occasion:

Never until the mankind making
Bird beast and flower
Fathering and all humbling darkness
Tells with silence the last light breaking
And the still hour
Is come of the sea tumbling in harness

And I must enter again the round
Zion of the water bead
And the synagogue of the ear of corn
Shall I let pray the shadow of a sound
Or sow my salt seed
In the least valley of sackcloth to mourn

The majesty and burning of the child's death . . .

> (Dylan Thomas, "A Refusal to Mourn the Death,
> by Fire, of a Child in London")

ODE

An extended lyric, on a single theme or subject, often of considerable length and usually using recognizable STANZA patterns. The word "ode" comes from the Greek *aeidein,* meaning to sing or chant, and the form may have had its origins with Sappho in the middle of the seventh century B.C., because her surviving work includes one complete ode and four stanzas of a second ode. The later Greek poet Pindar wrote triumphal odes, and the Roman poet Horace wrote odes as well as SATIRES and EPISTLES.

In modern poetry, the ode was practiced by Ronsard, Valéry, and Verlaine, and Schiller's "Ode to Joy" was set to music by Beethoven in his Ninth Symphony. Thomas Gray's "Elegy Written in a Country Churchyard" is more an ode written out of personal grief than an ELEGY.

During the Romantic period poets chose odes to convey their strongest sentiments; thus Coleridge wrote "Dejection, an Ode"; Wordsworth wrote "Ode: Intimations of Immortality from Recollections of Early Childhood"; and Keats wrote two great odes:

My heart aches, and a drowsy numbness pains
 My sense, as though of hemlock I had drunk,

Or emptied some dull opiate to the drains
 One minute past, and Lethe-wards had sunk . . .

<div align="right">(John Keats, "Ode to a Nightingale")</div>

Thou still unravished bride of quietness,
 Thou foster-child of Silence and slow Time,
Sylvan historian, who canst thus express
 A flowery tale more sweetly than our rhyme . . .

<div align="right">(John Keats, "Ode on a Grecian Urn")</div>

Shelley also wrote two great odes:

Hail to thee, blithe spirit!
 Bird thou never wert—
That from heaven or near it
 Pourest thy full heart
In profuse strains of unpremeditated art . . .

<div align="right">(Percy Bysshe Shelley, "To a Skylark")</div>

O wild West Wind, thou breath of Autumn's being,
 Thou from whose unseen presence the leaves dead
Are driven like ghosts from an enchanter fleeing . . .

<div align="right">(Percy Bysshe Shelley, "Ode to the West Wind")</div>

It could be argued that other poems of considerable length that are about one theme or subject might be seen as odes, whether or not they fall into recognizable stanza patterns. Walt Whitman's "Song of Myself," for example, which is made up of fifty-four irregular sections, could conceivably be seen as a free-form Ode to Selfhood. And in modern poetry, in addition to those poems that are clearly identifiable as odes, such as Allen Tate's "Ode to the Confederate Dead" and Robert Lowell's "Quaker Graveyard at Nantucket," there may be many other poems that qualify as odes. Thus Allen Ginsberg's "Howl" and "Kaddish" could be seen as odes; John Berryman's *Dream Songs* could be seen as an ode made up of individual poems; and W. H. Auden's two great elegies—"In Memory of W. B. Yeats" and "In Memory of Sigmund Freud"—could be seen as odes insofar as they are poems not so much of personal grief as of public statement.

ONOMATOPOEIA

Any recreation of a thing that tends to imitate the thing itself either through sound or RHYTHM. Alfred North Whitehead once gave this definition: "The art of literature, oral or written, is so to adjust the language that it embodies what it indicates." This "embodiment" of language is called onomatopoeia, which is always an echo or a direct imitation of the thing itself. Thus words like "bang" and "splat" and "zzz" are onomatopoetic insofar as they are a mimesis of the sounds they are imitating.

In the Greek, Homer describes the sound of waves rushing in and receding on a beach:

> poluphloisboio thalasses

In Latin poetry, Ennius tries to recreate the sound of trumpets in the line,

> At tuba terribili sonitu taratantara dixit.

Virgil recreates the galloping of horses with the line

> quadupedante putrem sonitu quatit ungula campum

In the canzos of Arnaut Daniel, the first two stanza openings mime the sound of bird songs:

> Doutz brais e critz,
> Lais e cantars e voutas . . .

> Non fui marritz
> Ni non presi destoutas . . .

In the heath scene of *King Lear,* Lear's outbursts seem to be an embodiment of the CACOPHONY and violence of the storm outside:

Blow, winds, and crack your cheeks! rage! blow!
You cataracts and hurricanoes, spout
Till you have drench'd our steeples, drown'd the cocks!
You sulphurous and thought-executing fires,
Vaunt-couriers to oak-cleaving thunderbolts,
Singe my white head! And thou, all-shaking thunder,

Strike flat the thick rotundity o' the world!
Crack nature's moulds, all germens spill at once
That make ingrateful man!

(William Shakespeare, *King Lear*, III.ii)

Tennyson seems to embody the sounds of doves and bees in these lines:

The moan of doves in immemorial elms
And murmuring of innumerable bees.

(Alfred, Lord Tennyson, song from *The Princess*)

Poe recreates the sound of tolling bells:

What a tale of terror now their turbulency tells!

(Edgar Allan Poe, "The Bells")

Hart Crane recreates the 20th Century Limited as it whizzes by:

So the 20th Century—so
whizzed the Limited—roared by and left
three men, still hungry on the tracks, ploddingly
watching the tail lights wizen and converge, slip-
ping gimleted and neatly out of sight.

(Hart Crane, "The Bridge")

In another railroad image, Allen Ginsberg recreates the clattering of a freight train:

who lit cigarettes in boxcars boxcars boxcars racketing through snow
toward lonesome farms in grandfather night

(Allen Ginsberg, "Howl")

Denise Levertov achieves onomatopoetic sounds of a lapping dog:

Shlup, shlup, the dog
as it laps up
water
makes intelligent
music, resting

now and then to
take breath in irregular
measure:
(Denise Levertov, from *Six Variations*)

OXYMORON

A radical paradox; a conjunction of extreme opposites. "Dry ice is so cold that it burns" is an example of oxymoron.

In poetry, oxymoron also functions metaphorically (see METAPHOR) to express a state of ambivalence or contradiction. Thus Sappho uses oxymoron to describe the paralysis she feels when a man sits in front of one of her favorite girls:

to me that man is
a god or greater
than a god

as he faces you
and listens to your
sweet speech and laughter—

my heart beats in
my breast for when I
look at you I become

dumb, a fire skims along
my skin, my eyes go
blind, my ears no longer

hear, a cold sweat breaks
out all over me and I know
I am nowhere—paler

than death, I feel myself
still falling forward
towards you until there is

nothing under me, but
I must suffer everything
being poor
(Sappho, Fragment 9, tr. William Packard)

Another example of oxymoron originates in sonnet CII of Francesco Petrarch, from his *canzoniere*, translated into English by Geoffrey Chaucer, who used it as his "Cantus Troili" in Book One of *Troilus and Criseyde*, in stanzas 58–60. Troilus is so overwhelmed with love for Criseyde that he cannot contain the extreme paradoxes of passion that are spilling over inside of him. In Chaucer's hands the entire poem is an oxymoron; note especially lines 7 and 21:

> If no love is, O god, what fele I so?
> And if love is, what thing and whice is he?
> If love be good, from whennes comth my wo?
> If it be wikke, a wonder thinketh me,
> When every torment and adversitee
> That cometh of him, may to me savory thinke;
> For ay thurst I, the more that I it drinke.
>
> And if that at myn owene lust I brenne,
> Fro whennes cometh my wailing and my pleynte?
> If harme agree me, wher-to pleyne I thenne?
> I noot, ne why unwery that I feynte.
> O quike deeth, so swete harm so queynte.
> How may of thee in me swich quantitee,
> But if that I consente that it be?
>
> And if that I consente, I wrongfully
> Compleyne, y-wis; thus possed to and fro,
> Al sterelees with-inne a boot am I
> A-mid the see, by-twixen windes two,
> That in contrarie stonden ever-mo.
> Allas! what is this wonder maladye?
> For hete of cold, for cold of hete, I dye.
>
> (Geoffrey Chaucer, *Troilus and Criseyde*)

Oxymoron can be seen in the equivocation of the witches in *Macbeth*, who announce in the opening scene that "fair is foul, and foul is fair." This deliberate equation of opposites wreaks havoc with the moral order of the play, and Macbeth himself is obviously attuned to the same level of oxymoron with his opening line:

> So foul and fair a day I have not seen.
>
> (William Shakespeare, *Macbeth*, I.ii)

P

PALINDROME

Any word or phrase or sentence that reads the same backwards as forwards. "Wow" and "dad" and "peep" are simple examples of palindromes. In Latin, the following line is a palindrome:

> Roma tibi subito motibus ibit amor.

In English, "Madam, I'm Adam" is probably the best-known palindrome in the language. There is also this statement, facetiously ascribed to Napoleon:

> Able was I ere I saw Elba.

Other palindromes include the farfetched line

> A slut nixes sex in Tulsa.

And there is this contemptible palindrome:

> Sis, sargass moss a grass is.

Palindromes are usually notoriously useless exercises in literary cleverness, akin to cipher writing or acrostics where the message is hardly worth the energy expended on its unraveling. However, the American poet Anne Sexton in an NYQ Craft Interview discussed how her fascination with a palindrome led her to the writing of a poem:

> Craft is a trick you make up to let you write the poem. The only game
> I ever played was with the word Star. I did everything I could with

the arrangement of S-T-A-R. Conrad Aiken once saw a palindrome
on the side of a barn: Rats Live On No Evil Star (and I want that to
be on my gravestone, because I see myself as a rat, but I live on no
evil star). Rats and Star: I wrote a list of all the words I could make
out of those letters. Then I sat down with the words and made up a
poem . . .

PARADOX *See* OXYMORON.

PASTICHE

A poem or poems written in deliberate imitation or parody of a previous
author or work.

The exercise of pastiche is one way of learning how to write poetry,
wherein a writer deliberately sets out to imitate the style and form and voice
of a poet he or she admires. Dante admitted to having written in the style of
earlier Italian poets; English Renaissance sonnet writers admittedly wrote
"in imitation" of Spencer and Sidney; and Shakespeare in the early comedies
shamelessly imitated the style of Lyly and the Euphuist poets. The following
lines of Thomas Chatterton were deliberately contrived to imitate Middle
English style:

> O! Synge untoe mie roundelaie,
> O! droppe thy brynie teare wythe mee,
> Daunce ne moe atte hallie daie,
> Lycke a reynynge ryver bee;
>> Mie love ys dedde,
>> Gon to hys death-bedde,
>> All under the wyllowe tree . . .

(Thomas Chatterton, "Mynstrelles Songe")

PASTORAL *See* ECLOGUE; IDYL.

PERSONA

An assumed voice, a mythical identity, a fictional mask that one speaks
through instead of using one's own voice. Aristotle in the *Poetics* says that
the poet should say very little *in propria persona* (in his own voice), as he is
no imitator or poet when speaking from himself.

Thus T. S. Eliot assumes the persona of a woman sitting in a pub:

> When Lil's husband got demobbed, I said—
> I didn't mince my words, I said to her myself,
> HURRY UP PLEASE ITS TIME
> Now Albert's coming back, make yourself a bit smart.
> He'll want to know what you done with that money he gave you
> To get yourself some teeth. He did. I was there.
> You have them all out, Lil, and get a nice set,
> He said, I swear, I can't bear to look at you.
> And no more can't I, I said, and think of poor Albert,
> He's been in the army four years, he wants a good time,
> And if you don't give it to him, there's others will, I said.
> Oh is there, she said. Something o' that, I said.
> Then I'll know who to thank, she said, and give me a straight look . . .
>
> (T. S. Eliot, *The Waste Land*)

Similarly, Sylvia Plath indicates in a note to her poem "Daddy" that the voice in the poem belongs not to Sylvia Plath, but to an assumed persona:

> Here is a poem spoken by a girl with an Electra complex. Her father died while she thought he was God. Her case is complicated by the fact that her father was also a Nazi and her mother very possibly part Jewish. In the daughter the two strains meet and paralyze each other —she has to act out the awful little allegory once over before she is free of it.

PERSONIFICATION

The humanization of an object; endowing something inanimate with human attributes and characteristics. At its extreme, personification may lapse into the pathetic fallacy ("the barn shrugged its shoulders"), which is both ludicrous and inappropriate. But judiciously used, personification can be a powerful figure:

> But, look, the morn in russet mantle clad
> Walks o'er the dew of yon high eastern hill.
>
> (William Shakespeare, *Hamlet*, I.i)

In "Adonais," Shelley makes all nature personify the soul of the dead poet:

XLII

> He is made one with Nature: there is heard
> His voice in all her music, from the moan
> Of thunder, to the song of night's sweet bird;
> He is a presence to be felt and known
> In darkness and in light, from herb and stone,
> Spreading itself where'er that Power may move
> Which has withdrawn his being to its own;
> Which wields the world with never-wearied love,
> Sustains it from beneath, and kindles it above.
>
> (Percy Bysshe Shelley, "Adonais")

In a single line, Hart Crane personifies New York City's subway system:

> The subway yawns the quickest promise home.
>
> (Hart Crane, "The Bridge")

PHILOSOPHICAL POETRY

Poetry that develops a discernable and systematic philosophical point of view. This is to be distinguished from poetry that presents a casual observation on the nature of life, or a world-view that does not fit into any consistent system of philosophy.

Examples of philosophical poems include *De Rerum Natura* by Lucretius, which is a clear exposition of the atomic theory of Epicurus; Valéry's "Le Cimetière Marin," which develops Zeno's paradox in which Achilles races the hare and neither one of them reaches the goal; and "The Tower" by William Butler Yeats, in which the poet develops a stance of stoicism. Wallace Stevens developed a consistent philosophical position of hedonism in almost all his poetry.

See also DIDACTIC POETRY.

PLACEMENT

The positioning of a word or phrase or poetic line on the page, to create a visual effect and to affect the way the poem is received by the reader.

Symmetrical patterns of stanzaic arrangement (see STANZA) were prac-
ticed by George Herbert in such poems as "Easter-Wings":

> Lord, who createdst man in wealth and store,
> Though foolishly he lost the same,
> Decaying more and more,
> Till he became
> Most poore;
> With thee
> O let me rise
> As larks, harmoniously,
> And sing this day thy victories:
> Then shall the fall further the flight in me.
>
> My tender age in sorrow did beginne:
> And still with sicknesses and shame
> Thou didst so punish sinne,
> That I became
> Most thinne.
> With thee
> Let me combine,
> And feel this day thy victorie;
> For, if I imp my wing on thine,
> Affliction shall advance the flight in me.

<div align="right">(George Herbert, "Easter-Wings")</div>

Other poets, like the French Surrealists in the early twentieth century,
also created visual shape poems which were as significant to the eye as to the
ear. The most important practice of placement in modern poetry has been in
breaking up the predetermined ideas of LINE LENGTH, breakage, and stanzaic
organization of a poem. Thus William Carlos Williams relies on placement
for a good deal of the effect of this poem:

> so much depends
> upon
>
> a red wheel
> barrow
>
> glazed with rain
> water

> beside the white
> chickens.

(William Carlos Williams,
"The Red Wheelbarrow")

And in another poem, Williams achieves a kind of onomatopoeia through the use of placement on the page:

> As the cat
> climbed over
> the top of
>
> the jamcloset
> first the right
> forefoot
>
> carefully
> then the hind
> stepped down
>
> into the pit of
> the empty
> flowerpot

(William Carlos Williams,
"Poem")

The effect of both poems comes principally from their placement on the page; stripped of punctuation, they are arranged in couplets and triplet lines, with significant breakages that reinforce the action of the images.

Other American poets practiced placement in their poems: Don Marquis, for example, created poems that a cockroach might have written by hitting its head against the typewriter keys in a newspaper office after hours; E. E. Cummings brought a painterly sensibility to the intriguing possibilities of placement in his poetry; and Charles Olson, who pioneered PROJECTIVE VERSE, railed against "the verse print bred" (placements that were arbitrarily set down by the conventions of the printing press and the typewriter, such as left-hand justification and automatic CAPITALIZATION).

Surely the *Cantos* of Ezra Pound is the most adventuresome experiment of placement in our time, with its indentations and stanzaic units that seem to parallel Cubist painting and atonal music. But one eyewitness reports that the distinctive placements of the *Cantos* may have been not so much aesthetic as whimsical: James Laughlin, in his memoir of time spent with Pound, *Pound as Wuz*, observed how Pound achieved some of his most noteworthy placement effects:

His typing, which was extremely eccentric, had, I think, a good deal to do with the visual arrangement of some of the pages in the *Cantos* because, in the fury of composition, he couldn't always take time to go all the way back to the left margin; he would slap the carriage and wherever it stopped that determined the indent.

PLAIN STYLE *See* DRAB POETRY.

POETRY

The rhythmic creation of beauty in words.

Plato and Aristotle defined poetry as a mode of imitation (mimesis), which along with singing, dancing, and other arts expresses RHYTHMS and emotions. If we add texture, which is made up of logopoeia (voice devices), phanopoeia (sight devices), and melopoeia (sound devices), to the definition, we have a classical definition of poetry.

But how do poets of other ages define poetry?

Wordsworth expresses the Romantic definition of poetry well in the 1800 preface to his and Coleridge's *Lyrical Ballads:*

I have said that Poetry is the spontaneous overflow of powerful feelings: it takes its origin from emotion recollected in tranquillity: the emotion is contemplated till by a species of reaction the tranquillity gradually disappears, and an emotion, similar to that which was before the subject of contemplation, is gradually produced, and does itself actually exist in the mind. In this mood successful composition generally begins, and in a mood similar to this it is carried on; but the emotion, of whatever kind and in whatever degree, from various causes is qualified by various pleasures, so that in describing any passions whatsoever, which are voluntarily described, the mind will upon the whole be in a state of enjoyment.

For Shelley, poetry was quite simply "the record of the best and happiest moments of the happiest and best minds."

For Emily Dickinson, the definition of poetry was inextricably linked to the recognition of it:

If I read a book and it makes my whole body so cold no fire can warm me, I know that is poetry. If I feel physically as if the top of my head were taken off, I know that is poetry. These are the only ways I know it. Is there any other way?

Dylan Thomas defined poetry as a kind of spiritual awakening—"the rhythmic, inevitably narrative, movement from an overclothed blindness to a naked vision."

Robert Frost held to an intuitive perception of poetry: "The right reader of a good poem can tell the moment it strikes him that he has taken an immortal wound—that he will never get over it."

Ezra Pound defined poetry as language charged with meaning, and the greatest poetry as simply language charged to the greatest possible extent.

Several contemporary American poets attempted their own definitions of poetry in a series of NYQ Craft Interviews. James Dickey said that poetry is the way words

come together into some kind of magical conjunction that will make the reader enter into a real experience of his own—*not* the poet's. I don't really believe what literary critics have believed from the beginning of time: that poetry is an attempt of the poet to create or recreate his own experience and to pass it on. I don't believe in that. I believe it's an awakening of the sensibilities of someone else, the stranger.

Erica Jong says that poetry is

voice music. Ancient poetry was all produced for that purpose. And that's still a very strong tradition. . . . When I write, I always hear the voice in my head. I'm baffled that there is even a question about it.

And Gary Snyder commented:

There are all kinds of song. The genres are: work-song, a personal power-vision song, war song, death song, courting song, hunting song—all of these are used by people for their own needs and uses. But the special genre is healing song. The Shaman was the specialist in that. He returned to his power-vision song experience many times and deepened it over and over again, whereas other people had one power-vision song and that was enough. The power of this type of song—the power that the Shaman connects with—enables him to hear and to see a certain classic song which has the capacity to heal. And I think that we could say that self-conscious, quote, "literary" poetry of the sort that has been transmitted for the last two millenniums in the West—the best of it belongs to that genre: healing song.

From a purely technical point of view, the only distinction we can make between poetry and prose is the incidence of poetic devices: ASSONANCE, ALLITERATION, METAPHOR, SIMILE, FIGURE, CONCEIT, and so on; the greater the incidence of poetic devices, the closer the piece in question is to poetry. External form and mere PLACEMENT on the page cannot be the sole determinants of what makes for poetry and what makes for prose.

The final determination of whether or not a piece is poetry rests with the individual reader.

Most poems can be divided into either LYRIC or DRAMATIC POETRY. Lyric poetry consists of lyric poems, odes, idyls, elegies, epics, epithalamions, epigrams, occasional poems, epistles, envois, and ballads, while dramatic poetry includes dramatic plays, dramatic narratives, and limericks. (All these kinds of poetry are defined elsewhere in this book.)

PROJECTIVE VERSE

Poetry where the kinetics of the poet's breath is reflected in the distinctive PLACEMENT on the page. Variously referred to as "Projective" or "Projectile" verse, or "open field composition," the poetry is loosely associated with the teaching and practice of the American poet Charles Olson and other poets who were affiliated with Black Mountain College in North Carolina during the 1940s and 1950s, most notably Paul Blackburn and Robert Duncan. Instead of traditional STANZA formations using left-margin alignment, the movement encouraged clusters of line formations which would occupy indentations relative to each other.

Olson defined his poetry as "a high energy-construct and, at all points, an energy-discharge" which reflected his immediate stance or relationship to the page:

If I hammer, if I recall in, and keep calling, the breath, the breathing as distinguished from the hearing, it is for cause, it is to insist upon a part that breath plays in verse which has not (due, I think, to the smothering of the power of the line by too set a concept of foot) has not been sufficiently observed or practiced, but which has to be if verse is to advance to its proper force and place in the day, now, and ahead. I take it that PROJECTIVE VERSE teaches, is, this lesson, that that verse will only do in which a poet manages to register both the acquisition of his ear *and* the pressures of his breath.

(Charles Olson, "Statement on Poetics," in *The New American Poetry 1945–1960*, edited by Donald Allan)

Statements by other poets concerned with the movement were also influential, most notably those by Robert Creeley, who wrote, "Form is never more than an extension of content." And Edward Dahlberg observed, "One perception must immediately and directly lead to a further perception."

Olson himself exemplified the practice in his *Maximus Poems*, which were a series of letters from the PERSONA Maximus to himself and others:

I have had to learn the simplest things
last. Which made for difficulties.
Even at sea I was slow, to get the hand out, or to cross
a wet deck.
 The sea was not, finally, my trade.
But even my trade, at it, I stood estranged
from that which was most familiar. Was delayed,
and not content with the man's argument
that such postponement
is now the nature of
obedience,
 that we are all late
 in a slow time,
 that we grow up many
 And the single
 is not easily
 known . . .

 (Charles Olson, "Maximus, to himself")

PROSE POETRY

Poetry having a high incidence of sight and sound and voice devices, but with no formal line arrangements; prose poems resemble loose paragraphs and are sometimes called "vignettes."

Well-known writers of prose poems include the French poet Charles Baudelaire, who published a volume titled *Petits Poèmes en Prose* and another, *Paris Spleen*, containing the prose poem "Get Drunk," which Eugene O'Neill cites in his play *Long Day's Journey into Night*. Arthur Rimbaud's *Les Illuminations* and *Une Saison en Enfer* and Stéphane Mallarmé's *Divagations* were in the form of prose poems. Ernest Hemingway includes prose poems between his short stories in *The Collected Short Stories of Ernest Hemingway*.

Antonin Artaud wrote the following prose poem:

All writing is garbage.

People who come from nowhere and try to write out what is going on inside their minds, are pigs.

The literary scene is a pigpen, and never more so than now . . .

<div align="right">

(Antonin Artaud, "Toute l'Écriture,"
tr. William Packard)

</div>

René Char wrote war journals in the form of prose poems:

 2 Don't loiter in the sewer of success.

 15 Children get bored on Sundays.

 31 Adoration of shepherds is no longer useful on this planet.

 56 A poem is furious ascension; poetry is the game of arid banks.

 72 Primitive in action and strategic in foresight.

 78 What matters most of all in certain situations is to master euphoria in time.

 101 Imagination, my child.

 138 A terrible day: I had to watch, from a distance of about one hundred meters, the execution of Bernard. All I had to do was squeeze the trigger of my automatic rifle and he could have been saved! We were on the hill over Céreste, weapons in the woods and at least equal in number with the SS. They did not know we were there. The eyes all around me were begging me to give the signal to open fire, but I shook my head. . . . The June sun shone a cold on my bones.

 He fell as if he could not see his killers, and so lightly, it seemed to me, the least breath of wind would have lifted him off the ground.

 I did not give the signal because the village had to be spared, at any price. But what is a village? A village like any other? Perhaps he knew, at that last instant?

 163 Sing your divine thirst.

 169 Lucidity is the wound nearest to the sun.

<div align="right">

(René Char, *Feuillets d'Hypnos,* tr. William Packard)

</div>

PROSODY

The study of verse as metered language (see METER); the anatomy of RHYTHM. Ezra Pound offered the following definition: "Prosody is the articulation of the total sound of a poem"; and Karl Shapiro described prosody as "sounds moving in time."

The great majority of strongly metered verse in English maintains a consistency and integrity that can be scanned for repeating patterns and textures of ACCENT and rhythms. In addition to metrical scansion, prosody also looks at syllable count, variations of foot, and the inflection of vowel sounds, whether long or short, ascending or descending.

In addition to the introduction of entirely new elements into contemporary prosody, there has also been a radical revision of the way traditional prosody is viewed. Thus Michael Moriarty, the poet and actor, described his own approach to prosody in an NYQ Craft Interview:

> The basic common denominator I have through writing poetry, prose, or acting, is music. And that's my own approach, my only aesthetic now. With each breath either of prose or of poetry there are certain principles of balance to music. Then, no matter what's in it, I never question its integrity or its authenticity. And, the more I look at the world through musical terms, the more I shed outworn modalities, outworn paradigms. And, an example: the diatonic system in Bach's time reached its highest level—then it had to be re-examined, and so the Romantics and the twelve tone series came along, and their creators said: "I don't care what people say; certain notes *can* live together and ought to live together." And they've proven that point well. And the same thing exists in plays and exists in life, like living in New York City. New York is a perfect example where not only certain notes can live together, but certain people can live together brushing elbows every day. People who are antithetical to one another can somehow live in relative peace and harmony. So I think of words, pauses, gestures, and communication generally in terms of music.

PUNCTUATION

Standard or traditional marks to indicate grammatical intervals and conventions in writing. Punctuation can also be orchestrated to indicate musical rhythms and space breaks in a poetic text.

In the 1623 First Folio of Shakespeare's plays, the punctuation is crude;

the more modern punctuation is the work of later editors. Similarly, the original manuscripts of Emily Dickinson's poems eschew conventional punctuation; as her editor, Thomas H. Johnson, comments in his introduction to *The Complete Poems of Emily Dickinson,* "Dickinson used dashes as a musical device, and though some may be elongated end stops, any 'correction' would be gratuitous. Capitalization [is] often capricious. . . ."

Modern poets like E. E. Cummings took punctuation play even further, seeing punctuation as a visual device akin to brushstrokes on a painting. The following poem by Robert Lax is stripped of most punctuation, which gives the lines a sense of being suspended in mid-air:

> the angel came to him & said
>
> i'm sorry, mac, but
> we talked it over
> in heaven
> & you're going
>
> to have to live
> a thousand years
>
> > (Robert Lax, from *33 Poems*)

Q

QUATRAIN

Any STANZA unit of four lines, whether rhymed or unrhymed (see RHYME). The quatrain is the most common stanza form in English poetry, and when rhymed it tends to fall into one of the following four categories:

Shakespearean rhyme	a/b/a/b
Petrarchean rhyme	a/b/b/a
Omar Khayyám stanza	a/a/x/a
Monorhyme	a/a/a/a

R

REFRAIN

A line or lines repeated throughout a poem. The word derives from the past participle of the Latin *refrangere,* "to break"; hence a refrain is a line that is "broken off" from the main body of a poem and keeps coming back; perhaps also, "broken" the way a wave breaks, always falling backwards on itself.

The earliest English BALLADS used either single refrain lines such as the repeated "Edward, Edward" and "mither, mither," or entire refrain stanzas, as in the ballad "Ladie Greensleeves," which has this refrain:

> Greensleeves was all my joy,
> Greensleeves was my delight:
> Greensleeves was my hart of gold,
> And who but Ladie Greensleeves?

William Dunbar uses a single refrain line that recurs throughout his great poem, "Lament for the Makaris":

> *Timor Mortis conturbat me*

And Edmund Spenser uses a single refrain line in "Prothalamion":

> Sweete *Themmes* runne softly, till I end my Song.

Robert Burns uses many refrain lines and stanzas in his poems and songs, as the following shows:

> Green grow the rashes, O;
> Green grow the rashes, O;

The sweetest hours that e'er I spend,
Are spent amang the lasses, O.
(Robert Burns, "Green Grow the Rashes")

Edgar Allan Poe uses a single refrain line in "The Raven":

Quoth the Raven, "Nevermore."

And the contemporary American poet Helen Adam uses a single refrain
line in one of her ballads:

Black is the color of my true love's skin.

REVISION

The act of rewriting, revising, or "re-visioning" one's original draft versions
of a poem. A Latin maxim ascribed to Horace, "ars est celare artem" (art lies
in concealing the art), hints at the enormous labor it takes to make a poem
appear to be effortless and artless.

Ben Jonson testifies to the prodigious labor that must go into the making
of any worthwhile verse:

And, that he,
Who casts to write a living line, must sweat,
 (Such as thine are) and strike the second heat
Upon the *Muses* anvile: turne the same,
 (And himselfe with it) that he thinkes to frame;
Or for the lawrell, he may gaine a scorne,
 For a good *Poet's* made, as well as borne.
And such wert thou . . .

(Ben Jonson, "To the Memory of My Beloved,
the Author, Mr. William Shakespeare:
and What He Hath Left Us")

William Butler Yeats made reference to the endless work of revising and
rewriting his verses, even after they had been published and accepted by his
contemporaries:

The friends that have it I do wrong
Whenever I remake a song,
Do not consider what is at stake:
It is myself that I remake.

Yeats described the arduous task of revision that must always accompany the making and shaping of poetry:

I said: 'A line will take us hours maybe;
Yet if it does not seem a moment's thought,
Our stitching and unstitching has been naught.
Better go down upon your marrow-bones
And scrub a kitchen pavement, or break stones
Like an old pauper, in all kinds of weather;
For to articulate sweet sounds together
Is to work harder than all these, and yet
Be thought an idler by the noisy set
Of bankers, schoolmasters, and clergymen
The martyrs call the world.'

(William Butler Yeats, "Adam's Curse")

The French philosopher and writer Albert Camus even went so far as to describe the problem of revision as if it were a moral question: "It is in order to shine sooner that authors refuse to rewrite. Despicable. Begin again."

Dylan Thomas was in the habit of writing out each poem in longhand as he worked on it, and if he changed even one word, he would recopy the entire poem by hand in order to begin with a fresh copy.

Anne Sexton spoke of the need for endless revision in her poetry in her NYQ Craft Interview: "How do I write? Expand, expand, cut, cut, expand, expand, cut, cut. Do not trust spontaneous first drafts. You can always write more fully."

RHETORIC

Any contrived or studied or artificial expression, hence any phrasing that is insincere, flamboyant, or inadmissably general. Originally, rhetoric referred to classically formulated speaking and writing and meant the art of speaking and writing effectively, employing the principles of composition and appropriate forms; today, however, the word has come to refer to what Webster calls "insincere or grandiloquent language." T. S. Eliot masterfully defines rhetoric as "Any adornment or inflation of speech which is not done for a particular effect but for a general impressiveness." Thus rhetoric would come to be seen as the opposite of simple plain-style speech.

An example of this type of rhetoric occurs in *Hamlet,* where the player is so filled with fustian sentiments and windy phrases that Hamlet eventually has to cut him off:

Out, out, thou strumpet Fortune! All you gods,
In general synod, take away her power;
Break all the spokes and fellies from her wheel,
And bowl the round nave down the hill of heaven,
As low as to the fiends!

(William Shakespeare, *Hamlet,* II.ii)

Another example of rhetoric occurs in *Measure for Measure,* when the harried Isabella tries to describe the lecherous pact that Angelo has tried to make with her:

He would not, but by gift of my chaste body
To his concupiscible intemperate lust,
Release my brother . . .

(William Shakespeare, *Measure for Measure,* V.i)

A macabre example of rhetoric occurs in *Macbeth,* when Lady Macbeth describes the impending murder of Duncan; the speech is filled with inversions and archaisms that seem wholly inappropriate for the occasion:

When Duncan is asleep,—
Whereto the rather shall his day's hard journey
Soundly invite him,—his two chamberlains
Will I with wine and wassail so convince,
That memory, the warder of the brain,
Shall be a fume, and the receipt of reason
A limbeck only: when in swinish sleep
Their drenched natures lie as in a death,
What cannot you and I perform upon
Th' unguarded Duncan? what not put upon
His spongy officers, who shall bear the guilt
Of our great quell?

(William Shakespeare, *Macbeth,* I.vii)

In modern poetry, Hart Crane deliberately invokes the densest rhetoric imaginable to raise his poem to a more exalted level:

Oval encyclicals in canyons leaping
The impasse high with choir. Banked voices slain!

Pagodas, campaniles with reveilles outleaping—
O terraced echoes prostrate on the plain!

(Hart Crane, "The Broken Tower")

Aristotle recommended a certain degree of rhetoric in poetry:

The perfection of diction is that it be at once clear and not pedestrian.
The clearest diction is made up of plain-style words for things. . . .
On the other hand, diction becomes distinguished and not prosy by
the use of unfamiliar terms, i.e., strange words, metaphors, elongated
forms, and whatever deviates from ordinary speech. . . .
 A certain admixture, therefore, of unfamiliar terms is necessary.
These strange words, metaphors, figurative phrases, &c., will keep
the language from seeming pedestrian and prosy, while the plain-style
words will keep the needed clearness. What helps most, however, to
render the diction at once clear and not prosy is the use of the elon-
gated, foreshortened, and altered forms of words.

(Aristotle, *Poetics*)

It is up to the individual poet to determine what constitutes rhetoric in
the sense of showy language, and what constitutes an effective mixture of
familiar and unfamiliar terms.

RHYME

Any sense of resonance among vowels or words that seems to echo previous
sounds and set up a patterning of aural effects. Rhyme probably began as a
strong mnemonic device in early poetry, and may also have been used for
incantatory purposes when closely allied with RHYTHMS to induce a trance
state.
 Rhyme in the broadest sense may include ASSONANCE and ALLITERA-
TION, as well as variations of internal rhyme and end-rhyme that may be
perfect or imperfect, masculine or feminine, and slant or dissonant. Listed
below are examples of each of these variants:

perfect rhyme: way/say/day

imperfect rhyme: dog/bog/hug

masculine rhyme: wear/bear (rhyme falls on last syllable)

feminine rhyme: sailing/failing (rhyme falls on the penultimate, or next-to-
last, syllable)

slant rhyme: love/move

dissonant rhyme: incest/pressure

An endless variety of rhyme patternings can be practiced in poetry; aside from COUPLET rhyme and simple a/b/a/b rhyme formations, perhaps the most intriguing rhyme scheme is *terza rima,* where the middle line of each triplet STANZA becomes the rhyme for the first and third lines of the following triplet stanza:

a b a / b c b / c d c / d e d / e f e / and so on

Dante wrote the entire *Commedia* in terza rima, and Shelley used terza rima in his "Ode to the West Wind."

In the following poem, Robert Herrick alternates masculine and feminine rhymes throughout the poem until the final couplet, which employs a mono-syllabic masculine rhyme:

> A sweet disorder in the dresse
> Kindles in cloathes a wantonnesse:
> A Lawne about the shoulders thrown
> Into a fine distraction:
> An erring Lace, which here and there
> Enthralls the Crimson Stomacher:
> A Cuffe neglectfull, and thereby
> Ribbands to flow confusedly:
> A winning wave (deserving Note)
> In the tempestuous petticote:
> A careless shooe-string, in whose tye
> I see a wilde civility:
> Doe more bewitch me, then when Art
> Is too precise in every part.
>
> (Robert Herrick, "Delight in Disorder")

The English Renaissance was a festival of rhyming, a time of exploration of the various ways rhyme could be used to enforce rhythm and wit and meaning. In *As You Like It,* Touchstone reads out some doggerel with a whole catalogue of forced rhymes, which he calls a "false gallop of verses":

> If a hart do lack a hind,
> Let him seek out Rosalind.

> If the cat will after kind,
> So be sure will Rosalind.
> Winter-garments must be lin'd,
> So must slender Rosalind.
> They that reap must sheaf and bind,
> Then to cart with Rosalind.
> Sweetest nut hath sourest rind,
> Such a nut is Rosalind.
> He that sweetest rose will find
> Must find love's prick and Rosalind.
>
> (William Shakespeare, *As You Like It*, III.ii)

In his SONNETS, Shakespeare experiments magnificently with the uses of rhyme words; in Sonnet 129, he couples no fewer than five internal rhymes using long "A" in the following two lines:

> Past reason hated, as a swallow'd bait
> On purpose laid to make the taker mad: . . .

And in the later *Hamlet*, a good deal of the poignance of Ophelia's mad scene comes from the songs she sings, which contain archaic and oblique rhymes:

> How should I your true love know
> From another one?
> By his cockle hat and staff,
> And his sandal shoon.
>
> He is dead and gone, lady,
> He is dead and gone:
> At his head a grass-green turf,
> At his heels a stone.
>
> White his shroud as the mountain snow,
> Larded with sweet flowers;
> Which bewept to the grave did go
> With true-love showers.
>
> (William Shakespeare, *Hamlet*, IV.v)

But during the Puritan Revolution and the later Restoration period John Milton lashed out against the convention and usage of rhyme. He explained

his reasons for omitting altogether the practice of rhyming in his epic poem *Paradise Lost:*

> The measure is English heroic verse without rhyme, as that of Homer in Greek, and of Virgil in Latin; rhyme being no necessary adjunct or true ornament of poem or good verse, in longer works especially, but the invention of a barbarous age, to set off wretched matter and lame metre; graced, indeed, since by the use of some famous modern poets, carried away by custom, but much to their own vexation, hindrance, and constraint to express many things otherwise, and for the most part worse, than else they would have expressed them.
>
> (John Milton, Statement on the Verse, *Paradise Lost*)

Yet Milton was immediately followed by Alexander Pope, who restored the use of rhyme in his chief works ("Essay on Criticism," "The Rape of the Lock," translations of Homer's *Iliad* and *Odyssey,* and "The Dunciad"), mostly in heroic couplets. The following lines reveal a rather jingly and didactic tendency in rhyming:

> Know then thyself, presume not God to scan;
> The proper study of mankind is Man.
> Placed on this isthmus of a middle state,
> A being darkly wise and rudely great:
> With too much knowledge for the Sceptic side,
> With too much weakness for the Stoic's pride,
> He hangs between; in doubt to act or rest,
> In doubt to deem himself a God or Beast,
> In doubt his mind or body to prefer;
> Born but to die, and reasoning but to err;
> Alike in ignorance, his reason such
> Whether he thinks too little or too much . . .
>
> (Alexander Pope, "Essay on Man")

In the Romantic period, true rhyme reasserted itself in the work of Wordsworth, Coleridge, and Keats. Shelley, who may have had one of the best ears of any modern poet, had difficulty restraining the use of too much rhyme; this is evident in "The Cloud," where he places a CAESURA rhyme on either side of a hemistich:

> I bring fresh showers for the thirsting flowers,
> From the seas and the streams;

I bear light shade for the leaves when laid
 In their noonday dreams.
From my wings are shaken the dews that waken
 The sweet buds every one,
When rocked to rest on their mother's breast,
 As she dances about the sun . . .

 (Percy Bysshe Shelley, "The Cloud")

The Romantic poets were also enormously skilled at the more sophisti-
cated uses of rhyme. The following is an excellent example of patterning in
false rhyme, where the poet alternates perfect and near-perfect rhymes:

Little Lamb,
Here I am; *(perfect rhyme)*
Come and lick
My white neck; *(imperfect rhyme)*
Let me pull
Your soft wool; *(almost perfect rhyme)*
Let me kiss
Your soft face . . . *(imperfect rhyme)*

 (William Blake, "Spring")

Modern poets tend to eschew the formal patterning of rhyme, but they
are still drawn to the extraordinary effects that only rhyme can give their
work. Thus Theodore Roethke exploits false rhyme brilliantly in these lines,
where "dizzy" and "easy" are made to rhyme:

 The whisky on your breath
 Could make a small boy dizzy;
 But I hung on like death:
 Such waltzing was not easy.
 (Theodore Roethke, "My Papa's Waltz")

In "What Are Years," Marianne Moore uses *occasional rhyme* in each
stanza; the first and third lines rhyme with each other, and the last two lines
rhyme with each other:

 So he who strongly feels,
 behaves. The very bird,
 grown taller as he sings, steels

his form straight up. Though he is captive,
his mighty singing
says, satisfaction is a lowly
thing, how pure a thing is joy.
 This is mortality,
 this is eternity.

 (Marianne Moore, "What Are Years")

And in "Man and Wife," Robert Lowell employs *random rhyme,* casually
dipping in and out of a formal rhyme patterning. The opening lines of the
poem are rhymed couplets, but as the poem proceeds the poet seems to allow
the lines to find their own rhyme sequences:

Tamed by *Miltown,* we lie on Mother's bed;
the rising sun in war paint dyes us red;
in broad daylight her gilded bed-posts shine,
abandoned, almost Dionysian.
At last the trees are green on Marlborough Street,
blossoms on our magnolia ignite
the morning with their murderous five days' white.
All night I've held your hand,
as if you had
a fourth time faced the kingdom of the mad—
its hackneyed speech, its homicidal eye—
and dragged me home alive. . . . Oh my *Petite,*
clearest of all God's creatures, still all air and nerve:
you were in your twenties, and I,
once hand on glass
and heart in mouth,
outdrank the Rahvs in the heat
of Greenwich Village, fainting at your feet—
too boiled and shy
and poker-faced to make a pass,
while the shrill verve
of your invective scorched the traditional South.

Now twelve years later, you turn your back.
Sleepless, you hold
your pillow to your hollows like a child;

your old-fashioned tirade—
loving, rapid, merciless—
breaks like the Atlantic Ocean on my head.

(Robert Lowell, "Man and Wife")

Rhyme will always have a very special place in the practice of light verse.
A good deal of the humor in poems by Edward Lear and Lewis Carroll, and
in the operettas of Gilbert and Sullivan, comes from the use of surprise
rhyme, a ludicrous or unexpected rhyme which usually results in some rever-
sal or revelation. For example, the whole point of Ogden Nash's brief poem
is in the surprise rhyme:

I would live all my life in nonchalance and insouciance
Were it not for making a living, which is rather a nouciance.

(Ogden Nash, "Introspective Reflection")

The following couplet by Walter James Miller is another example of
surprise rhyme:

She's in her latency:
We'll have to wait and see.

An absolutely abominable example of surprise rhyme—or the absence of
an expected rhyme—is the following anonymous QUATRAIN:

Roses are red
Violets are blue,
I'm schizophrenic
And so am I.

RHYTHM

The immeasurable music in poetry, above and beyond mere metrics, that is
characterized by cadence, pace, and ongoing momentum. Poetic rhythms
embody and echo the larger rhythms of the universe—the rhythms of breath-
ing, of the heartbeat, of day and night, of birth and maturity and death, of
the seasons, of tides, of the menstrual cycle, and of the agricultural fertility
cycle of ploughing and seed-time and harvest.

Poetic rhythms are usually made up of individual elements, such as

METER, vowel sounds, RHYMES, DICTION textures, and VOICE, all working together to achieve a single effect. Rising rhythms seem to lift a line upward in an ascension pattern, while falling rhythms seem to create a sense of diminishment toward the end of a line.

In the following lines, Christopher Marlowe uses five strong assonantal rhymes (see ASSONANCE) in two lines to create a breathtaking effect of desperate ascension:

> O Ile leape up to my God: who pulls me downe?
> See, see where Christ's blood streames in the firmament . . .
>
> (Christopher Marlowe, *Doctor Faustus*)

Here John Milton creates a hurtling rhythm that seems to cascade over the ENJAMBEMENTS to simulate the overwhelming power of Satan's violent expulsion from heaven:

> Him the Almighty Power
> Hurl'd headlong flaming from the ethereal sky,
> With hideous ruin and combustion, down
> To bottomless perdition; there to dwell
> In adamantine chains and penal fire,
> Who durst defy the Omnipotent to arms.
>
> (John Milton, *Paradise Lost*)

John Keats uses assonance and ALLITERATION and a lapsed iambic beat to create a diminishment effect, the rhythm creating a tone of extreme lassitude and hopelessness:

> The weariness, the fever and the fret
> Here, where men sit and hear each other groan . . .
>
> (John Keats, "Ode to a Nightingale")

Gerard Manley Hopkins uses "sprung rhythm" meter and a peculiar sort of forced rhyme to create a gentle cacophony in his poetry. Sprung rhythm counts the number of stresses per line as normally sounded in everyday speech; the peculiarity of sprung rhythm is that these stresses will sometimes seem to pile up or impinge on one another, going against the expectation of a more conventional metrical scansion.

> Márgaret, áre you grieving
> Over Goldengrove unleaving?

Léaves, like the things of man, you
.With your fresh thoughts care for, can you?

> (Gerard Manley Hopkins, "Spring and Fall,
> to a young child")

Walt Whitman uses a loose anapestic meter to create a musical gait of meditative rhythm:

The youth lies awake in the cedar-roof'd garret and harks to the musical
 rain . . .

> (Walt Whitman, "Song of Myself")

W. H. Auden uses a sprightly trimeter line to recreate the casual rhythm of walking:

> As I walked out one evening,
> Walking down Bristol Street,
> The crowds upon the pavement
> Were fields of harvest wheat.
>
> And down by the brimming river
> I heard a lover sing
> Under an arch of the railway:
> "Love has no ending . . ."

> (W. H. Auden, "As I walked out one evening")

ROMANTICISM

A period ranging roughly over the eighteenth and nineteenth centuries, broadly including the theory and practice of poets such as Blake, Shelley, Wordsworth, Coleridge, Keats, and Byron. The basic statement of Romantic principles was published in 1800 as Wordsworth's preface to the *Lyrical Ballads:*

> The principal object, then, proposed in these Poems, was to choose incidents and situations from common life, and to relate or describe them throughout, as far as was possible, in a selection of language really used by men. . . . For all good poetry is the spontaneous over-flow of powerful feelings . . . it takes its origin from emotion recollected in tranquillity. . . .

From this and other sources are derived the basic tenets of Romanticism in poetry and literature and art, as follows:

Reverence for nature: As a reaction against the Industrial Revolution, Romanticism preached a contempt for cities and city living, a contempt for the exploitation of women and children in factories and sweat-shops, and an idealization of a pastoral life that is uncontaminated by industrialization.

Reverence for the child: Wordsworth calls the child "Nature's priest" in his "Ode," and the other Romantics taught a reverence for innocence and primal consciousness which was unconditioned by civilization and logic and rationalism. The Romantics substituted a religion of pure intuition for reason.

Reverence for the individual: The Romantics believed that each self had unique impulses which led naturally to God, therefore the individual was *ipso facto* more important than Church or State or Tradition.

Social criticism: The Romantics heartily approved of the American (1776) and French (1789) revolutions. The American Declaration of Independence spoke of "self-evident" truths which were more intuitive than rational, and asserted that all men were endowed with certain "inalienable" rights; similarly, the French Revolution hailed a tripartite banner of "Liberty, Equality, Fraternity"—all things which the Romantics could readily espouse. It was only after the Reign of Terror toward the end of the French Revolution that most Romantics felt betrayed by these revolutionary ideals.

Because the Industrial Revolution had centered in England, it was natural that Romanticism should arise as a reaction against modern urban industrialization in England.

The Romantic reaction registered strong protest against the dehumanization of the human heart, reasserted primal values of love and compassion and emotion, and gave strong impetus to modern ideas of democracy and the dignity of all men and women.

RONDEL

A simple song, usually in strict stanzaic form (see STANZA) using REFRAIN, RHYME, and METER. The oldest extant rondel was composed in 1240 by a Reading monk:

Sumer is icumen in
 Llude sing cuccu!
Groweth sed and bloweth med
 And springth the wude nu:
 Sing cuccu!

 Cuckoo, cuckoo, well singest thou cuckoo;
 Cease thou not, never now;
 Sing cuckoo now, sing cuckoo,
 Sing cuckoo, sing cuckoo, now!

Chaucer's "Merciles Beautè" is an example of a triple rondel, where the refrain lines take part in a pattern of increasing repetition:

Your yën two wol slee me sodenly,
I may the beautè of hem not sustene,
So woundeth hit through-out my herte kene.

And but your word wol helen hastily
My hertes wounde, whyl that hit is grene,
 Your yën two wol slee me sodenly,
 I may the beautè of hem not sustene.

Upon my trouth I sey yow feighfully,
That ye ben of my lyf and deeth the quene;
For with my deeth the trouthe shal be sene.
 Your yën two wol slee me sodenly,
 I may the beautè of hem not sustene,
 So woundeth hit through-out my herte kene.

 (Geoffrey Chaucer, "Merciles Beautè")

S

SATIRE

Traditionally, any comment on contemporary social or political or artistic affairs that tends to hold prevailing vices and follies up to ridicule.

Among the earliest examples of satire are the plays of Aristophanes, in which he lampooned the excesses of Athenian life, including the plays of Euripides and the teachings of Socrates.

In Latin poetry, Horace wrote two books of *Satires;* Juvenal pilloried contemporary poets and poetry in his *Satires;* and Petronius authored the *Satyricon,* a ribald classic of prose and verse.

There is a strong satirical element in Dante's *Commedia,* especially in the *Inferno* and the *Purgatorio,* where Dante lashes out at corruption and madness in thirteenth-century Florence and Christendom.

During the English Renaissance, satire was often present in Shakespeare's early comedies, and Ben Jonson sought to ridicule men and manners according to the theory of humours in his play *The Alchemist.*

The seventeenth and eighteenth centuries saw satire reach its full scope. Daniel Defoe wrote allegorical satire in *Robinson Crusoe,* where he ridiculed the gullibility of idealizing man in a state of nature. Jonathan Swift wrote allegorical satire in *Gulliver's Travels,* and in 1739 he commented on his strong penchant for satire:

> 'Perhaps I may allow the Dean
> Had too much satire in his vein;
> And seem'd determined not to starve it,
> Because no age could more deserve it.
> Yet malice never was his aim;
> He lash'd the vice, but spar'd the name.
> No individual could resent,
> Where thousands equally were meant;

> His satire points at no defect,
> But what all mortals may correct;
> For he abhorr'd that senseless tribe
> Who call it humour when they gibe:
> He spar'd a hump, or crooked nose,
> Whose owners set not up for beaux . . .'
>
> (Jonathan Swift, "Verses on the Death
> of Doctor Swift")

Alexander Pope also set out to pillory prevailing excesses of taste and manner in "The Dunciad," especially the poetasters of his time:

> Three College Sophs, and three pert Templars came,
> The same their talents, and their tastes the same;
> Each prompt to query, answer, and debate,
> And smit with love of Poesy and Prate . . .
>
> (Alexander Pope, "The Dunciad")

The Romantic movement tended to be more idealistic than satirical, although poets like Blake and Shelley could rip off acid satires when the mood struck them. Byron was probably the leading satirist of his day, composing satirical poems like "The Age of Bronze" and his masterwork, *Don Juan.* This epic satire in sixteen cantos manages to savage most of the mores of Byron's time, including the personalities of Coleridge, Southey, and other leading figures.

Modern poetry is punctuated by satire at practically every turn. T. S. Eliot's *The Waste Land* is filled with satirical portraits of men and women who are living lives of utter meaninglessness. And Ezra Pound gives quick satirical portraits of personalities he knew in London:

> At the age of 27
> Its home mail is still opened by its maternal parent
> And its office mail may be opened by
> its parent of the opposite gender.
> It is an officer,
> and a gentleman,
> and an architect.
>
> (Ezra Pound, "Sketch 48 B II")

Similarly, E. E. Cummings wrote unrelentingly biting satire, as in this sonnet
ridiculing the rhetoric of demagogues:

> "next to of course god america i
> love you land of the pilgrims' and so forth oh
> say can you see by the dawn's early my
> country 'tis of centuries come and go
> and are no more what of it we should worry
> in every language even deafanddumb
> thy sons acclaim your glorious name by gorry
> by jingo by gee by gosh by gum
> why talk of beauty what could be more beaut-
> iful than these heroic happy dead
> who rushed like lions to the roaring slaughter
> they did not stop to think they died instead
> then shall the voice of liberty be mute?"
>
> He spoke. And drank rapidly a glass of water.
>
> (E. E. Cummings, "next to of course god")

The American poet J. V. Cunningham develops a series of satirical QUA-
TRAINS which ridicule specific psychological types, such as the following:

> You ask me how *Contempt* who claims to sleep
> With every woman that has ever been
> Can still maintain that women are skin deep?
> They never let him any deeper in.
>
> (J. V. Cunningham, "The Exclusions of a Rhyme")

And Allen Ginsberg develops a scathing satire in his poem "America":

> America I've given you all and now I'm nothing.
> America two dollars and twentyseven cents January 17, 1956.
> I can't stand my own mind.
> America when will we end the human war?
> Go fuck yourself with your atom bomb.
> I don't feel good don't bother me.
> I won't write my poem till I'm in my right mind.
> America when will you be angelic?
> When will you take off your clothes?
> When will you look at yourself through the grave?

When will you be worthy of your million Trotskyites?
America why are your libraries full of tears?
I'm sick of your insane demands.
When can I go into the supermarket and buy what I need with my good
 looks?
America after all it is you and I who are perfect not the next world.

(Allen Ginsberg, "America")

SCANSION *See* METER.

SENTENCES

Strong VOICE in poetry is expressed through the four different types of
sentences in English GRAMMAR: declarative, imperative, interrogative, and
exclamatory. The following are examples of poetic lines that derive their force
from the type of sentence they illustrate:

Declarative—makes a statement:

The One remains, the many change and pass.

(Percy Bysshe Shelley, "Adonais")

Interrogative—asks a question:

Should auld acquaintance be forgot
And never brought to mind?

(Robert Burns, "Auld Lang Syne")

Imperative—gives a command:

At the round earths imagin'd corners, blow
Your trumpets, Angells, and arise, arise
From death, you numberlesse infinities
Of soules, and to your scattred bodies goe . . .

(John Donne, "Holy Sonnet VII")

Exclamatory—makes an outcry or ejaculation:

They are all gone into the world of light!

(Henry Vaughan, "They are all gone
into the world of light")

SESTINA

An intricate verse form of repeating end words, of Troubadour (see JON-GLEUR) origin, generally ascribed to Arnaut Daniel and taken from Proven-çal to Italian by Dante (*rime pietrose* are famous sestinas by Dante) and Petrarch.

A sestina has six STANZAS of six lines each, with a concluding coda or ENVOI of three lines. Each stanza repeats the same six key end words accord-ing to the following sequence:

$$1 \longrightarrow 2 \longrightarrow 4 \longrightarrow 5 \longrightarrow 3 \longrightarrow 6$$

The end word of line 1 of any stanza becomes the end word of line 2 of the following stanza. The end word of line 2 becomes that of line 4 of the following stanza. The end word of line 4 becomes that of line 5 of the following stanza. And so on.

We can see how this sequencing occurs by looking at Ezra Pound's "Sestina: Altaforte," which is written in the VOICE of Bertrans de Born, a Medieval Troubadour who is crying out for war and bloodshed:

I Damn it all! all this our South stinks peace.
You whoreson dog, Papiols, come! Let's to music!
I have no life save when the swords clash.
But ah! when I see the standards gold, vair, purple, opposing
And the broad fields beneath them turn crimson,
Then howl I my heart nigh mad with rejoicing.

II In hot summer have I great rejoicing
When the tempests kill the earth's foul peace,
And the lightnings from black heav'n flash crimson,
And the fierce thunders roar me their music
And the winds shriek through the clouds mad, opposing,
And through all the riven skies God's swords clash.

III Hell grant soon we hear again the swords clash!
And the shrill neighs of destriers in battle rejoicing,
Spiked breast to spiked breast opposing!
Better one hour's stour than a year's peace
With fat boards, bawds, wine and frail music!
Bah! there's no wine like the blood's crimson!

IV And I love to see the sun rise blood-crimson.
 And I watch his spears through the dark clash
 And it fills all my heart with rejoicing
 And pries wide my mouth with fast music
 When I see him so scorn and defy peace,
 His lone might 'gainst all darkness opposing.

V The man who fears war and squats opposing
 My words for stour, hath no blood of crimson
 But is fit only to rot in womanish peace
 Far from where worth's won and the swords clash
 For the death of such sluts I go rejoicing;
 Yea, I fill all the air with my music.

VI Papiols, Papiols, to the music!
 There's no sound like to swords swords opposing,
 No cry like the battle's rejoicing
 When our elbows and swords drip the crimson
 And our charges 'gainst "The Leopard's" rush clash.
 May God damn for ever all who cry "Peace!"

VII And let the music of the swords make them crimson!
 Hell grant soon we hear again the swords clash!
 Hell blot black for alway the thought "Peace!"

 (Ezra Pound, "Sestina: Altaforte")

In the first stanza above, the end words are as follows:

1 peace
2 music
3 clash
4 opposing
5 crimson
6 rejoicing

In the second stanza, these words rearrange their order according to the 1-2-4-5-3-6 sequence, as follows:

1 rejoicing
2 peace

3 crimson
4 music
5 opposing
6 clash

In the three-line coda the key words are arranged music/crimson/clash/
peace. Note there are three peculiarities to this sestina: first, Pound does not
include all six key words in the coda; second, Pound uses additional repeating
words, such as swords/heart/blood, within the sestina lines, although they
are not key end words; third, the fourth stanza takes license with the 1-2-4-
5-3-6 sequence, transposing the end words in lines 3 and 4.

SIMILE

An indirect comparison, using *like* or *as*.

> O my luve's like a red, red rose
> That's newly sprung in June . . .
> (Robert Burns, "A Red, Red Rose")

Other examples of *simple simile,* which compares a single subject with an
image, are

> As the hart panteth after the water brooks, so panteth my soul after
> thee, O God.
>
> (Psalm 42:1)

> Bright star! would I were steadfast as thou art—
>
> (John Keats, Last Sonnet)

> The soul of Adonais, like a star,
> Beacons from the abode where the Eternal are.
> (Percy Bysshe Shelley, "Adonais")

Similes can be more extended and complex. When similes become so
drawn out that they seem to digress from the subject, they are called *heroic*
or *Homeric similes*. Gilbert Murray describes these as similes where a poet
says A is like B, but then proceeds to describe B in so much detail that points
are added to it that have absolutely nothing to do with A. An example of

this heroic or Homeric simile can be seen in the following lines from Homer's *Iliad:*

> From the camp
> the troops were turning out now, thick as bees
> that issue from some crevice in a rock face,
> endlessly pouring forth to make a cluster
> and swarm on blooms of summer here and there,
> glinting and droning, busy in bright air.
> Like bees innumerable from ships and huts
> down the deep foreshore streamed those regiments
> toward the assembly ground—and rumor blazed
> among them like a crier sent from Zeus.
> Turmoil grew in the great field as they entered
> and sat down, clangorous companies, the ground
> under them groaning, hubbub everywhere . . .
>
> (Homer, *Iliad,* tr. Robert Fitzgerald)

There are heroic similes in Virgil's *Aeneid:*

> As in the African hinterland a lion,
> Hit in the chest by hunters, badly hurt,
> Gives battle then at last and revels in it,
> Tossing his bunch of mane back from his nape;
> All fighting heart, he snaps the shaft the tracker
> Put into him, and roars with bloody maw.
> So Turnus in the extremity flared up
> And stormed at the old king . . .
>
> (Virgil, *Aeneid,* tr. Robert Fitzgerald)

An *epic simile* usually conjoins a single image with a single subject, in order to clarify or exalt the thing being compared:

> As he who dreams sees, and when disappears
> The dream, the passion of its print remains,
> And naught else to the memory adheres,
> Even such am I; for almost wholly wanes
> My vision now, yet still the drops I feel
> Of sweetness it distilled into my veins.
>
> (Dante Alighieri, *Paradiso,* canto 33,
> tr. Laurence Binyon)

Another extraordinary example of epic simile occurs in the same canto, where Dante compares his own incomprehension at the mystery of the Trinity with the ancient mathematical dilemma of trying to square the circle:

> As the geometer who bends all his will
> To measure the circle, and howsoe'er he try
> Fails, for the principle escapes him still,
> Such at this mystery new-disclosed was I,
> Fain to understand how the image doth alight
> Upon the circle, and with its form comply.

In *dramatic simile,* a single-image comparison helps advance the dramatic action of the play. In *Julius Caesar,* Cassius uses dramatic simile to persuade Brutus to conspire against Caesar:

> Why, man, he doth bestride the narrow world
> Like a Colossus; and we petty men
> Walk under his huge legs, and peep about
> To find ourselves dishonourable graves . . .
>
> (William Shakespeare, *Julius Caesar,* I.ii)

In *Romeo and Juliet,* Juliet urges the sun to set so she can be with Romeo:

> Gallop apace, you fiery-footed steeds,
> Towards Phoebus' lodging; such a waggoner
> As Phaethon would whip you to the west,
> And bring in cloudy night immediately . . .
>
> (William Shakespeare, *Romeo and Juliet,* III.ii)

Occasionally Shakespeare scrambles images in a dramatic simile to give the sense of accumulated rhetorical power:

> Our revels now are ended. These our actors,
> As I foretold you, were all spirits and
> Are melted into air, into thin air:
> And, like the baseless fabric of this vision,
> The cloud-capp'd towers, the gorgeous palaces,
> The solemn temples, the great globe itself,

Yea, all which it inherit, shall dissolve
And, like this insubstantial pageant faded,
Leave not a rack behind. We are such stuff
As dreams are made on, and our little life
Is rounded with a sleep . . .

(William Shakespeare, *The Tempest*, IV.i)

In the modern period, T. S. Eliot uses simple simile in the opening lines
of "The Love Song of J. Alfred Prufrock":

Let us go then, you and I,
When the evening is spread out against the sky
Like a patient etherised upon a table . . .

(T. S. Eliot, "The Love Song of J. Alfred Prufrock")

Dylan Thomas uses simile in a VILLANELLE:

Blind eyes could blaze like meteors and be gay.

(Dylan Thomas, "Do Not Go Gentle
into That Good Night")

And there is a remarkably graphic and apt simile in the following lines,
where the poet describes the sight of birch trees bent over in the woods:

You may see their trunks arching in the woods
Years afterwards, trailing their leaves on the ground
Like girls on hands and knees that throw their hair
Before them over their heads to dry in the sun.

(Robert Frost, "Birches")

SONG

From the French chanson, any poem that is set to music; or any poem having
strong and lyrical musical RHYTHMS.

The strongest language in the Old Testament tends to take the form of
song. Thus the Psalms of King David were originally sung to harp accom-
paniment; David called himself "the sweet psalmist of Israel." The Song of
Solomon, written in the fourth century B.C., is similarly lyrical and songlike
in its strong, clear rhythms.

During the Medieval period, the Troubadour tradition was based on pure song and comes down to us in English in such anonymous poems as "Cuckoo Song," "The Irish Dancer," "I Sing of a Maiden," "Corpus Christi Carol," and "The Jolly Shepherd." By the fourteenth century, Chaucer filled his *Canterbury Tales* and *Troilus and Criseyde* with songs and songlike lyrical rhythms.

In the English Renaissance songs and songbooks filled with CAROLS and LYRICS and madrigals by such poets as John Lyly, Nicholas Breton, Sir Walter Ralegh, and George Chapman were quite popular. The anonymous poem "A Pedlar" both imitates and comments on the singing of an itinerant street merchant:

> Fine knacks for ladies, cheap, choice, brave and new!
> Good pennyworths! but money cannot move.
> I keep a fair but for the Fair to view;
> A beggar may be liberal of love.
> Though all my wares be trash, the heart is true.
>
> Great gifts are guiles and look for gifts again;
> My trifles come as treasures from my mind.
> It is a precious jewel to be plain;
> Sometimes in shell the orient's pearl we find.
> Of others take a sheaf, of me a grain.
>
> Within this pack pins, points, laces, and gloves,
> And divers toys fitting a country fair,
> But in my heart, where duty serves and loves,
> Turtles and twins, court's brood, a heavenly pair.
> Happy the heart that thinks of no removes!

By far the best examples of song in our language are poems in Shakespeare's plays that serve as lyric interludes to the dramatic action:

> It was a lover and his lass,
> With a hey, and a ho, and a hey nonino,
> That o'er the green corn-field did pass,
> In the spring time, the only pretty ring time,
> When birds do sing, hey ding a ding ding;
> Sweet lovers love the spring . . .

(William Shakespeare, *As You Like It,* V.iii)

Tell me where is fancy bred,
Or in the heart or in the head?
How begot, how nourished?
 Reply, reply.
It is engender'd in the eyes,
With gazing fed; and fancy dies
In the cradle where it lies.
 Let us all ring fancy's knell:
 I'll begin it,—Ding, dong, bell.

(William Shakespeare,
The Merchant of Venice, III.ii)

The tradition of song in poetry continues into the eighteenth century
with Christopher Smart's "Song to David" and William Blake's *Songs of
Innocence and Experience*. Song also merged with liturgy and choral works, as
in Schiller's "Ode to Joy," which Beethoven set to music in his Ninth Sym-
phony.

Robert Burns set many of his poems and songs to preexisting Scottish
melodies, hence their strong and lyrical musical rhythms:

Ye flowery banks o' bonie Doon,
 How can ye blume sae fair;
How can ye chant, ye little birds,
 And I sae fu' o' care!

(Robert Burns, "The Banks o' Doon")

In modern poetry, the alienation and estrangement of the contemporary
world may seem to militate against the preeminence of song. T. S. Eliot
entitled his early poem "The Love Song of J. Alfred Prufrock" with mocking
irony, and the last lines of the poem seem to despair of the efficacy of song:

Shall I part my hair behind? Do I dare to eat a peach?
I shall wear white flannel trousers, and walk upon the beach.
I have heard the mermaids singing, each to each.

I do not think that they will sing to me . . .

(T. S. Eliot, "The Love Song of J. Alfred Prufrock")

But Ezra Pound was content to entitle his major epic poem *Cantos* in
tribute to the enduring nature of song, and at its height it reaches lyric
splendors that can be associated only with song:

What thou lovest well remains,
 the rest is dross
What thou lov'st well shall not be reft from thee
What thou lov'st well is thy true heritage
Whose world, or mine or theirs
 or is it of none?
First came the seen, then thus the palpable
 Elysium, though it were in the halls of hell
What thou lovest well is thy true heritage
What thou lov'st well shall not be reft from thee . . .
 (Ezra Pound, "Canto LXXXI")

Contemporary song generally falls under the rubric of rock music, although many scholars refuse to acknowledge rock music as poetry. Yet rock lyrics should be regarded with the same analytical eye as songs in Shakespeare's plays; the lyrics to many of Bob Dylan's compositions, for example, are generally acknowledged to represent the pinnacle of contemporary songwriting and should be taken seriously:

> Lay Lady Lay
> lay across my big brass bed
> lay lady lay
> lay across my big brass bed
>
> whatever colors you have
> in your mind
> I'll show them to you
> and you'll see them shine
>
> Lady lady lay
> lay across my big brass bed
> stay lady stay
> stay with your man awhile . . .
> (Bob Dylan, "Lay, Lady, Lay")

Judy Collins, another contemporary musician noted for her lyrics, achieves extraordinary poignance through the use of simple, plain-style language:

> My father always promised us that we
> would live in France.

> We'd go boating on the Seine and I
> would learn to dance.
> We lived in Ohio then and he worked
> in the mines.
> Honest dreams, like boats, we knew
> would sail in time.
>
> (Judy Collins, "My Father")

To be sure, there is a natural resentment on the part of our schools against these songs and poems of rock. How dare someone like Bob Dylan come along with his awkward voice and his guitar and harmonica, and set up as a major poet? It's an affront to the entire graduate-degree, university structure. Besides, there has always been a prejudice that anything which is popular can't be much good—it's uncouth and vulgar and cliché, therefore vernacular in the extreme.

Well, let the schools and universities grouse all they want to about rock. Over half a century ago, Robert Frost wrote the answer to this:

> I have wished a bird would fly away,
> And not sing by my house all day;
>
> Have clapped my hands at him from the door
> When it seemed as if I could bear no more.
>
> The fault must partly have been in me.
> The bird was not to blame for his key.
>
> And of course there must be something wrong
> In wanting to silence any song.
>
> (Robert Frost, "A Minor Bird")

SONNET

A fourteen-line poem usually with octet/sestet separation of eight- and six-line formations, usually with a RHYME scheme in either Shakespearean or Petrarchean sequence. The sonnet form first appeared around the year 1221 in Italian poetry.

The outstanding practitioners of the sonnet form include the following:

Dante Alighieri (1265–1321) Sir Thomas Wyatt (1503–1542)
Francesco Petrarch (1304–1374) Henry Howard, Earl of Surrey
Geoffrey Chaucer (c. 1344–1400) (1517?–1547)

Edmund Spenser (1552–1599)
Sir Philip Sidney (1554–1586)
Mark Alexander Boyd (1563–1601)
William Shakespeare (1564–1616)
John Donne (1571–1631)
John Milton (1608–1674)
William Wordsworth (1770–1850)
Percy Bysshe Shelley (1792–1822)
John Keats (1795–1821)

Gerard Manley Hopkins (1844–1889)
Robert Frost (1874–1963)
Rainer Maria Rilke (1875–1927)
Edna St. Vincent Millay (1892–1950)
E. E. Cummings (1894–1962)
Allen Tate (1899–1979)
John Berryman (1914–1972)
Robert Lowell (1917–1977)

The most common rhyme schemes for the sonnet include the following:

Shakespearean rhyme scheme: a/b/a/b/c/d/c/d/e/f/e/f/g/g

Petrarchean rhyme scheme: a/b/b/a/a/b/b/a/ c/e/f/g/e/f/ (sestet in this scheme can vary)

Spenserian rhyme scheme: a/b/a/b/b/c/b/c/c/d/c/d/e/e

Diaspora rhyme scheme: a/b/a/b/c/b/c/d/c/d/e/d/e/e

Shakespeare's Sonnet 18 can serve as a model for the Shakespearean sonnet form:

LINE NO.		RHYME SCHEME
1	Shall I compare thee to a summer's day?	a
2	Thou art more lovely and more temperate:	b
3	Rough winds do shake the darling buds of May,	a
4	And summer's lease hath all too short a date:	b
5	Sometimes too hot the eye of heav'n shines,	c
6	And often is his gold complexion dimm'd:	d
7	And every fair from fair sometimes declines,	c
8	By chance, or nature's changing course untrimm'd.	d
9	But thy eternal summer shall not fade	e
10	Nor lose possession of that fair thou owest;	f
11	Nor shall death brag thou wanderest in his shade,	e
12	When in eternal lines to time thou growest:	f

| 13 | So long as men can breathe, or eyes can see, | g |
| 14 | So long lives this, and this gives life to thee. | g |

The *octet* of the poem above includes lines 1–8, or the opening two QUA-TRAINS (lines 1–4, 5–8); the *sestet* includes lines 9–14, or the third quatrain and a COUPLET at the end (lines 9–12, 13–14). Between the octet and the sestet there is a *pivot,* or *volta,* which represents a slight shift or tilting or refraction of the main line of thought in the poet. In the poem above, the pivot occurs between lines 8 and 9.

The usual line for the Shakespearean sonnet form is iambic pentameter (see METER), as in the poem above. Sometimes the opening foot of the sonnet begins with a trochee before the poem falls into a regular pentameter meter.

While Sonnet 18 may be taken as a model for the sonnet form, Shakespeare experimented throughout his sonnet cycle—thus Sonnet 99 has fifteen lines; Sonnet 126 has twelve lines and is written entirely in rhymed couplets; and Sonnet 145 is written in tetrameter rather than pentameter. In other sonnets Shakespeare practices delaying the pivot in the poem, as in Sonnet 30, where it does not occur until line thirteen.

An extended sequence of sonnets is called a *crown of sonnets.* This sequence is usually made up of seven Italianate or Petrarchan sonnets, and the last line of each of the first six sonnets becomes the first line of each succeeding sonnet, and the last line of the seventh sonnet echoes the first line of the first sonnet. A *sonnet redoublé* is a group of fifteen sonnets where each line of the first sonnet becomes the final line in each of the succeeding fourteen sonnets. It is important to remember that these sonnet sequences are not narrative devices: as C. S. Lewis notes in *English Literature in the Sixteenth Century (Excluding Drama),*

> The first thing to grasp about the sonnet sequence is that it is not a way of telling a story. It is a form which exists for the sake of prolonged lyrical meditation, chiefly on love but relieved from time to time by excursions into public affairs, literary criticism, compliment, or what you will.

Sir Thomas Wyatt is generally credited with carrying the Italian sonnet form over into English poetry through his translations of the poems of Petrarch. The following sonnet is in the Petrarchan rhyme scheme:

> Who so list to hunt, I knowe where is an hynde,
> But as for me, helas, I may no more:

The vayne travaill hath weried me so sore.
I ame of theim that farthest commeth behinde;
Yet may I by no meanes my weried mynde
Draw from the Diere: but as she fleeth afore,
Fayntng I folowe. I leve off therefore,
Sins in a nett I seke to hold the wynde.
Who list her hount, I put him owte of doubte,
As well as I may spend his tyme in vain:
And, graven with Diamonds, in letters plain
There is written her fairer neck rounde abowte:
 Noli me tangere, for Cesars I ame;
 And wylde for to hold, though I seme tame.

 (Sir Thomas Wyatt, "Who so list to hunt")

The following poem by Michael Drayton is in a Shakespearean rhyme scheme, and has the distinction of delaying the pivot of the whole poem until the very last line:

Since ther's no helpe, Come let us kisse and part,
Nay, I have done: You get no more of Me,
And I am glad, yea glad withall my heart,
That thus so cleanly, I my Selfe can free,
Shake hands for ever, Cancell all our Vowes,
And when We meet at any time againe,
Be it not seene in either of our Browes,
That We one jot of former Love reteyne;
Now at the last gaspe, of Loves latest Breath,
When his pulse fayling, Passion speechlesse lies,
When Faith is kneeling by his bed of Death,
And innocence is closing up his Eeyes,
 Now if thou would'st, when all have given him over,
 From Death to Life thou might'st him yet recover.

 (Michael Drayton, "Since ther's no helpe")

During the Romantic period, Wordsworth and Keats wrote sonnets with Petrarchean rhyme schemes, in imitation of the Italian models they so admired—thus Wordsworth's "Upon Westminster Bridge" and "The World Is Too Much with Us" are Petrarchean, as are Keats' "On First Looking into Chapman's Homer," "When I Have Fears That I May Cease to Be," and "Bright Star, Would I Were Steadfast as Thou Art." However, Shelley's

"Ozymandias" and "England in 1810" exhibit Shakespearean rhyme schemes.

In modern poetry, sonnets seem to be evenly divided between Shakespearean and Petrarchean models. Thus Gerard Manley Hopkins uses a Petrarchean rhyme scheme for the following sonnet, which is a loose translation of the twelfth chapter of Jeremiah in the Old Testament:

Thou art indeed just, Lord, if I contend
With thee; but, sir, so what I plead is just.
Why do sinners' ways prosper? and why must
Disappointment all I endeavor end?
 Wert thou my enemy, O thou my friend,
How wouldst thou worse, I wonder, than thou dost
Defeat, thwart me? Oh, the sots and thralls of lust
Do in spare hours more thrive than I that spend,
Sir, life upon thy cause. See, banks and brakes
Now, leavèd how thick! lacèd they are again
With fretty chervil, look, and fresh wind shakes
Them; birds build—but not I build; no, but strain,
Time's eunuch, and not breed one work that wakes.
Mine, O thou lord of life, send my roots rain.

> (Gerard Manley Hopkins, "Justus Quidem Tu Es,
> Domine, Si Disputem Tecum: Verumtamen Justa Loquar
> Ad Te: Quare Via Impiorum Prosperatur? &c.")

William Butler Yeats used a mixed Shakespearean rhyme scheme for this great sonnet:

A sudden blow: the great wings beating still
Above the staggering girl, her thighs caressed
By the dark webs, her nape caught in his bill,
He holds her helpless breast upon his breast.

How can those terrified vague fingers push
The feathered glory from her loosening thighs?
And how can body, laid in that white rush,
But feel the strange heart beating where it lies?

A shudder in the loins engenders there
The broken wall, the burning roof and tower
And Agamemnon dead.
 Being so caught up,

So mastered by the brute blood of the air,
Did she put on his knowledge with his power
Before the indifferent beak could let her drop?

> (William Butler Yeats, "Leda and the Swan")

Edna St. Vincent Millay used everyday speech to explore psychological situations in Shakespearean sonnets such as the following:

If I should learn, in some quite casual way,
That you were gone, not to return again—
Read from the back-page of a paper, say,
Held by a neighbor in a subway train,
How at the corner of this avenue
And such a street (so are the papers filled)
A hurrying man, who happened to be you,
At noon today had happened to be killed,
I should not cry aloud—I could not cry
Aloud, or wring my hands in such a place—
I should but watch the station lights rush by
With a more careful interest on my face;
Or raise my eyes and read with greater care
Where to store furs and how to treat the hair.

> (Edna St. Vincent Millay, "If I should learn")

Robert Lowell wrote volumes of sonnet-like poems which he called not "sonnets" but rather "fourteen-line poems"—they have no discernible rhyme patterning, but they still bear a strong general resemblance to the form and movement of the traditional sonnet:

I fear my conscience because it makes me lie.
A dog seems to lap water from the pipes,
life-enhancing water brims my bath—
(the bag of waters of the lake of the grave . . . ?)
from the palms of my feet to my wet neck—
I have no mother to lift me in her arms.
I feel my old infection, it comes once yearly:
lowered good humor, then an ominous
rise of irritable enthusiasm . . .
Three dolphins bear our little toilet-stand,
the grin of the eyes rebukes the scowl of the lips,

they are crazy with the thirst. I soak,
examining and then examining
what I really have against myself.

<div style="text-align: right">(Robert Lowell, "Symptoms")</div>

STANZA

An organized unit of poetic lines which are more or less regularly divided
into separate groups, usually (but not always) with strict METER and some
kind of recurring RHYME pattern; from the Italian, "resting place or abode";
hence, a place along the way of a poem.

The following are the most common stanza forms in English poetry:

Monostich One-line unit.

<div style="text-align: center">

Sun smudge on the smoky water
(Archibald MacLeish, "Autumn")

</div>

Couplet A two-line unit; also called "distich."

<div style="text-align: center">

So full of artless jealousy is guilt,
It spills itself in fearing to be spilt.
(William Shakespeare, *Hamlet,* IV.v)

</div>

See COUPLET.

Tercet A three-line unit, which often uses *terza rima* (see RHYME); also
called "triplet."

O wild West Wind, thou breath of Autumn's being,
Thou, from whose unseen presence the leaves dead
Are driven, like ghosts from an enchanter fleeing,

Yellow, and black, and pale, and hectic red,
Pestilence-stricken multitudes: O thou,
Who chariotest to their dark wintry bed . . .

<div style="text-align: right">(Percy Bysshe Shelley, "Ode to the West Wind")</div>

Quatrain A four-line unit.

<div style="text-align: center">

Western wind, when wilt thou blow
The small rain down can rain?

</div>

> Christ, if my love were in my arms
> And I in my bed again!
>> (Anonymous, fourteenth–fifteenth century)

See QUATRAIN.

Cinquain A five-line unit.

> Helen, thy beauty is to me
>> Like those Nicean barks of yore
> That gently o'er a perfumed sea
>> The weary, way-worn wanderer bore
> To his own native shore.
>> (Edgar Allan Poe, "To Helen")

Sixain A six-line unit; also called "sestet."

> Even as the sun with purple-color'd face
> Had ta'en his last leave of the weeping morn,
> Rose-cheek'd Adonis hied him to the chase;
> Hunting he lov'd, but love he laugh'd to scorn.
>> Sick-thoughted Venus makes amain unto him,
>> And like a bold-fac'd suitor 'gins to woo him.
>>> (William Shakespeare, "Venus and Adonis")

Septet A seven-line unit, which sometimes uses *rime royale* (a/b/a/b/b/c/c).

> "Lucrece," quoth he, "this night I must enjoy thee:
> If thou deny, then force must work my way,
> For in thy bed I purpose to destroy thee.
> That done, some worthless slave of thine I'll slay,
> To kill thine honor with thy life's decay;
>> And in thy dead arms do I mean to place him,
>> Swearing I slew him, seeing thee embrace him . . ."
>>> (William Shakespeare, "The Rape of Lucrece")

Octave An eight-line unit; also called "octet."

> That is no country for old men. The young
> In one another's arms, birds in the trees
> —Those dying generations—at their song,

The salmon falls, the mackerel-crowded seas,
Fish, flesh, or fowl, commend all summer long
Whatever is begotten, born, and dies.
Caught in that sensual music, all neglect
Monuments of unageing intellect.

 (William Butler Yeats, "Sailing to Byzantium")

Nine-Line Stanza Sometimes uses the rhyme scheme a/a/a/a/b/c/c/c/b.

 There is a God and He has made
 all things and I am not afraid
 to ask him for His aid.
 He made this child and He made
 me lay it in this hay.
 Go and tell everyone
 that His young Son
 is here and has begun
 His work today.

 (The Wakefield Master, *The Second Shepherds Play*,
 tr. William Packard)

This same nine-line stanza unit eventually became the *Spenserian stanza*, usually consisting of eight pentameter lines and one hexameter line, based on Spenser's usage in *The Fairie Queene*. The Romantics revived the Spenserian stanza, and Keats used it:

 St. Agnes' Eve—Ah, bitter chill it was!
 The owl, for all his feathers, was a-cold;
 The hare limped trembling through the frozen grass,
 And silent was the flock in woolly fold:
 Numb were the Beadsman's fingers, while he told
 His rosary, and while his frosted breath,
 Like pious incense from a censer old,
 Seem'd taking flight for heaven, without a death,
 Past the sweet Virgin's picture, while his prayer he saith.

 (John Keats, "The Eve of St. Agnes")

STRESS *See* METER; RHYTHM.

STROPHE

Any loose grouping of stanzaic (see STANZA) lines immediately followed by antiphonal counterparts, with a final coming to rest. The word comes from the Greek, "a turning"; in the great tragedies of Aeschylus and Sophocles and Euripides, a chorus would move across the stage chanting a set of stanzas, and would suddenly turn and move across the stage in the opposite direction chanting a different set of stanzas, the anti-strophes. The chorus would end its chanting with an epode, or "standing still."

Strophes are sometimes referred to as long breath lines, as in the poems of Walt Whitman or Robinson Jeffers or Allen Ginsberg.

SUBSTITUTION

A sudden or unexpected change in the METER of a foot. One can observe this in the following example:

> Cowards die many times before their deaths;
> The valiant never taste of death but once.
> Of all the wonders that I yet have heard,
> It seems to me most strange that men should fear;
> Seeing that death, a necessary end,
> Will come when it will come.

> (William Shakespeare, *Julius Caesar,* II.ii)

In this example, line 1 begins with a trochee but then develops a strong iambic beat that continues over lines 2–4. Line 5 suddenly reverts to trochee with the word "seeing," but returns to the strong iambic beat at "that," which continues over to line 6. The specific substitution, then, occurs at the opening of line 5.

Another example of substitution is the following:

> My life closed twice before its close—
> It yet remains to see
> If Immortality unveil
> A third event to me
>
> So huge, so hopeless to conceive
> As these that twice befell.
> Parting is all we know of heaven,
> And all we need of hell.

> (Emily Dickinson, "My life closed twice")

In this example, the first six lines are entirely in a strong iambic rhythm; however, the seventh line begins with a trochee foot with the word "parting," then reverts to iambic which continues over to the eighth line. The substitution occurs at the opening of line 7.

In both of these examples, one can sense the power of substitution by reading the passages aloud; the substituted feet seem to bring the poem to a halt for an instant, before allowing it to resume its accustomed meter. Substitution is one of the most effective devices for varying and enforcing a strong regular meter.

SURREALISM

In poetry, the use of radically surprising or anti-logical associations of words or images. The poet Guillaume Apollinaire was the first to use the word *surréalisme*, and he illustrated the way Surrealism achieved its uncanny effects by citing an example: "When man wanted to imitate the action of walking, he invented the wheel, which does not resemble the leg."

André Breton's first *Surrealist Manifesto*, of 1920, includes the following definition:

> pure psychic automatism by which it is intended to express, be it verbally, in writing or by any other means, the true functioning of thought. Dictation of thought without any control by reason, and outside any aesthetic or moral preoccupation . . .

In the second *Surrealist Manifesto*, of 1929, Breton went even further and described how it feels to practice surrealism:

> a vertiginous descent within ourselves, the systematic illumination of hidden places, and the progressive darkening of all other places, the perpetual rambling in the depth of the forbidden zone . . .

Surrealism was deeply influenced by the works of Sigmund Freud, particularly his 1900 pioneer volume *The Interpretation of Dreams* and the ensuing books on the psychopathology of everyday life, slips of the tongue, and the analysis of wit. Indeed, according to the Surrealists, the goal of Surrealism is the same as the goal of psychoanalysis—as Breton wrote, "Human emancipation remains the only cause worth serving." Most definitions of Surrealism insist on this liberated and liberating aspect of the movement. Precursors of

Surrealism include Swift, de Sade, Victor Hugo, Baudelaire, Rimbaud, and Mallarmé. Chief among the Surrealist poets were Breton, Apollinaire, Paul Éluard, Robert Desnos, Louis Aragon, and Max Ernst.

One senses a grotesque personification in these Surrealist lines:

> wonderful ailing fall
> you will die when strong winds
> blow through rose parks,
> when snows come to
> orchards . . .
>
> (Guillaume Apollinaire, "Automne Malade,"
> tr. William Packard)

The following lines are surprising and anti-logical in their Surrealism:

my wife whose hair is wild fire
whose thoughts are bright lightning
whose waist is an hour glass
whose waist is an otter caught in the teeth of a tiger
whose mouth is a red rosette with the radiance of a star of the first
 magnitude
whose teeth leave tiny marks like the footprints of white mice on new
 snow
whose tongue is translucent as the clearest mirrors
whose tongue is a raped wafer . . .

> (André Breton, "Free Union," tr. William Packard)

There are swift dissociations in the following Surrealist lines:

birds are the aroma of the woods
rocks are their dark lakes

they play at silhouettes
and succeed

may these birds be one
with their wings

wondering
 i live in this thorn
my claws perch on the live breasts
of poverty and air

> (Paul Éluard, "Confections," tr. William Packard)

SYLLABICS

Poetry that is measured by the phonetic units of syllables rather than by ACCENTS or vowel elongations.

In classical practice, syllabics took account of long and short syllables; as Gilbert Murray writes in *The Classical Tradition in Poetry,*

> In earliest Greek verse the unit is no longer merely the syllable, but the "short syllable," and on this precision of phonetic analysis the whole development of European meter is based. Syllables were divided into two classes, short and long, and the long was conventionally accepted as equal to two short, while an elided syllable was not counted at all.

In modern practice, however, syllabics refers to the quantitative measure of syllables. This stanza by Marianne Moore shows the actual practice:

	SYLLABLE COUNT
Strengthened to live, strengthened to die for	9
medals and positioned victories?	9
They're fighting fighting fighting the blind	9
man who thinks he sees—	5
who cannot see that the enslaver is	10
enslaved; the hater, harmed. O shining, O	10
firm star, O tumultuous	7
ocean lashed till small things go	7
as they will, the mountainous	7
wave makes us who look, know	6

(Marianne Moore, "In Distrust of Merits")

Moore then duplicated the same syllable count, line for line, in every other stanza of the poem. Hence the last stanza of this poem becomes

	SYLLABLE COUNT
Hate-hardened heart, O heart of iron,	9
iron is iron till it is rust.	9

	SYLLABLE COUNT
There never was a war that was	8
not inward; I must	5
fight till I have conquered in myself what	10
causes war, but I would not believe it.	10
I inwardly did nothing.	7
O Iscariotlike crime!	7
Beauty is everlasting	7
and dust is for a time.	6

Because the latter stanza is the climax of the poem, there is a slight divergence from strict syllable count in line 3; one may also note the unobtrusive RHYME pattern in both stanzas above, rhyming lines 2 and 4, and lines 8 and 10.

SYMBOLISM

The practice of using symbols—emblems or ciphers or signs that stand for something else—to convey ideas.

In Eastern poetry, symbolism has always been more central to the nature of imagery than it has been in Western poetry. Thus a Chinese opera which dates to the Tang Dynasty contains the following seemingly innocent song of the Drunken Boatman:

> These are good days on West Lake,
> as we go through wind and rain—
> ten lifetimes to meet a mate,
> then a hundred to embrace.
> (*The White Snake,* tr. William Packard)

These simple lines stand for a complex pattern of associations: this life is good, even though we go through wind and rain; it takes a total of ten lifetimes just to meet the right mate, then it takes a hundred lifetimes to be able to become one with this mate.

In Japanese HAIKU, images are used for their symbolic value; thus "dew-drop" will mean that which vanishes; "cherry blossom" will mean that which is briefly beautiful; and so on.

In Medieval poetry, Dante tells us at the beginning of the *Commedia* that halfway through his life he lost the true way, and that he saw three animals: a leopard, a lion, and a she-wolf. These three image-symbols stand for the

three sins of which Dante accuses himself: lust (the leopard), pride (the lion), and avarice (the she-wolf). Readers familiar with Medieval iconography would immediately recognize these image-symbols, and Dante apparently felt no need to elaborate further on their meaning.

Repetition of key image-words can raise them to the status of ciphers, and capitalization of key image-words can turn them into universal symbols. Both of these devices are at work in William Blake's poem "London"; the words "charter'd," "marks," and "cry" are repeated in order to take on cipher meanings, and the words "Man," "Infant," "Church," "Soldier," "Palace," and "Marriage" are capitalized to create collective symbols of universal meaning:

> I wander thro' each charter'd street,
> Near where the charter'd Thames does flow,
> And mark in every face I meet
> Marks of weakness, marks of woe.
>
> In every cry of every Man,
> In every Infant's cry of fear,
> In every voice, in every ban,
> The mind-forg'd manacles I hear.
>
> How the Chimney-sweeper's cry
> Every black'ning Church appalls;
> And the hapless Soldier's sigh
> Runs in blood down Palace walls.
>
> But most thro' midnight streets I hear
> How the youthful Harlot's curse
> Blasts the new born Infant's tear,
> And blights with plagues the Marriage hearse.
>
> (William Blake, "London")

In modern poetry, the French Symbolists such as Valéry, Mallarmé, Verlaine, and Baudelaire explored the uses of image-symbols in their poetry; in German, Rainer Maria Rilke used Symbolism in his *Duino Elegies* and "Sonnets to Orpheus"; and in English, William Butler Yeats chose certain key images such as the "gyre" to stand for the spiraling of time and the eternal recurrence of all things.

Hart Crane presents a simple image-symbol which stands for the encroachment of technology on the wilderness:

The last bear, shot drinking in the Dakotas
Loped under wires that span the mountain stream.

<div align="right">(Hart Crane, "The Bridge")</div>

And in Wallace Stevens' "Sunday Morning," the symbol of the time indicated in the title shows that the woman is not in church but is staying home instead, listening to the sound of wakened birds who stand for the vague bloodstream memory of "a ring of men" who shall "chant in orgy on a summer morn / Their boisterous devotion to the sun. . . ." The poem ends with an explicit statement, not by the poet, but by a voice that the woman hears:

> "The tomb in Palestine
> Is not the porch of spirits lingering.
> It is the grave of Jesus, where he lay."
> We live in an old chaos of the sun,
> Or old dependency of day and night,
> Or island solitude, unsponsored, free,
> Of that wide water, inescapable . . .

<div align="right">(Wallace Stevens, "Sunday Morning")</div>

SYNECHDOCHE

A figure of speech, a species of METONYMY, in which a part is made to stand for a whole. Thus, so many "head" of cattle stand for the animals themselves, and Shakespeare's "pen" stands for his entire writing faculty.

T

TANKA *See* HAIKU.

TONE

The accumulated effect of style, coloration, and texture. Like atmosphere in a short story or like mood in symphonic music, tone in poetry is the result of particular choices which affect the reader's overall feeling toward a poem.

The following statement by the contemporary American poet Robert Creeley in an NYQ Craft Interview comes close to showing the relation of tone and intention in a poem:

> NYQ: There's a widely influential quotation attributed to you—the one about "Form is never more than an extension of content." Would you comment on that?
>
> CREELEY: I still feel that to be true. The thing to be said tends to dictate the mode in which it can be said. I really believe Charles' [Olson's] contention that there's an appropriate way of saying something inherent in the thing to be said. . . .

TRANSLATION

The transmission of poetry from one language to another, transmission not only of meaning, but also of sound and RHYTHM and nuance of form—admittedly, an impossibility. Sigmund Freud confirms this difficulty in *The Interpretation of Dreams,* when he claims that a dream can never be adequately translated from one language to another, because of the unique collocation of words and images that takes place in any given dream cluster.

Some poets have known otherwise. Pushkin called translators "the post-horses of enlightenment," and we remember the authentic exaltation John

197

Keats felt on first looking into Chapman's translation of Homer. Indeed, translating can be as creative an art of discovery as poetry writing or narrative prose or dramatic writing; and it is as difficult and exacting as any of these other arts.

The task of the translator goes far beyond finding "le mot juste." It has to do with locating and recreating the appropriate forms and rhythms of a subtext. The Irish poet John Millington Synge said it best: "A translation is no translation unless it will give you the music of a poem along with the words of it."

The German poet Rainer Maria Rilke in his *Notebooks of Malte Laurids Brigge* describes the extraordinary patience and labor and faith that it takes to embody the experiences of an original text in an authentic translation:

> The translation does not give back the full meaning and he wants to show to young people the beautiful and real fragments of this massive and glorious language which has been fused and made pliable in such intense flame. . . . He warms himself again to his work. Now, come evenings, fine, almost youthful evenings, like those of autumn, for instance, which bring with them such long calm nights. In his study the lamp burns late. He does not always bend over the pages; he often leans back, closing within his eyes a line he has read over and over, until its meaning flows into his very blood . . .

And yet, difficult as the task may be, the problem of translation is with us always. As Muriel Rukeyser once commented, "Might it not be that all poetry and indeed all speech are a translation?"

In the opening lines of the *Cantos,* Ezra Pound provides his own translation of part of Book XI of Homer's *Odyssey:*

> And then went down to the ship,
> Set keel to breakers, forth on the godly sea, and
> We set up mast and sail on that swart ship,
> Bore sheep aboard her, and our bodies also
> Heavy with weeping, and winds from sternward
> Bore us out onward with bellying canvass,
> Circe's this craft, the trim-coifed goddess . . .
>
> (Ezra Pound, "Canto I")

The following is poem 5 by the Latin poet Catullus, one of the greatest love poems ever written:

Vivamus, mea Lesbia, atque amemus,
rumoresque senum seueriorum
omnes unius aestimemus assis.
soles occidere et redire possunt:
nobis cum semel occidit breuis lux,
nox est perpetua una dormienda.
da mi basia mille, deinde centum,
dein mille altera, dein secunda centum,
deinde usque altera mille, deinde centum.
dein, cum milia multa fecerimus,
conturbabimus illa, ne sciamus,
aut ne quis malus inuidere possit,
cum tantum sciat esse basiorum.

In the English version by Horace Gregory, the translator opens up the form
through use of line PLACEMENT:

Come, Lesbia, let us live and love,
nor give a damn what sour old men say.
The sun that sets may rise again
but when our light has sunk into the earth,
it is gone forever.
 Give me a thousand kisses,
then a hundred, another thousand,
another hundred
 and in one breath
still kiss another thousand,
another hundred.
 O then with lips and bodies joined
many deep thousands;
 confuse
their number,
 so that poor fools and cuckolds (envious
even now) shall never
learn our wealth and curse us
with their
evil eyes.

Over the past fifty years there has been a renaissance of translation of the
important classics of world literature into English. The following is a brief
listing of some major translations available to the general reader:

From classical Greek: Homer's *Iliad* and *Odyssey* have been rendered by Richmond Lattimore and Robert Fitzgerald, among others. Sappho's poems have been translated well by Willis Barnstone. The Greek tragedies of Aeschylus and Sophocles and Euripides have been variously translated by Lattimore, Fitzgerald, William Arrowsmith, Dudley Fitts, Robinson Jeffers, Ezra Pound, Rex Warner, Witter Bynner, Emily Townsend Vermeule, and Elizabeth Wyckoff. Plato and Aristotle remain in the competent translations of Benjamin Jowett and Richard McKeon, respectively.

From Latin: Ovid's *Amores* and *Metamorphoses* have been well rendered in numerous versions. Catullus is in the excellent translations of Horace Gregory, cited above. Virgil's *Aeneid* has been brilliantly translated by Robert Fitzgerald.

From Italian: Pound has done Guido Cavalcanti masterfully. For Dante, the *Vita Nuova* was exquisitely done by Dante Gabriel Rossetti. The *Commedia* has been given contemporary translation by John Ciardi, although the earlier Laurence Binyon translation may be more accurate and more musical.

From Spanish: *Don Quixote* by Cervantes in translation by J. M. Cohen. The poems of García Lorca by Roy Campbell. Poems of Jiménez by Antonio de Nicolas. Poems of Pablo Neruda by a wide variety of contemporary American poets.

From German: Goethe in translation by Louis Simpson. Kafka in translation by Max Brod. The poems of Rainer Maria Rilke in translations by M. D. Herter Norton, C. F. MacIntyre, Stephen Spender, and Stephen Mitchell.

From Russian: Tolstoy himself worked with the Maudes on their translation of *War and Peace;* Constance Garnett retranslated it in slightly bowdlerized version. Helen Michailoff and David Magarshack have done brilliant translations of Russian classics, and Vladimir Nabokov has done the definitive Pushkin.

From French: The plays of Molière in translations by Richard Wilbur; Racine's *Phèdre* in free rendering by Robert Lowell, William Packard's translation retains strict alexandrine couplets. Scott Moncreiff for Marcel Proust. Maurice Valency for Giraudoux. Modern French poems have been excellently translated by a whole host of distinguished contemporary poets, including Paul Blackburn, James Wright, Wallace Stevens, Kenneth Rexroth, and Malcolm Cowley.

From Japanese: Harold Henderson, Kenneth Rexroth, and R. H. Blyth have all done excellent translations of haiku and other kinds of poem, and Noboyuki Yuasa has done an excellent translation of Issa's *Oraga Haru,* the *haibun* "Year of My Life."

From Chinese: Arthur Waley's excellent translations; Ezra Pound's *Cathay;* Kenneth Rexroth's translations. Also *The Red Pear Garden: Three Great Dramas of Revolutionary China,* includes *The White Snake, The Wild Boar Forest,* and *Taking Tiger Mountain by Strategy.*

From Norwegian: Eva Le Gallienne did excellent translations of Ibsen; Robert Bly for Knut Hamsun and other Norwegian poetry.

From Swedish: Elisabeth Sprigge for Strindberg.

TROCHEE *See* METER.

TROPE *See* FIGURE.

TROUBADOUR *See* JONGLEUR.

U

UBI SUNT

A CATALOGUE listing of the names of heroes or poets or other persons who have gone away; the poet inquires after their absence with a passage beginning *Ubi sunt?* (from the Latin, "where are?"). The convention may derive from the Old Testament genealogies, which carried over into the opening verses of Matthew:

> The book of the generation of Jesus Christ, the son of David, the son of Abraham.
>
> Abraham begat Isaac; and Isaac begat Jacob; and Jacob begat Judas and his brethren. . . .
>
> (Matthew 1:1–2)

The *ubi sunt* may also be an echo of the catalogue listing of names and city-states in the Greek epic poems, as in Book Two of the *Iliad* where Homer recites the names of all the chief Danaan lords and officers from Boiotia, Athens, Sparta, Pylos, Salamis, Argos, Mycenae, and so on.

François Villon in his Medieval poem "Où sont les neiges de hier?" asked a variation of the *ubi sunt* question; and William Dunbar asked where the great poets or makaris were:

> He has done petuously devour
> The noble Chaucer, of makaris flour,
> The Monk of Bury, and Gower, all three:—
> *Timor Mortis conturbat me*.
>
> (William Dunbar, "Lament for the Makaris")

The *ubi sunt* convention has become traditional in the ELEGY, as the poet calls on wood nymphs or Muses or any other relevant Spirits to ask where

they had been at the time of a death and why they were not able to save the person being mourned:

> Where were ye Nymphs when the remorseless deep
> Clos'd o'er the head of your lov'd Lycidas? . . .
>
> (John Milton, "Lycidas")

In modern poetry, there is an effective use of the *ubi sunt* convention at the beginning of Edgar Lee Masters' *Spoon River Anthology:*

> Where are Elmer, Herman, Bert, Tom and Charley,
> The weak of will, the strong of arm, the clown, the boozer, the fighter?
> All, all, are sleeping on the hill . . .

VARIABLE FOOT

A modern form of METER in which the basic unit of measure can shift from regular to irregular scansion.

This prosody concept was introduced by the American poet William Carlos Williams, in an attempt to substitute intuitive cadence for traditional metric, and the poet's own breath for customary stress patterns. The best examples of variable foot can be found in Williams' LONG POEM *Paterson*.

Williams defined variable foot as follows:

It rejects the standard of the conventionally fixed foot and suggests that measure varies with the idiom by which it is employed and the tonality of the individual poem. Thus, as in speech, the prosodic pattern is evaluated by criteria of effectiveness and expressiveness rather than mechanical syllable counts. The verse of genuine poetry can never be "free," but free verse, interpreted in terms of the variable foot, removes many artificial obstacles between the poet and the fulfillment of the laws of his design.

VERSE *See* POETRY; STANZA.

VILLANELLE

An intricate French verse form dating from the late fifteenth century, with end-rhymes and repeated key lines which are arranged according to the following formula:

A/c/B ab/c/A ab/c/B ab/c/A ab/c/B ab/c/A/B

"A" and "B" stand for complete lines which RHYME with each other, and which are repeated in their entirety throughout the poem as indicated in the

formula; "c" stands for different lines sharing the same outside rhyme; and "ab" stands for different lines sharing the same rhyme as "A" and "B."

In Dylan Thomas' "Do Not Go Gentle into That Good Night," one of the most successful villanelles in modern poetry, the repeated "A" and "B" lines alternate as imperatives and predicates throughout the poem. Other modern poets who wrote villanelles include William Empson, who wrote "Missing Dates," and Edwin Arlington Robinson, whose villanelle "The House on the Hill" abandons pentameter in favor of trimeter with the repeating lines "They have all gone away" and "There is nothing more to say."

VOICE

An inimitable way of saying something; the sense of the poet's presence in a poem, whether deriving from a special inflection or stance of the poet, or from a PERSONA assumed in the poem, or from a dramatic character the poet may be speaking through. Voice is what is meant when one says, "I can hear Yeats in that line." Voice is created by the admixture of syntax, sentence force, and DICTION in a poem, and is used to reveal the unique personality of the poet or of a dramatic character the poet is presenting to us.

An example of parenthetical voice, or a voice that seems to be making an aside:

> And some are loaves and some so nearly balls
> We have to use a spell to make them balance:
> "Stay where you are until our backs are turned!"
>
> (Robert Frost, "Mending Wall")

An example of a poet recalling her voice when she was a twelve-year-old girl occurs in the following poem:

> Come out from under the Reo, Da,
> And look into my little brown eyes.
> I am twelve, I am twelve, I am twelve.
>
> Wipe those hands of their axle grease,
> Smile on me, Da, as though you saw me.
> Wipe those hands of their axle grease.
>
> Touch me, Da, like a Da, like a Da,
> Say hello and smile and touch me, say,
> My shoulder, there's a safety zone.

Touch me, Da, wipe off that axle grease
Before, then touch me, with your gnarled
Hand, the thumb shot by a bullet.

I remember the spot. I remember the smoking
As you built: built what? O Da,
What did you build with all that building?

The dock has washed away; the roof needs mending.
The fireplace stands with some staggering
In its loins, the grass needs mowing.

Come out from under the Reo, Da,
The bogeymen have all gone away,
I won't let anything hurt you, Da.

There'll be money in the bank; our credit
Will be white as newblown grain,
Come out, May is here, the depression is over.

Come out, Da; and Mum, you come out of the matinee,
The menopause is over now, hurray.
I am twelve, I am twelve, I am twelve.

(Ruth Herschberger, "Out of the Past")

John Berryman's rambling, self-intoxicated voice is evident in "Dream
Song #4":

Life, friends, is boring. We must not say so.
After all, the sky flashes, the great sea yearns,
we ourselves flash and yearn,
and moreover my mother told me as a boy
(repeatedly) "Ever to confess you're bored
means you have no

Inner Resources." I conclude now I have no
inner resources, because I am heavy bored . . .

(John Berryman, "Dream Song #4")

There is the terse, gnomic, elliptical, and clipped voice of Robert Creeley
in this poem:

As I sd to my
friend, because I am
always talking,—John, I

sd, which was not his
name, the darkness sur-
rounds us, what

can we do against
it, or else, shall we &
why not, buy a goddamn big car,

drive, he sd, for
christ's sake, look
out where yr going.
 (Robert Creeley, "I Know a Man")

The voice of Charles Bukowski is laid back and insouciant in this poem:

style is the answer to everything—
a fresh way to approach a dull or a
dangerous thing.
to do a dull thing with style
is preferable to doing a dangerous thing
without it.

Joan of Arc had style
John the Baptist
Christ
Socrates
Caesar,
Garcia Lorca

style is the difference,
a way of doing,
a way of being done.

6 herons standing quietly in a pool of water
or you walking out of the bathroom naked
without seeing
me.

 (Charles Bukowski, "Style")

WORD

In any language, the basic unit of expression; from the Latin *verbum*. Each word in English contains at least one vowel and one consonant, making ASSONANCE and ALLITERATION almost inevitable consequences of conjoining words.

In some civilizations the word itself is sacred; the Gospel of John in the New Testament translates the Greek *logos* as "word" and makes it co-equal with God:

> In the beginning was the Word, and the Word was with God, and the Word was God.

In the French it is just as strong:

> Au commencement de tout, il y avait le Verbe qui est la Parole de Dieu. Le Verbe était avec Dieu et le Verbe était Dieu.

This identification of God with the Word is an echo of Plato in the *Timaeus* dialogue, describing the creation of the world.

In Chinese written characters, each word is an ideogram which contains an image aspect, as if it had sprung from picture-writing. In *The ABC of Reading* Ezra Pound discusses Chinese "words": "In tables showing primitive Chinese characters in one column and the present 'conventionalized' signs in another, anyone can see how the ideogram for man or tree or sunrise developed, or 'was simplified from,' or was reduced to the essentials of the first picture of man, tree or sunrise."

X

XANADU POEM

Any poem depicting a Utopian setting, or a place of idyllic beauty. The term is derived from Coleridge's poem "Kubla Khan," in which the poet presents an underground world of indescribable wonders:

> In Xanadu did Kubla Khan
> A stately pleasure-dome decree:
> Where Alph, the sacred river, ran
> Through caverns measureless to man
> Down to a sunless sea.
> So twice five miles of fertile ground
> With walls and towers were girdled round:
> And there were gardens bright with sinuous rills,
> Where blossomed many an incense-bearing tree;
> And here were forests ancient as the hills,
> Enfolding sunny spots of greenery . . .
>
> (Samuel Taylor Coleridge, "Kubla Khan")

Robert Burns describes his own Utopia as the Highland hills of Scotland:

> My heart's in the Highlands, my heart is not here;
> My heart's in the Highlands a chasing the deer;
> Chasing the wild deer, and following the roe;
> My heart's in the Highlands, wherever I go.
>
> (Robert Burns, "My heart's in the Highlands")

William Butler Yeats describes his Utopian setting as the Lake Country of Ireland:

I will arise and go now, and go to Innisfree,
And a small cabin build there, of clay and wattles made:
Nine bee-rows will I have there, a hive for the honey-bee,
And live alone in the bee-loud glade . . .

(William Butler Yeats, "The Lake Isle of Innisfree")

Descriptions of inner landscapes and settings qualify as Utopian poems also; one of the most exquisite Xanadu poems is this one, by Robert Duncan:

OFTEN I AM PERMITTED TO RETURN TO A MEADOW

as if it were a scene made-up by the mind,
that is not mine, but is a made place,

that is mine, it is so near to the heart,
an eternal pasture folded in all thought
so that there is a hall therein

that is a made place, created by light
wherefrom the shadows that are forms fall.

Wherefrom fall all architectures I am
I say are likenesses of the First Beloved
whose flowers are flames lit to the Lady . . .

(Robert Duncan, from *The Opening of the Field*)

Y

YEATS OCTAVE

An octave STANZA form that has the RHYME scheme a/b/b/a/c/d/d/c, perfected by William Butler Yeats. The following stanza is a good example of the Yeats octave:

> I am content to follow to its source
> Every event in action or in thought;
> Measure the lot; forgive myself the lot!
> When such as I cast out remorse
> So great a sweetness flows into the breast
> We must laugh and we must sing,
> We are blest by everything,
> Everything we look upon is blest.
>
> (William Butler Yeats,
> "A Dialogue of Self and Soul")

Z

ZEUGMA

From the Greek, a joining or a yoking together of two different descriptive words, each pertaining in its own way to a subject. Thus: "She opened the door and her heart to the homeless boy."

The opening lines of *Paradise Lost* contain a zeugma:

> Of Man's first disobedience, and the Fruit
> Of that Forbidden Tree . . .
>
> (John Milton, *Paradise Lost*)

In these lines, both "disobedience" and "Fruit" are aspects of the subject that Milton is asking the Muse to sing about.

Appendix: How to Submit Manuscripts for Publication

Each poet must work out his or her own reasons for submitting poetry manuscripts to literary magazines or publishers for consideration. However, once one is decided to submit, there are certain procedures and guidelines to follow:

1. Be sure there is sufficient postage on the outside envelope; magazines and publishers will not pay postage due on manuscript submissions.
2. Be sure to enclose a stamped, self-addressed envelope, with sufficient postage on it for the return of your work.
3. Be sure to keep copies of all work you send out.
4. Type all manuscripts on 8½" × 11" bond paper. Use a fresh typewriter ribbon and avoid thin tissuey paper that will not stand up under handling. Be sure your submission is a clean and original copy, so it will not look like it has been through the magazine or publishing mills.
5. It is acceptable to type poems single-spaced.
6. Type only one poem per page.
7. Be sure you proofread each poem submission for spelling and grammatical errors, as any typos will probably prejudice an editorial reader against your poem manuscript.
8. Do not fold each poem submission separately, as this adds an extra step in collating your work for screening.
9. Include from three to five poem manuscripts with each submission to any literary magazine; this gives an editorial staff a fair sample of your range without overburdening the readers.
10. Be sure your name and address are on each page of the submission.
11. Generally, there is no need to put word count or copyright symbol on your submission.

12. Cover letter is optional to literary magazines. If you do decide to include a letter, be sure it is brief and courteous and sane. Any attempt to be cute or pretentious will prejudice the consideration of your manuscript.
13. Keep track of which poems you submit to what magazine, together with date of submission.
14. Allow a reasonable period of time for a magazine to consider your work. Some magazines are notoriously slow; others pride themselves on prompt replies. If a poem is held anywhere longer than two or three months, it is appropriate to send a card of inquiry about the disposition of the submission.

You can compile your own directory of literary magazines you feel are worth submitting to, based on your reading of magazines from local bookstores. The Coordinating Council of Literary Magazines (C.C.L.M.) publishes an annual *Directory of Literary Magazines,* which can be obtained by writing to:

C.C.L.M.
666 Broadway
New York, NY 10012-2301

Selected Bibliography

The following books are recommended for further reading in prosody, poetics, and the art and craft of poetry:

Aristotle. *Poetics*.

W. H. Auden. *The Dyer's Hand*. Random House, 1962.

H. S. Bennett. *Chaucer and the Fifteenth Century*. 1947.

Leonard Bernstein. *The Norton Lectures*. Harvard University Press, 1973.

John Berryman. *The Freedom of the Poet*. Farrar, Straus & Giroux, 1966.

R. H. Blyth. *Haiku*. 4 volumes. Hokuseido Press, Tokyo, and Heian International, San Francisco, 1952 (paperback edition, 1982).

Louise Bogan. *A Poet's Alphabet*. McGraw-Hill, 1967.

E. K. Chambers. *English Literature at the Close of the Middle Ages*. 1945.

Samuel Taylor Coleridge. *Biographia Literaria*.

Babette Deutsch. *Poetry Handbook*. Fourth edition. Harper & Row, 1974.

James Dickey. *Babel to Byzantium*. Farrar, Straus & Giroux, 1968.

Martin Duberman. *Black Mountain: An Exploration in Community*. E. P. Dutton, 1972.

Mircea Eliade. *Myth and Reality*. Harper & Row, 1963.

T. S. Eliot. *Literary Essays*. Harcourt, Brace.

Sir James Frazer. *The Golden Bough*. New American Library, 1975.

Paul Fussell, Jr. *Poetic Meter and Poetic Form*. Random House, 1965.

Robert Graves. *The White Goddess*. Farrar, Straus & Giroux, 1966.

Edith Hamilton. *Mythology*. Mentor, 1953.

Harold G. Henderson. *An Introduction to Haiku*. Doubleday Anchor, 1958.

Richard Howard. *Alone with America*. Atheneum, 1971.

William Irvine. *Madam, I'm Adam and Other Palindromes*. Scribners, 1988.

Issa. *Oraga Haru, The Year of My Life*. University of California Press, 1960.

Judson Jerome. *The Poet's Handbook*. Writer's Digest Books, 1980.

Larousse Encyclopedia of Mythology. Prometheus Press, 1960.

C. S. Lewis. *The Allegory of Love*.

———. *English Literature in the Sixteenth Century (Excluding Drama)*. 1954.

Joseph Malof. *A Manual of English Meters*. Indiana University Press, 1970.

Brander Matthews. *Study of Versification*.

John D. Mitchell. *Phèdre on Stage*. Northwood Institute, 1988.

Mark P. Morford and Robert J. Lenardon, eds. *Classical Mythology*. David McKay, 1971.

Oxford Companion to Classical Literature. Second edition. 1937.

Oxford Companion to English Literature. Fifth edition. 1985.

William Packard. *The Poet's Craft*. Paragon House, 1987.

Robert Peters. *The Great American Poetry Bake-Off*. Scarecrow Press, 1954.

Edgar Allan Poe. *The Rationale of Verse*.

Ezra Pound. *The ABC of Reading*. New Directions, 1960.

———. *How to Read*. New Directions.

———. *Literary Essays*. New Directions, 1968.

———. *The Spirit of Romance*. New Directions, 1968.

Princeton Encyclopedia of Poetry and Poetics. Princeton University Press, 1974.

Rainer Maria Rilke. *Letters to a Young Poet*. Norton, 1963, and Random House, 1984.

Theodore Roethke. *On the Poet and His Craft*. University of Washington Press, 1965.

H. J. Rose. *Handbook of Greek Mythology*. Dutton, 1959.

M. L. Rosenthal. *The Modern Poets*. Oxford University Press, 1967.

George Saintsbury. *A History of English Prosody from the Twelfth Century to the Present Day*. 3 volumes. 1906–1910.

Karl Shapiro. *In Defense of Ignorance*. Random House, 1960.

———. *The Poetry Wreck*. Random House, 1975.

Karl Shapiro and Robert Beum. *A Prosody Handbook*. Harper & Row, 1965.

Barbara H. Smith. *Poetic Closure: A Study of How Poems End*. University of Chicago Press, 1968.

Stephen Stepanchev. *American Poetry Since 1945*. Harper & Row, 1965.

Francis Stillman and Jane Whitfield. *Poet's Manual and Rhyming Dictionary*. Crowell, 1965.

Lewis Turco. *The Book of Forms: A Handbook of Poetics*. Dutton, 1968.

Maurice Valency. *In Praise of Love*. 1958.

Paul Valéry. *The Art of Poetry*. Vintage.

John Hall Wheelock. *What Is Poetry?* Scribners.

Miller Williams. *Patterns of Poetry: An Encyclopedia of Forms*. University of Louisiana Press, 1986.

William Carlos Williams. *I Wanted to Write a Poem*. New Directions, 1978.

———. *In the American Grain*. New Directions, 1956.

Yvor Winters. *In Defense of Reason*. Alan Swallow, 1947.

Clement Wood. *Complete Rhyming Dictionary*. Doubleday, 1936.

William Wordsworth. Preface to *Lyrical Ballads*. 1800.

COPYRIGHT ACKNOWLEDGMENTS

About the Author

William Packard is the founder and editor of *The New York Quarterly,* a national magazine devoted to the craft of poetry. He has been professor of poetry at New York University for over twenty years, and has published six volumes of poetry and a novel, seen his plays staged in the United States and abroad, written texts on screenwriting, playwriting, and poetry writing, and produced several translations of poetry. Packard was one of the distinguished American poets honored with a reception at the White House in 1980.